Praise for *Threads*

"Leslie retells her journey in prose that is as beautiful, meticulous, and captivating as the thangkas themselves."

❧ MEHER MCARTHUR, author of *Reading Buddhist Art*

"All of us are granted the same 24-hour day. But great memoirs show us how much life we can pack into every moment if our heart says 'yes.' Leslie Rinchen-Wongmo, whose name means precious, empowered woman, did just that. She came upon a group stitching sacred Tibetan tapestries in India and stayed to become the first Western woman trained to make them. Her story takes us deep into the art and culture she embraced. But just as importantly, Leslie provides a luminous lesson on what she calls 'the experience of traveling off course to a wondrous life.'"

❧ BARBARA CORNELL, Pulitzer Prize nominated journalist and librarian

"*Threads of Awakening* is a wonderful and illuminating window into the amazing worlds of brocade and embroidery tangkas. Leslie Rinchen-Wongmo is not only, to my knowledge, the first American woman to have mastered these exquisite artistic traditions but also the first to write extensively on them. And we are the fortunate ones who reap the fruits of her endeavors."

❧ GLENN H. MULLIN, author of *Female Buddhas* and four more books on Tibetan Buddhist art

"Profoundly meaningful and deeply spiritual, *Threads of Awakening* is a delightful and inspiring travel memoir about a Tibetan Buddhist textile tradition and a woman's search for purpose."

❧ ISADORA LEIDENFROST, PhD, filmmaker of *Creating Buddhas: The Making and Meaning of Fabric Thangkas*

Threads of Awakening

An American Woman's Journey
into Tibet's Sacred Textile Art

Leslie Rinchen-Wongmo

SHE WRITES PRESS

For the Tibetans who welcomed me.

For the teachers who taught me.

For Mom, Dad, and Francesco
who have given me more
than could ever fit on this page.

Thank you.

Published 2022
Printed in the United States of America
Print ISBN: 978-1-64742-093-2
E-ISBN: 978-1-64742-094-9
Library of Congress Control Number: 2022903757

For information, address:
She Writes Press
1569 Solano Ave #546
Berkeley, CA 94707

Interior design by Tabitha Lahr
Illustrations by Cory Yniguez

She Writes Press is a division of SparkPoint Studio, LLC.

Contents

THE DALAI LAMA

Foreword

I am pleased that, having been drawn to a unique Tibetan craft, Leslie Rinchen-Wongmo studied it deeply and is carrying it forward faithfully, in a personal artistic manner.

The tradition of Tibetan appliqué goes back centuries. Since coming into exile, we have made a concerted effort to preserve and restore our rich culture, including artistic heritage. Our distinctive Tibetan culture, a culture of peace, non-violence, and compassion, has great potential to make a constructive contribution to the whole of humanity toward maintaining peace of mind.

This book, *Threads of Awakening*, reveals the intricacies and richness of the appliqué tradition. I am sure it will enhance appreciation for our unique artistic traditions.

Tenzin Gyatso, the Dalai Lama
8 February 2021

Preface

L eslie Rinchen-Wongmo is a pioneer in introducing to the Western world the rare and sacred Tibetan art of *lhemthuk*—appliqué thangkas created with hundreds of pieces of brightly colored fabrics that are meticulously cut and stitched together to create enlightened icons and motifs. This ancient tradition requires a tremendous amount of skill: it demands a degree of mastery of the eyes and hands that exceeds the skills of the more commonly known painted thangkas (traditional Tibetan scroll paintings). Appliqué thangka creation also commands an extraordinary aesthetic maturity in the design and overall color placement and skillful layering of a myriad of fabric pieces to create a three-dimensional perspective in two-dimensional form. Beyond the technical skills that appliqué thangkas require, lineage blessings, spiritual training, and genuine compassion for all living sentient beings must ripen within the artist. For these reasons, appliqué thangka creation is an art form that is extremely difficult to accomplish—something which Leslie has achieved through her rigorous apprenticeships, dedication, meticulous skills training, and compassionate motivation to benefit all beings. *Threads of Awakening* is a celebration of this accomplishment, demonstrating that the authentic lineage of creating traditional Tibetan appliqué thangkas has been planted firmly in America and made accessible to the world at large.

Threads of Awakening shares Leslie's fascinating travels of exploration and growth. Interconnected moments of her life weave together like a mosaic in her quest of finding and accomplishing this rare and precious art form. In her articulate and joyfully relatable stories, Leslie lays her heart open with candor, drawing you in to walk alongside her as a companion on her journey. Of particular note, the appendix, "Stitches and Steps of Tibetan Appliqué," is perhaps the first written record on the topic ever published. *Threads of Awakening* not only fulfills a critical gap in the recorded literature and preservation of traditional Tibetan appliqué thangkas—it is also sure to enrapture, delight, and inspire you!

❧ PEMA NAMDOL THAYE, traditional Tibetan architect, painter, sculptor, 3-D mandala specialist, author, and art educator

Introduction

This is a book about wonder.

I didn't know that when I started writing it. I thought it would be about art—Tibetan art, sacred art, textile art—and my experience learning how to make that art in India. And it is about all those things. But it's also a vehicle for a deeper and more universal story about wonder—finding it, seeing it, making it.

It's about charting a course in life with wonder as your guide—*your* wonder, which is unlike anyone else's. It's about delight in the simplest, most ordinary details and encounters—with a spider, a flower, a human being, or a strand of thread.

To wonder, you have to loosen your grip on what you think you know. "It ain't what you don't know that gets you into trouble. It's what you know for sure that just ain't so." Mark Twain supposedly said that, and Buddhist teachings agree. Things are not as they seem.

There are many ways to look at the same thing, and in our looking we create the thing—even if that thing is our self, even if it's the world. Travel can help us look differently. So can Buddhism. The ideas that animate Tibetan Buddhist art are all about examining what we see, interrogating it, wondering about it, seeing it differently, and creating a fresh experience.

In this book, you'll read about how I found my way halfway around the globe in the 1990s and settled in the Himalayan hill town of Dharamsala to study Buddhism and volunteer for the Tibetans in exile. There, I learned an ancient textile art: a pieced-silk version of the Tibetan wall hanging icons called *thangkas*.

Being in a strange land, among people who spoke an unfamiliar language and saw the world in an unfamiliar way, highlighted the arbitrariness of my own viewpoint and made it easier to try on new perspectives. Facing uncertainty and confusion every day was both disorienting and rich with possibilities.

Such physical wandering can open the door to deep spiritual wondering, but exotic travel is not the only way to make those journeys. There are many ways to challenge the familiar, and there's a long spiritual tradition of doing so. You can do it in your own backyard and even inside your own home. Tibetans, in fact, refer to themselves as *nangpa* or "insiders" because they know the path of spiritual transformation is an inside job: the most important work happens in our inner world. We just have to leave the comfort of what we think we already know.

As one of very few Westerners to have mastered the art of Tibetan appliqué, I've always known that someday I'd write a book about it, especially after His Holiness the Dalai Lama encouraged me to make it relevant to people from my own culture. Even so, it took me a long time to feel ready. For many years, I was more interested in making the art than writing about it, convinced as I was that I'd have to take a scholarly approach to the subject rather than writing from my own experience. I explored university graduate programs in Asian art history, believing my hands-on knowledge wasn't enough.

As I continued to make my thangkas and to share them with a wider audience, however, I noticed a distinct strand of questions arising. At each exhibition or talk, someone would invariably ask, "How on earth did you get to India? Why did you end up doing this artwork? What drew you to such an exotic life?" Someone else would say, "I wish I could do that!" or "I never could." Over time, I realized that alongside and underneath people's curiosity

about Tibetan appliqué and my particular journey, were the barely audible questions: *How can I find what I love? How can I find the courage to follow my heart and discover my dreams? How can I, too, live freely?*

After years of being asked how I chose my unconventional path with this rare and sacred art, I finally realized I have all I need for writing this book: a unique expertise gained from learning the techniques of Tibetan appliqué from two of its greatest living masters, an intimate connection with Tibetan teachers and friends, good stories to tell, and the personal experience of traveling off course to a wondrous life.

My purpose in writing this book is to share my knowledge and experience of Tibetan appliqué in a way that stirs your curiosity not only about this art form and the culture it came from but also for your own possibilities. I hope my story will fuel your sense of wonder and embolden you to follow your own threads to a uniquely beautiful and meaningful life.

A note on terminology

Throughout this book, you'll read about the art of Tibetan appliqué and my experience making silk thangkas. Thangkas are wall hangings that depict sacred figures of Tibetan Buddhism, and I will address the Tibetan word *thangka*, for which there's no English translation, in Part Three of the book. Before we get started, though, I want to talk about the English words I'll use to define the particular form of thangka that I describe on these pages: the form made from pieces of silk.

"Appliqué" is the term most often chosen by English-speaking art scholars and museum curators to describe the textile technique Tibetans use to create sacred images from pieces of silk. But the term doesn't really fit the art. In their own language, Tibetans employ a variety of non-specific words that basically just mean "sacred images made from really good fabric that's cut up and sewn together." Here are a few terms I've heard:

- *göchen thangka* = thangka made of great or special cloth
- *göku* = cloth image
- *lhandrubma* or *lhandrubpa* = sewn together
- *tsemdrub* = sewing (or embroidery)

After hearing the term "appliqué" from visitors and reading it in books about their culture, Tibetans adopted this label for describing their indigenous technique to the outside world. Still, it doesn't fit.

Appliqué is a type of ornamental needlework in which pieces of fabric are sewn or stuck onto a larger piece of fabric to form a picture or pattern. The word "appliqué" is derived from the Latin *applicare* or the French *appliquer*, which means "to apply." But that is not how these thangkas are made.

In Tibetan "appliqué," there's no single ground, no base material to which pieces are applied. Instead, the fabric image is a composite whole, constructed of pieces. Each segment of the design, each splash of color, is a distinct piece of silk outlined with a special piping, which I'll describe in Part Four and Five. These outlined pieces are assembled like a jigsaw puzzle, or like stained glass. The pieces overlap slightly to form a bond where they meet their neighbors. Then, they're stitched together to create a unified picture. They depend on one another, not on any unifying foundation.

This serves as an apt metaphor for existence—for the interdependent nature of our lives and the world. From a Buddhist point of view, nothing exists inherently and singularly. Every phenomenon is, in fact, a composite of parts. And no being exists separately from all the other beings who love, hate, notice, antagonize, and support them.

I have searched for years for the perfect word to describe the distinct textile art form I inherited from the Tibetans. I'm still looking. In my personal view, "patchwork" is the best single word in the textile field. It's the one word that accurately conveys the piecemeal structure of the textile artworks the Tibetans taught me to make.

Patchwork is both the act and the product of stitching small pieces of fabric together to create a larger, composite design. Throughout history, and around the world, patchwork has found its way into every realm of society.

Whereas appliqué is used to decorate the surface of a garment or object in the same way that attributes might decorate an independently existent self—if such a self existed—patchwork actually constructs the garment or object: the joined pieces become the "fabric" of the item. This integral, inseparable nature is crucial in understanding how Tibetan fabric images are built—and how we and our world are built.

Unfortunately, to many readers, the word "patchwork" may imply an ordinariness or a haphazardness that in no way characterizes the delicate meticulousness of this sacred artwork. I don't think anyone who has ever worked in patchwork would make this error of understanding. In my experience, patchwork is frequently executed with extraordinary precision and ingenious engineering. It takes meticulous planning and execution to cut and stitch together hundreds of pieces at precise angles and achieve a flat, perfectly squared surface. Even the smallest imprecision can result in misshaping puckers.

Patchwork in the West often involves the assembly of many similar pieces, creating a repetitive pattern of geometric shapes. Tibetan fabric images, on the contrary, are formed from a multitude of irregular shapes. And they are figurative, not abstract.

For the first solo exhibition of my work in 2002 (at the Pacific Asia Museum in Pasadena, California), I invented the term "pieced-silk images." Perhaps, that phrase still fits better than anything else. Pieced-silk images. Pieced-fabric pictures. Pieced thangkas. Pieced buddhas. Pieced.

And aren't we all pieced together every day, every moment? Everything we perceive is composed of pieces. We imagine a through-line, a thread, a base, a self, an "I." But is it really there? If you actually look, you won't find anything solid, and certainly nothing autonomous. Instead, you'll discover a thread of stories, of experiences, thoughts, memories, sensations, relationships . . .

parts and pieces. That's what this book is made of too: pieces that made me into a pieced silk thangka maker and pieces of the thangkas themselves.

Despite the inaccuracy of the term appliqué, I do use it in this book. I do so because language is imperfect, and because that's the conventionally accepted term, and because I don't yet have a perfect alternative. When you read the word, I hope you'll look below the surface and perceive all the complexity I've described within it.

Part One: FIBERS

Traveler, there is no path. The path is made by walking.
—ANTONIO MACHADO, *Proverbios y Cantares XXIX*

❊ *Piece 1* ❊

His Holiness Will See You Now

〰〰〰〰〰〰〰〰〰〰〰〰〰〰〰〰〰〰〰〰〰〰〰〰〰〰〰〰〰〰〰

Voices wafted through the glass doors, muffled by heavy cream-colored curtains decorated with rust-hued flowers and gray-green leaves. We'd been told he was meeting a group of new arrivals on the veranda and would then come inside to talk with us. The Dalai Lama would be with us shortly. I urged my breath to calm and my hands to cease their nervous fidgeting.

From our seats in the reception room, we could hear urgent murmuring laced with soft whimpers and punctuated by an aching wail.

"Ya, ya." The deep voice that responded was unmistakable and full of empathy. His Holiness welcomed the group of refugees into the warm embrace of his presence. The force of his listening filled the space like a balm as he comforted and reassured compatriots of all ages who had made the long and perilous trek out of Tibet to Dharamsala, India, to see him at least once in this lifetime. They'd traveled over frozen mountains, spent all their money, risked capture by Chinese guards and shakedowns by

Nepali officials for this opportunity to glimpse their exiled leader. They yearned to receive his blessing and, maybe, to give their children the possibility of a Tibetan education. Some would settle here. Others would leave their children here to study their native language and culture among the Tibetan exile community while they themselves made the long journey back to a home where such study is forbidden.

Inside, I sat erect on the firm edge of a beige tweed sofa, fiddling with the rolled white scarf I'd brought to offer my respect to His Holiness in the customary Tibetan way. Excitement coursed through my body, making it hard to keep my hands still. Every now and then I stretched out my fingers, willing my sweaty palms to dry.

An arm's length to my left on the same couch sat my father, quietly thrilled to have been invited to share such an unexpected opportunity with his itinerant daughter. I don't think I'd ever seen my dad nervous before. It made him look younger than his sixty-two years, and softer. He'd been growing more tender anyway as time passed. The high-strung young father who had expected perfection and made me feel like mistakes were dangerous had been replaced some years back by an easygoing guy I liked a lot better. To have Dad here as my companion and witness in this moment, awaiting the blessing of the kindest man on earth, well, that in itself felt like a blessing.

The room was large enough to hold fifty people or more and contained as many chairs—some capacious enough to draw one's legs up and sit cross-legged within them, others straight and narrow. But the furnishings had been arranged with such attention that our seating area at one end of the room felt almost cozy, just right for intimate conversation. Mountain sunlight filtered through leaf-shaded windows softly illuminating the space.

In one window near our end of the room, curtains had been parted to reveal the Buddha, my Buddha, the silk *thangka* I'd spent the last two years stitching. It hung from the window latches, precisely framed by the curtains as if it had been made for just this spot, this moment. I delighted at the way the backlighting brought it to life. Was it just the light from the window making

it glow in that way? Or was it the fact that His Holiness the Dalai Lama was about to lay eyes on my creation, to offer his assessment, his advice, and (dare I hope?) his approval?

A door swung open without warning. Dad and I scrambled to our feet, white scarves in hand, as a guard ushered the maroon-robed monk into the room. He paused before the thangka, offering a respectful greeting to the patchwork Buddha, then turned, fully present, to convene with us humans.

❊ *Piece 2* ❊

Fabric

❈━━━━━━━━━━━━━━━━━━━━━━━━━━━━━━━━━━━━━━━❈

Thought of as material, fabric is cloth, textile, tissue. As a metaphor, it suggests structure, infrastructure, framework, foundations. Fabric even has psychological, social, and cultural implications as in *the fabric of society*.

Fabric as a material is the literal foundation for my work. I'm a textile artist. I make sacred pictures from pieces of silk fabric. The silk is beautiful to begin with. Then, cut into pieces and reassembled, it becomes beauty in a new form, like impermanence, like rebirth, like life.

Supple fabric is constructed of lines. The warp and the weft. Straight lines of intersecting threads, each strand incapable of covering or holding anything. These insubstantial fibers meet each other at right angles, greet and pass, greet and pass, greet and pass, slipping over and under one another at regular intervals, becoming enmeshed. This is fabric. Rows and rows, columns and columns, intersecting again and again. Each individual thread meets each specific other only once and chooses to pass over or under. "You first." "No, you." Each choice is made in concert with the whole, in perfect relationship to all the others. Together, these single encounters transform the insubstantial

fibers from one-dimensional lines into a fluid two-dimensional plane: a strong and pliant tissue that can hold, carry, wrap, warm, protect, adorn, and inspire. Fabric is an embodiment of the strength and flexibility of interconnection.

My life as an American maker of Tibetan textile art is the moving weft that intersects with the long warp of tradition from another culture. By my steps and with my stitches, I weave into a lineage that is not my own but that welcomes me, supports me, and changes me. Like a golden yarn shuttled through a silk warp to create brocade, diverse fibers of life and culture interact to create a fabric of strength and beauty, resilience and shimmer.

❈ *Piece 3* ❈

First Contact

━━

I first saw His Holiness the Dalai Lama in 1979 when I was in college, and he was visiting the United States for the first time. I don't think I knew who he was. I don't know if anyone around me did either.

Half a world away, in India and Nepal, Western hippies and students traveling overland by bus from Europe had encountered the Tibetans a decade earlier. The Hippie Trail was a twentieth-century Silk Road through Turkey, Iran, Afghanistan, and Pakistan (or alternatively through Syria, Jordan, and Iraq). Rather than commerce, these modern explorers were trading in experience, discovering entirely new ways of being. Upon reaching India, some had taken vows to become Buddhist monks. Many were attending teachings, doing retreats, and studying language with Tibetan lamas and Indian gurus. A *lama* is a Tibetan Buddhist monk or spiritual master.

But I didn't know any of that yet. My classmates and I at the University of California, Santa Cruz, had been in utero when the Chinese overtook Lhasa and the Dalai Lama was forced to flee Tibet, followed by a hundred thousand of his compatriots. By

8

1979, His Holiness and the Tibetan refugees had been resettled in India and Nepal for twenty years. A generation of Tibetan children had been born in exile. While we UCSC students were children, Tibetans who remained in Tibet had suffered religious repression, nomad collectivization, and starvation, and had endured the Cultural Revolution along with their Chinese occupiers. Thousands of monasteries had been destroyed and tens of thousands of monks and nuns killed. People had been forced to denounce the Dalai Lama, renounce their vows, and even to beat and humiliate one another.

We students, in contrast, had grown up in prosperous cities and suburbs in a period of free expression, empowerment, abundance, and experimentation. UCSC was at the cutting edge of that experimentation, exploring new modes of education, evaluation, and fields of study. Egalitarian relationships were promoted, and students called professors by their first names. Idyllic redwood forests, rolling hills, and pastures were our classrooms, looking out over a spectacular bay and some of the best surfing in California. "Question Authority" buttons and bumper stickers urged us not to accept as givens the stories by which we'd been conditioned.

Eastern spirituality had entered our awareness from an early age and was an ingredient in the human-potential milieu in which we immersed ourselves. The Esalen Institute just down the road offered mind-expanding ideas and beautiful hot tubs, open to the public after midnight, clothing discouraged. Most of our soaks were in simpler surroundings, in the redwood-clad hills of the Santa Cruz Mountains.

We were insatiably curious, and at least some of us were oriented toward growth in every aspect of our lives. So, when a friend showed me a flyer announcing that a Tibetan holy man was coming to speak on the East Field, I rushed to see him with the same mix of enthusiasm and trepidation I would have taken to an antinuclear protest, an open-air dance concert, or a walk in the woods on magic mushrooms.

On this first visit to the United States, the Dalai Lama was not greeted by statesmen but was welcomed at college campuses

and spiritual centers around the country, avoiding media and politics. I have no idea how our small, nonconformist university got on his itinerary.

His Holiness's talk focused on the need for compassion in society. He highlighted the common goals of the world's religions, explained the workings of karma, introduced the Four Noble Truths, and delved into the luminous nature of mind. He started in soft-spoken English, then switched to Tibetan—deftly translated by an interpreter—when the subject matter got more complex.

It was a sunny day, and everything seemed to sparkle around me, ordinary and extraordinary at the same time. Something in my core felt strengthened as if it were being seen anew, understood, and welcomed home. There on that open field, listening to His Holiness, I knew I was in the right place. What I didn't know then was where that "place" actually was or that a seed planted there would grow to become my life's path.

❈ *Piece 4* ❈

A Finger Pointing
to the Himalayas

SAN BERNARDINO MOUNTAINS,
CALIFORNIA—1987

"How long have you been a saint?"

I craned my neck trying to look back at Joe as he lobbed the unexpected question. I was barely holding on, halfway up a tall pine. Harnessed and roped, my task was to climb up up up to a tiny platform near the top of that majestic tree. From there, if I could harness the courage, I'd jump for a ring that was suspended just a bit higher and waaaay out in the center of that circle of pines. I would fall. Fall fall fall. But I would be safe, caught by the rope, held by Joe. Wooden slats nailed to the trunk acted as a ladder. Joe held the belay. I climbed.

"How long have you been a saint?"

Lacking the agility to talk and climb at the same time, I stared straight into the tree trunk instead.

Huh?

After a confused pause, I resumed my climb. I must have misheard.

"How long have you been a saint?"

There it was again. That strange question. Joe was behind me. I was scared of the upcoming jump, of letting go, of looking stupid, of the myriad questions I didn't have answers for.

I need to get to the top of this tree and jump off so I can survive this fear and get on with my life, thank you very much. I'm trying to have a breakthrough here. Please don't distract me with wacky questions! Obviously, I'm not saying these words out loud. The din in my head is far too loud to talk over.

"How long have you been a saint?"

Me?! I'm just a scared little girl trying to be good enough, trying to make some difference. Really, I'm trying. . . .

Joe was a ropes course trainer who could see through to the soul of a person. My heart felt naked before him. He was the most insightful being I'd met up to that point in my life. And I took every chance I got to attend his wilderness courses, experiences in which the inner wilderness met the outer wilderness and magic ensued.

"How long have you been a saint?"

What is a saint anyway? I don't believe in that Christian stuff. I've never been religious.

Raised in a mixed family, with a Jewish father and a Christian mother, the first thought I ever had about religion was, "I'm not Christian." I couldn't abide by a worldview that required belief in what seemed to me an arbitrary magical story. So, I identified as Jewish, because that was the only other option I saw, and the more rational one.

Throughout childhood and into young adulthood, most of my friends were Jewish—or mostly Jewish. But, spiritually, I found a resonance with Eastern thought from the moment I encountered it. Mom began meditating in the 1970s. I read Ram Dass's *Be Here Now* at age twelve, and my heart-mind flew wide open. I was initiated into Transcendental Meditation at fourteen and began a lifelong resistant relationship with meditation. I'd done human-potential trainings that encouraged a responsible and reciprocal relationship with reality—the est Training at fifteen and Lifespring at twenty-five. It was through Lifespring that I'd been introduced to Joe's ropes course.

"How long have you been a saint?"

Always? Never? Can you give me a hint?

I had no idea why Joe was harping on this saint question, not an inkling of myself as saintly in any way. I did try to be good. Tried to be a good friend, a good girl, a good student, a good citizen. My curious nature may have led to some quirky choices, but even when I stepped off the beaten path, I always stepped carefully, trying to do this life thing right. What could he possibly be getting at?

A few months later, I found myself once again standing in a circle of earnest personal-growth junkies as Joe introduced another ropes course.

He had just returned from a trip to the South Pacific. As soft California mountain soil and pine needles crunched beneath our feet, Joe spoke of his experience of coming home from a tropical archipelago. A month-long immersion into a very different world had rendered his home culture freshly visible, and fascinating, almost as if he were discovering it for the first time. Through his words, I sensed his visceral experience of home and caught a whiff of what it might feel like to journey far outside my own cultural boundaries.

I was always captivated when Joe spoke. Even when the things he said didn't make much sense in the moment, they always opened up possibilities in my mind. Under the towering pines, this talk about islands and home flipped a switch in my soul/heart/gut. I instantly made a decision that had been waiting to be made: *I'm going trekking in Nepal.*

Huh? Where on earth did that come from?

My travels were to take place the next summer. I would finish grad school in June and start my real estate consulting job in September. A herniated lumbar disc just after college had derailed my plans to study architecture—sending me to get an MBA, instead, with a degree in urban planning on the side. I was one of only two students enrolled concurrently in UCLA's urban planning and business schools. My intention up to that point had been to apply

management skills in the nonprofit world, developing affordable housing and innovative communities. Already I'd become a voyager of sorts between the radically different cultures of the two graduate schools—the progressive urban planning community and the more conservative business students. Situated opposite each other across a wide walking path, the two buildings offered worldviews as distant as America and Asia.

The fact was, I'd been born and raised bridging cultures. My Jewish father came from New York City. My mother was raised in rural small towns. My father's secular rationalism was a world apart from my mother's artistic mysticism. They had met in Washington, DC, married and had me, then set out for the West like twentieth-century pioneers, a green Dodge for a covered wagon. As a colicky one-month-old infant, I went on my first transcontinental road trip.

In the 1980s, it was common for new graduates from UCLA's business school to go on some kind of travel adventure between getting an MBA and starting a job. Most went to Europe and came back to start their intended careers relatively unchanged. My path would be different, as it so often was. I don't do ordinary very well, though ordinary life in southern California was nothing to complain about. I shared a rent-controlled apartment near the beach with nice roommates. My career prospects were promising. I planned to work in real estate consulting for a while just to see if I hated the corporate world as much as I expected to. Then I'd get a job in public service or in a nonprofit where I could be somewhat useful to the world, I thought.

I wanted my post-grad-school travel to be context shifting. As a little girl, I'd fancied myself a Saturnian, an explorer from that most beautiful and idiosyncratic planet, the only one adorned with rings. It was time for me to explore another planet. I hoped for an experience that would move my inner world at least as far as the airplane carried my body. Whatever that meant! I'd been waiting for a stroke of inspiration to show me where to go. Well, here it was. As Joe recounted his journey to and from a tropical island, my decision emerged whole and clear: *I'm going trekking in Nepal.*

Don't ask how talk of the tropics turned me to the Himalayas! That's still as much a mystery as Joe's interrogations into my sainthood, which I now suspect might have been intended to point me toward my buddha-nature, always perfect even when I'm not. In hindsight, I can see that the groundwork had already been laid for me to connect with Asia. Joe's tropical story wasn't about the tropics at all, not for me.

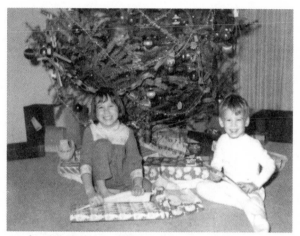

My brother Danny and I open Christmas gifts, circa 1965.

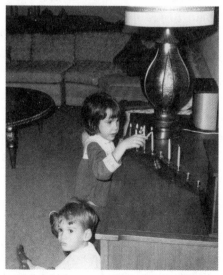

Lighting the menorah on the sixth night of Hanukkah, circa 1965.

❖ *Piece 5* ❖

Stepping Out

LOS ANGELES, CALIFORNIA—1988

B ack at my kitchen table after talk of the South Pacific directed me unexpectedly toward the Himalayas, I began to research trips to Nepal. It didn't take long to figure out that I'd have to adjust my new plan to reality—specifically climate reality. The summer months are rainy on the Indian subcontinent. I love rain and would later come to love the monsoon, but rainy season is a miserable time to trek in Nepal. Clouds obscure the mountains, trails are muddy, and leeches are abundant. Not the experience I was looking for.

Nearby Ladakh, in contrast, lies in the rain shadow. Protected from monsoon by high mountains, Ladakh is a Tibetan Buddhist region that ended up in the Indian state of Jammu and Kashmir by geopolitical happenstance and was thereby protected from the Chinese occupation that had afflicted Tibet. Because the high passes that separate the area from the rest of India are closed by snow for most of the year, trekking season in Ladakh is limited to the summer, from July through September. This was perfect timing for my post-grad-school adventure. I signed up for a

two-part trek through Kashmir and Ladakh, with a treacherous bus ride over the mountain passes in between.

Kashmir is a majority-Muslim state that was divided between India and Pakistan when both countries gained independence from Britain in 1947. It's also the most beautiful place on earth. Its deep green meadows, pristine and glistening snow-capped mountains, lakes, and rivers are each more breathtaking than the last. The extraordinary serenity of the landscape makes it hard to imagine the sectarian violence that has occurred and persisted there. The year of my trip was a good year—the last year of peace before fighting disrupted tourist traffic and the lives of Kashmir's residents for a decade. (As I write this book, the people of Kashmir are once again in pain.)

In July 1988, on my twenty-eighth birthday, I flew from Los Angeles to New Delhi, via Bangkok, planning to be away for three weeks. It was the biggest adventure I could imagine taking. I'd traveled cross-country before and had gone to Europe with my family as a teenager. But I'd never been to the other side of the globe, never walked for days on end, never traveled to a foreign land all alone, never been away from everything I knew for three whole weeks.

Remember the story of *Gilligan's Island*? Remember how it started with a three-hour tour? Powerful number, three. You just never know where it will lead. Three's an important number on the Buddhist itinerary too. Not that I was aware of being a Buddhist at that time, but a path is made by walking and becomes visible when we look back at our footprints. In hindsight, I can see that a track was already forming.

Through the three doors of body, speech, and mind, travelers on the Buddhist path seek safe haven in three refuges, also known as The Three Jewels.

There's Buddha—not a god but an example. "Buddha" can refer to the man who became enlightened in India five hundred years before Christ or to your own buddha-nature. Buddha is not

only the teacher but is also the seed of awakening in all students.

There's Dharma, which can refer to the teachings of that same historical Buddha or to the reality we seek to understand and open ourselves to: life as it is, with its impermanence, causes, and consequences. Dharma is the path as well as its signposts.

And there's Sangha, our community of support and inspiration—the ones who have already made it and those who travel beside us.

What dangers do we seek haven from in these three precious refuges? From all our distresses—our dashed hopes, our disappointments and losses, our fear of death, our failures, and the successes that don't turn out to be all they're cracked up to be. We seek shelter from the untrustworthiness of the world or, more precisely, from the trustworthy inadequacy of that world—as we see it—to meet our needs and make us whole.

For me, though, three was merely the number of weeks I thought I'd be away before resuming the journey I believed I was on—the journey of being a slightly-norm-challenging-but-basically-normal contributing member of society in America. If I sought refuge from anything, it was from my pervasive insecurity, the incessant chatter in my head, and my constantly fidgeting fingers. By no choice of my own, I chewed on my cuticles and tugged at my eyebrows as I prepared to depart on my great adventure.

❈ *Piece 6* ❈

Making Moves

KASHMIR AND LADAKH—SUMMER 1988

Our trekking guide, Jim, was in Srinagar, the capital of Kashmir, preparing for the group's arrival. We must have submitted some kind of participant questionnaire because he already knew I had an MBA (or, as he phrased it, that I *was* an MBA). He told me later he'd imagined some conservative woman in a business suit was about to land in his trekking group, and he wasn't looking forward to the prospect. Iconoclastic, hippie, intellectual, mountain-man, expat freak that he was, how would he relate? Little did he know, his MBA stereotype was completely misplaced. I'd ended up in business school almost by accident and had little in common with my classmates. In fact, Jim and I had much more in common and would end up falling passionately in love before the trek was done. And though that love wouldn't last, it would open several gates along my metaphorical trail.

Jim, from Massachusetts, was a weird and wonderful man with the most endearing-if-you-loved-him-annoying-if-you-didn't bray of a laugh. Set aside your mental image of a mountain man. Yes, he was one, but not the one you're picturing. With wiry black hair and a receding hairline at thirty-three, he looked a bit like a

grasshopper and a lot like Malcolm Gladwell. He was similarly brilliant, too. Scrawny but strong, sexy as all get-out, afraid of nothing, he had a low-key, even temperament that let him take anything in stride, even while his total adaptability to the moment threw anyone who actually expected plans to be followed into a tizzy. He would flow with that sort of upset too and appreciate something beautiful about it, diffusing it in the process. Completely disorganized in his own life, he was absolutely impeccable in orchestrating complex journeys and travel experiences for others.

A decade and a half earlier, Jim had dropped out of college to become an outdoor educator and wilderness guide. He lived for adventure. (Sadly, yet somehow perfectly, he later died for adventure while kayaking his beloved Sun Kosi River in Nepal. I imagine him laughing until the last moment. He never lost his childlike enthusiasm for the unconventional, adventurous life.) By the time we met in 1988, Jim had lived in Nepal for seven years. That struck me as extraordinary; I could never have imagined that I myself would end up living even longer in India.

Jim led a small group of American trekkers through the wooded, green mountains of Kashmir, our boots heavy with mud. Then, we traveled for two days by bus along a serpentine dirt road over Himalayan passes to the moonscape-like region of Ladakh. There, I was entranced by ancient monasteries and the warm smiles of the Ladakhi people. I had the uncanny feeling I'd been there before, as if I were greeting old friends rather than visiting a strange new land.

At the end of our trek, as other group members took off for the airport, I changed my reservation and stayed on for another week before Jim's next group was scheduled to arrive. We lived on a houseboat and slept on deck under the stars. He taught me to kayak on Lake Manasbal, where we made out in a *shikara* (a Kashmirian boat resembling a gondola). If the boatman saw us, he gave no sign, perhaps inwardly bolstering his preconceptions of loose-moraled Westerners.

I met Jim's friends, mostly Peace Corps grads who'd chosen to stay on after their tour was up, leading treks, working for aid

organizations, playing guitar, and smoking weed on the dock by Dal Lake. I didn't partake much in the smoking, never liked the feeling of being stoned, but the fragrance and the music, the greenery, the water, the laughter, and the wide-ranging conversation—about culture and politics and hope—all brought back memories of my Santa Cruz days of hot tubs and redwoods, experimentation and curiosity.

Sitting among Jim's friends felt like home and freedom. It felt like realness—not that things weren't real at home. Reality is everywhere, even in suburban Los Angeles where I'd grown up. It was all around me, of course, but that was the thing: at home it was around me, while here it felt like it was *in* me—or that I was in it. There was a predictability and a sterility to the life I knew. A distance. A separation. Things moved fast. People were busy. And with my enthusiastic energy and fear of being left out, I could be busy with the best of them. But I was happiest when I could sink into a moment: watching clouds form shapes in the sky, watching infinite shades of green emerge from the trees when those clouds shaded the sun, dancing in my living room, or sitting here among people who had chosen a different style of life.

I was intrigued by the choices these people had made, by their willingness to break from the conventional—from what was expected of them and expected *by* them. I felt shy among them, but I also felt at home and welcome in a world that somehow fit my skin.

Two years and a couple of treks later, I moved to Boston. Jim had recently returned to live in the US, and I was eager to see how our relationship might grow if we were separated by miles instead of continents. I had also always been curious about life on the other coast as, throughout my childhood, we'd made regular family trips to visit my grandparents in Brooklyn and my cousins in Connecticut.

I made the move without a job but with confidence I'd find one. Friends thought that was risky, that I was quite the adventurer. I thought I was just realistic. Those were economic boom times. I

held graduate degrees from a university where employers lined up to recruit graduates before they'd finished school. I didn't need the highest paying job or the most prestigious career; I just wanted to do something interesting and helpful. There were living expenses to cover, and I expected to get paid enough to cover them, but I could live simply and wasn't striving for material accumulation. I've always been more interested in experiences than things, and I wanted to experience living somewhere new.

Jim and I broke up the day after I arrived, when he told me he'd slept with someone else. He wanted an open relationship. I didn't. This unwelcome display of the world's impermanence brought its requisite pain, but my curiosity to explore life in a new place was stronger than heartbreak. I stayed and sought to make a home.

Within two weeks, I had two job offers. I accepted one from the City of Boston and became a project manager in a program that built new, affordable homes on vacant land in blighted neighborhoods and then helped low-income families buy them. Living modestly, inspired by the families I was serving in Boston and by the travelers and ex-Peace Corps volunteers I'd met in India, I began to save money for a longer trip abroad.

Since my first trek in Kashmir and Ladakh, I'd been to Nepal too. I'd visited Tibetan communities there and had read several books on Tibetan culture and history. That feeling I'd experienced—of already being connected—only grew with each encounter. Wandering through bookshops, nostalgia would well up unexpectedly when I saw photo of a Ladakhi or Tibetan face. Curious to explore this kin-like affinity, I used the move to Boston to establish relationships with the small community of Tibetan immigrants and graduate students living in Massachusetts. I became involved with the US Tibet Committee and started taking Tibetan language lessons. Many Westerners study classical Tibetan in order to translate dharma or to connect more deeply with the Buddhist liturgy they recite in Tibetan. My motivation was more mundane: I was drawn in by the Tibetans' sense of humor. They seemed to enjoy being together, and they laughed so easily. I loved the melodic cadence of their language, and I wanted to get the jokes!

Memories of India visited me frequently, enticing me to hit the road, to explore the world, to delve headlong into the wandering life. I wanted to see more, see differently, understand deeply, and experience the world on my skin. I wanted to understand how I was put together and maybe to learn how the world was put together too.

These thoughts and memories gradually took the form of a plan to travel for a year. I would put my things in storage, buy a one-way ticket to Asia, and take off with a backpack, a couple of *Lonely Planet* guidebooks, an empty journal, and ten thousand dollars I'd saved from working and living frugally and car-less for two years.

I investigated volunteer options that might complement my travels and allow me to immerse myself in a culture. I visited the Peace Corps office in Boston and wrote to various organizations. There was no Internet then; research was slower and more focused.

The Peace Corps wanted to send me to Eastern Europe (and required a three-year commitment, which I might have been willing to make had the destination been Asia). The Cold War had just ended, and everyone was focused on making new connections and new business relationships across the now-defunct Iron Curtain.

Then, at a meeting of the US Tibet Committee, I picked up a flyer. It listed volunteer positions available in the Central Tibetan Administration in India. Some of the options looked doable. I certainly didn't qualify for any of the healthcare positions, but most of the others I could do. I had degrees in urban planning and business, and I could certainly teach English.

But the list was two years out of date. I needed an update. That evening, I wrote a letter to the director of the Tibetan Planning Council, whose address appeared at the bottom of the page. The next day, I took my letter to the post office, adhered the multiple stamps required to reach India, and put the envelope in the slot.

A month later, a formal letter came back on Planning Council letterhead. The list of volunteer opportunities had never been updated. It had been created just once by a well-intentioned helper who'd since moved on. As is so common in organizations that

depend on volunteers, efforts made in one helper's tenure had not been maintained. The letter went on to invite me to submit my CV for consideration. Once they knew my qualifications, they would consider in what way I might be able to contribute. So, I sent my resume and waited again. The response came quickly. In less than three weeks, I held in my hands an invitation to assist the planning council itself in establishing a revolving loan fund for economic development projects in the refugee community. Wow, was I really going to do this? I chewed my already ragged fingernails as the words brought tears of nervous joy to my eyes.

❈ *Piece 7* ❈

My Good Friend, Fear

A long with joy—and nudging her out of the way at times—fear has been my most reliable companion in this life. My mother introduced me to fear before I could even talk. Not her fault; she'd grown up in scary circumstances. But I hadn't. I just adopted Mom's fear as my own. I guess I should thank fear for hanging out with me, making sure I never lacked for company. Instead, I've been pretty rude to my old companion over the years, actually making it my life's mission to get rid of it.

Buddhist teachings urge us to identify our strongest affliction and to work on that one thing first and foremost. If we're quick to anger, cultivate compassion and remember that every being has been both our mother and our child at some point in infinite, beginningless history. If we're envious, learn to rejoice in others' good fortune. But the teachings rarely mention fear. It doesn't appear on the usual list of disturbing emotions: the five poisons of ignorance, attachment, aversion, pride, and jealousy. I kept looking for teachings on fear and asking my dharma friends, occasionally even asking teachers about it. It took me a while to figure out that my fear is rooted in the most fundamental ignorance, the mistaken idea that there's a self to protect. This most basic ignorance misapprehends *me* as real, separate, enduring,

and thus vulnerable to harm or annihilation. The invention of danger and its associated fear arise from that ignorance.

In fact, self and other are intertwined. There is no separate, enduring *me*, and there is no ground fabric on which everything rests. The fabric of reality itself is woven from everything.

I don't think most people would see me as fearful. I do a good job of masking it for the general public. But those who have traveled with me, worked with me, or been married to me know the truth. They see the extent to which my every move is cautious, considered, and how I play out every contingency in my head before acting.

People tell me I'm courageous because I've traveled the world alone, lived in foreign countries, and diverged from the conventional path. But those things—the things others think are scary—are not the things that scare me.

My fear shows up in the length of time I procrastinate a phone call, because talking into that little device has always terrified me. Airplane landings frighten me out of my wits. (Okay, maybe I *am* courageous there because I *do* continue to travel even though I swear with each survived landing that I'll never fly again.)

Every creak of the house as I lay in bed at night used to stop my heart.

In school, I was willing to take a lower grade rather than raise my hand to speak and risk being wrong and, by extension, sounding stupid.

Even something as simple as going to a nursery to shop for plants can be scary. If I don't know anything about gardening, how will I ask the right questions?

But plop me down in an unfamiliar Asian city (in daylight, please), and let me wander the streets, and I'm in my element! I meander wide-eyed, drinking in the differences, the distinctions, the color. Set me on a bus in Bangkok with a map, and I thrill to the challenge of following an unfolding route, alert to every turn—senses awake, open, alive. And, hanging out with people who don't speak my language, far from being frightening, is soothing relief. Gone is any pressure to be clever or eloquent! Simplicity and connection reign, and I feel free.

I have a dear friend whose teenage son soars gracefully on a trapeze twenty feet above the ground before a rapt audience. Yet it took him years to work up the courage to get his driver's license. Fears are so very personal.

From the moment I touched down in Bangkok, and then in Delhi, I felt released from my habitual fear. I was still responsibly cautious, but traveling seemed to lift me out of the armor of anxiety I'd been wearing all my life. That armor belonged to a context I'd left behind. Perhaps here, where no one knew me and where I knew English better than anyone, where I wasn't expected to know the local language or customs or to be witty or right, the anxiety lost its function to keep me safe from embarrassment. I could finally let go.

Part Two: THREADS

*Nature uses only the longest threads to weave her patterns,
so that each small piece of her fabric reveals the organization
of the entire tapestry.*
 —RICHARD P. FEYNMAN, "The Law of Gravitation, an
 Example of Physical Law"

❈ *Piece 8* ❈

Sick in Delhi

New Delhi, India—1992

━━━

"No, no, wait! Show me the package! I need to see that it's new." My head was swirling. Or was it the room? My fever blurred the difference but didn't quell my fear or relax my guard. I extended my hand in a gesture that fell somewhere between warding off (invaders?) and reaching out (for control? answers?).

Arjun came toward me with a syringe to take my blood. But Nisha was the doctor. Why was her friend going to take my blood?

"Show me that the needle is new!" I insisted, protesting the imminent violation of my skin.

I'd lost friends to the AIDS epidemic in the late 1980s. I knew that getting a used needle stuck into my vein would put me at risk. And I was in India, for God's sake—a land not known for perfect sanitation—in a private home with people I'd met just two days earlier.

Nisha was a medical doctor employed by the government hospital. Her friend Arjun was, well, just her friend, a well-traveled businessman who'd worked in film, cosmetics, and health products in a variety of capacities I hadn't quite figured out. He'd taken me out for beer in a luxury hotel. He'd told me he dreamed

of starting a health spa in the Indian countryside. That was all I knew.

I'd connected with Nisha through Servas, an international network of hosts and travelers, and she had invited me to stay in her home. Although she'd been a member of the network for years, she rarely accepted visitors. But she said there was something about my letter, something about me, that made her respond differently this time. She told me she'd known as soon as the letter arrived that we were family, that I was her sister.

Before arriving at Nisha's apartment in the city, I had stayed for three days in the home of a retired Sanskrit teacher, also contacted through Servas. The teacher's mud-wall home was situated in a small village that felt rural, even though it was just a few minutes' drive from New Delhi's Indira Gandhi International Airport. The teacher was strict, formal, and knowledgeable. The village children were delightful. Taking photos of them with their cow, and letting them take photos of me was pure, innocent joy. The teacher kept scolding them and telling them to leave me alone, but they were much more fun than he was.

A wiry old man wearing a white kurta pajama, Shastri-ji the Sanskrit teacher proudly gave me a tour of the capital while schooling me in Indian history. We traveled by public bus, crammed in among locals. Late-monsoon August was hot and humid. Sweat dripped down my legs, concealed beneath my baggy drawstring pants. Shastri-ji took me to the thirteenth-century minaret of Qutab Minar, through Hindu temples, and to the homes of professors and friends who lived in neighborhoods at the outskirts of the capital city.

Everyone we met offered Bengali sweets along with glasses of water, which anyone in their right mind would have been thirsty for in that heat. All these kind hosts could see the sweat pouring down my face. Certainly, they couldn't have been convinced by my repeated assertions that I wasn't thirsty. But I was concerned for my health. A foreigner just arrived in India drinking tap water? That's a recipe for dysentery. I didn't want to offend, yet I knew I had to refuse.

"But it has lemon!" they insisted, holding up a freshly cut wedge they'd squeezed into the water, as if that would sterilize it and render it safe. To me, the fresh lemon was just one more source of threatening microorganisms. It was not by any measure a water purifier. To be safe, the water needed to be boiled. Maybe filtered, too. With iodine added for good measure.

"May I have tea, please, instead?" I hated to ask. I so wanted to be a proper guest. And I so didn't want to get sick.

Back in the village at night, I slept on a *charpoy*, a traditional wooden bed with interlaced webbing in place of a mattress, on Shastri-ji's porch. The night air was relatively cool, welcoming me to sleep. But the mosquitoes did not sleep. Those nocturnal creatures stayed awake to feast on my fresh, pink skin. The DEET I thought I'd covered myself with must have sweated away. Or perhaps, having little private space or time in which to care for myself, I hadn't been able to cover every inch of my body with the protective poison. The mosquitoes bit right through my light-weight clothes.

When Shastri-ji delivered me to Nisha's apartment in a well-maintained government compound in the center of the city, I was covered with mosquito bites, scratched raw. Forty-eight hours later, I had diarrhea and a fever. I'd been taking medicine to prevent malaria, but Nisha wanted to make sure I hadn't contracted the disease anyway.

Nisha's upscale government-issued apartment was much more comfortable than Shastri-ji's village, but it was also unfamiliar. I was out of my element and, thanks to the fever, slightly out of my mind. Now some man was coming at me with a needle and a syringe to take my blood.

"Show me!" I demanded. "Open the package so I can see the needle's new."

I hated to offend him, but I couldn't take a risk. He handed me the sealed package with a sterile needle inside. I turned the package in my hand, examining it through my fevered haze, then handed it back. With thanks, I offered my arm. Together, Arjun and Nisha drew my blood into a vial. I heard their voices fade

away as they left me to sleep, indoors now, on a thin mattress atop a wooden platform bed, a simple sheet covering my body, a fan turning slowly overhead.

They would take my blood sample to Nisha's hospital to test for malaria. Every now and then, I opened my eyes to stare at a crack in the concrete wall or to admire the green vine creeping along the balcony outside the open door.

Good news came back the next day. I did not have malaria. Just a run-of-the-mill case of "Welcome-to-India Delhi Belly." In the nine years I would subsequently live in India, I was only seriously ill that first week and once again in the final week, on a parting visit to the sacred city of Bodh Gaya. Maybe that's the cost of admission: a strange ritual of blessings on arrival and departure.

The village where I spent my first couple of nights in India, sleeping on a charpoy on Shastri-ji's porch and getting devoured by mosquitoes.

❈ *Piece 9* ❈

A False Start . . . or Was It?

A few days of rest settled my stomach and brought my tempera-
ture down to normal. Back on my feet, I was antsy to strike
out on my own. An economic development job was waiting for me
in Dharamsala, a twelve-hour bus ride away. I'd looked it up in
my trusty *Lonely Planet India* guidebook. (Those books, created
by a couple of early Hippie Trail overlanders, held the secrets to
the universe for backpack travelers.) I needed to go to the ISBT
(Inter State Bus Terminal) to buy a ticket for the direct express
bus to Dharamsala.

"Arjun can do that for you," Nisha said.

Arjun jumped right in when he came for tea that evening.
"Yes, of course! No need for you to bother. I will procure your
ticket. No problem. Don't you worry."

"No, thank you," I politely refused. "I'd prefer to do it myself."

Sure, I was still recovering from a brief but traumatic episode of
traveler's fever—and even more from the trauma of the syringe—
but I was okay. It was time to move on.

Nisha and Arjun took turns making their argument: "We are
here. We are your family now. You don't need to help yourself.
We will help you."

This made me very uncomfortable. "I have to buy my own ticket so that I'll know how to do it next time," I insisted. "I need to learn how it works so I can handle it myself in the future."

"But you will *never need* to handle it yourself in the future," Arjun responded as if this were obvious. "We will *always* help you. We are your family now."

My American individualism (or was it my inner control freak?) was bumping up against Asian communalism for the umpteenth time, and my journey was still in its infancy. Arjun and Nisha simply couldn't understand why I should do something myself when they could do it for me—especially if what needed to be done was challenging and inconvenient for me and would be easy for them. My desire to exercise and strengthen my autonomy as a traveler made no sense in their world, and it did battle with my desire to be a good guest. My words landed in empty air, and I was running out of arguments and breath. In the end, I surrendered and gave Arjun the information to get my ticket.

"I need to take the express bus to Dharamsala in District Kangra, Himachal Pradesh." I sighed, while specifying my destination with precision.

"Yes, Madam. I will make the booking. No problem. Don't worry." Those famous words Western travelers in Asia come to know so well: *don't worry, no problem*. I released my precious autonomy and trusted, warily.

The mountain town of Dharamsala is located in the Kangra district of the northern Indian state of Himachal Pradesh. It was established as a cantonment for Gurkha troops of the British Indian Army in 1849 on land where a pilgrims' rest house, or *dharamshala* in Hindi, had previously stood. In 1960, the town named for a rest house became the home of the exiled fourteenth Dalai Lama of Tibet and his government in exile.

Dharamsala is now a popular weekend getaway for the urban middle class and the site of a famous cricket stadium, but in 1992 few Indians had heard of the northern Indian town. These were the days before widespread car ownership and a traveling Indian middle class. Most Indians knew nothing of Tibet or of its exiled

leader the Dalai Lama who had recently won the Nobel Peace Prize. So, when you told people you were headed to "Dharamsala," they thought you were going to a rest house and would often ask, "which dharamshala?"

Apparently, Arjun shared this confusion. A few days after I reluctantly turned my trip planning over to him, Arjun delivered me to Delhi's main bus station just in time to board the bus—the wrong bus, as it turns out.

Did I ever see the ticket? Was the destination printed on it? Was it in English? Perhaps the ticket was right but the bus wrong? I don't remember. I know it was a daytime bus because I reached Mandi in the evening. At some point (was it only on arrival in Mandi?) I realized this bus wasn't going any farther. It was not taking me to Dharamsala. Arjun had either gotten the wrong ticket or had put me on the wrong bus. At this point it didn't matter which. I was stuck in a town called Mandi. I stepped out of that mis-taken bus and into a crowd, weighed down by my backpack and duffel bag and by my utter aloneness as night descended in this strange land.

Rifling nervously through the pages of my *Lonely Planet* book, I sought a guesthouse that might provide a suitable room for the night. The market was bustling and the roads crowded with early evening shoppers, but away from the market lights, it was dark. I trudged along the edge of the road as trucks and buses roared by. Men stared at me blankly from roadside *chai* shops and *dhabas* (simple open-front eateries where men served up fresh, hot rice, dal, and vegetable curries to other men). I looked down at the pavement and up at the signs, making my way to the closest guesthouse listed in my book, desperately hoping they would have space and that they would take me in and keep me safe. Foreigners didn't travel here much. I didn't see any others.

Fortunately, I did find shelter and made it through that night without incident, beyond the pounding heart that scared sleep away. The next morning, I got to exercise my autonomy much more uncomfortably than I would have if I'd been allowed to buy my own bus ticket—the right bus ticket—in Delhi. I pushed and

shoved into the small municipal station and caught the only bus available from Mandi to Dharamsala—an ordinary local bus that would stop at every village and every roadside tea shop. Mandi and Dharamsala are less than a hundred miles apart, but it's hill country, and vehicles travel slowly on narrow, winding roads. I spent the whole day on that crowded bus with a changing cast of local men, women, children, goats, and chickens. Bumping along, squeezed in on a cramped bench, the space was too tight for my long legs to fit straight on without pressing against the metal back of the seat in front of me. I turned sideways when there was room on the bench next to me and gathered my knees to my chest when there wasn't.

Once I'd surrendered to the change in plans—and after a few bouts of cursing Arjun in my head—I *loved* this experience! Schoolgirls in blue-and-white *salwar kameez* uniforms giggled behind their *dupatta* scarves. A toddler twirled his mother's hair and stared goggle-eyed at me over the seat back. A symphony of words I didn't understand tickled my ears. Sacks of flour were loaded here, a letter dropped off there. The aisle filled and emptied, filled and emptied. Women glowed, elegant and sturdy in their colorful dresses and scarves. The driver made a quick stop at a roadside altar to leave a flower in front of a statue of a giant yellow monkey and receive a blessing in return from Hanuman. *This* was travel. *This* was life. People say that India is an assault on the senses. I say it's an awakening of those senses. And, man, were my senses awake!

❖ *Piece 10* ❖

Coming Home
to Dharamsala

●◦◦◦●

Ten hours and a hundred and twenty-five winding kilometers later, the bus made a sharp left, then curved to the right down a steep hill, and pulled into the Dharamsala bus station, delivering me to what I thought would be home for the next several weeks.

As my fellow passengers gathered their things, I rose from my seat and tested my legs, stiff from hours of awkward sitting. With no small amount of shoving and chatter, we poured out through the bus door and onto the pavement. A scrawny porter was already standing on the roof of the bus. With a nod, I acknowledged my bag which he then lowered to me as I fought off the many porters at ground level offering their services to carry it. *No, ji. No, thank you. I've got this. I'm carrying it myself, thank you. Yes, I can. No, I don't need a hotel. No, no guesthouse. I'm staying with a friend. No, No, ji no, please, no!*

I gathered my dusty, blue backpack, shook off the crowd of porters and guesthouse hawkers, and managed to find an empty spot on a bench to go through the now-familiar maneuvers required to get the pack on my once-injured always-vulnerable back. Setting

it upright on the bench, I sat down and scuttled myself backward against the pack. Then, threading my arms through the straps, I hoisted its weight onto my shoulders before leaning forward and standing up. My legs hesitatingly assured me they could bear the extra weight as I pulled myself upright with my entire wardrobe and library on my back. I took a little hop to reposition the pack on my shoulders, then fastened the padded belt. *That's better.* The weight lessened as it settled firmly on my hip bones.

Throughout this process, a group of young men, and a couple of older ones, looked on blankly. There were always men hanging out in bus stands, train stations, and airports, not seeming to be on their way anywhere—at least not in any hurry—and not clearly engaged in any work. Just there. People significantly outnumbered jobs in India, so hanging out became the job of anyone not otherwise occupied. And, in fact, hanging out watching someone's bags or shoes could be a paid job in itself.

Observing the flow of pedestrian traffic, I figured the way to town was up a steep staircase that snaked up the cliffside behind the bus stand. Several flights of stairs skimmed the crumbling hill, past rocks and brambles, through mud and garbage. At the base of the stairs, a *chai wallah* sat enshrouded in steam, offering cups of sweet tea for five rupees to passersby strengthening themselves for the ascent or refreshing themselves after descent.

I nodded toward the chai wallah and began the slow climb up the cliff, weighed down by my pack. Hugging an extra duffel bag of rain-and-mountain gear in my arms, I somehow freed one hand to use the rail to steady my pack-laden body. I was determined not to lose balance. In some sections, the rail was broken away, leaving me to navigate hands-free. How many flights were there? Ten? More? At least a hundred steps . . . Somewhere around the halfway point, rain started to fall. I smiled and continued pulling myself up each step to my strange new home.

Tsewang was expecting me some time that month, though he didn't know exactly when I'd arrive. He was the husband of the woman who had given me Tibetan language lessons in Boston. I'd arranged to stay my first couple of nights in a room above

their restaurant, The Rising Moon, the only Tibetan restaurant in lower Dharamsala, the Indian part of town.

The directions seemed simple enough. At the top of the stairs, I should turn left on the road. Then left again at the fork in the main bazaar. All uphill, mind you! And in pouring rain. But okay. *I can do this*, said some confident part of me I was just getting to know. The rain baptized me—washing away the false start of my bus journey; washing away the illness, heat, and dust of Delhi; washing away fear and doubt over whether I could handle this solo travel thing. *I can do this*, I repeated to myself as my hiking-booted foot plunged into a deep puddle drenching my left pant leg up to the knee.

I had grown up in the wrong place, climatically. People all over the world covet the Southern California climate. I, on the other hand, covet the rainy places. While others yearn for clear skies and sunshine, I yearn for billowy clouds and frequent downpours.

Like a plant, I seek moisture. The sound of raindrops tickles my heart. Gray skies saturate the colors of the landscape even before the first drop falls. Especially the greens. Oh, the multitude of green hues that emerge under overcast skies. They make me swoon. Under a sunny sky, there's just green. Maybe light green and dark green and a few shades in between if you're lucky and observant. But under a stormy sky, green explodes into a million shades, refracted as though through a prism, a kaleidoscope of color. At least, that's how I see it. And though I can't comprehend it, I recognize that I'm in a minority on this. For some reason, most people still prefer the sun.

In Southern California, a forecast of rain often results in just a few fleeting drops, a drizzle that clears to disappointingly brilliant sunshine all too soon. Even on those blessed occasions when rain lasts a day or two, I always feel a pang of, "Wait! Don't go yet! Please stay with me a bit longer!" when the drops cease and the clouds start to clear. Others greet the sunshine gleefully, while adding a responsible nod of environmental awareness: "We need the water, so I appreciate the rain . . . as long as it doesn't last

more than a couple of days. Aren't we lucky to live in Southern California?" And, of course, we are. Still, I long to bathe in weeks of moisture under deep gray skies embellished with occasional patches of blue against which green plants sing. Like I said, I grew up in the wrong place. So, when Dharamsala welcomed me with a downpour, I was instantly smitten.

By the time I'd hoisted my overloaded body all the way to the top of the stairs, the rain had slowed. Kotwali Bazaar was bustling with early evening shoppers who stepped out from under protective eaves to continue their errands. Smiling Tibetan faces mixed with the local Indian population. They must have found me an odd sight—a rain-soaked backpacker with a bulging duffel bag in her arms. But they showed no sign they'd noticed. They'd become used to seeing all sorts of travelers pass through town on their way up the hill to the Tibetan enclave at McLeod Ganj. I wasn't that special, really.

An impossible wave of nostalgia overtook me. Though I'd never been here before, it felt like I was returning home after a long absence. Warmth rose from my belly to my heart. An unprovoked smile curled my lips and crinkled my eyes. What was this? Maybe I was just glad the long bus journey was finished. Or maybe it was the way the rain deepened all the colors.

I saw Tibetan faces. I saw myself reflected in Tibetan eyes. I saw long lost brothers and sisters. The warmth that had been rising from my belly to my heart now filled my throat. My eyes were moist like the streets of the bazaar. I was home. In this strange and foreign land, I was home. Amid peeling paint, broken pavement, storefronts built right onto a street barely wide enough to fit the bus and the stream of pedestrians squeezing by it, smoking coals roasting corn, steaming pots of chai, horns blaring, unfamiliar languages, piles of garbage, and monkeys swinging from roofs above . . . somehow, I was home.

Dear Mom & Dad, 22/8/92

I've come home. I've never been here before and, yet, as surely I'll feel when I return to our home in Chatsworth or as I always feel when I return to Santa Cruz, I feel here that I've returned to that warm place called home. / All day, riding the bus & walking through the town where I stayed last night, I had doubts. Will I be able to make it here? It's been a hard ten days. And while I felt fascinated with India and eager to explore it, the feeling of being a stranger was acute. Then I arrived in Dharamsala and it lifted completely. It's probably partially due to the beauty of the mountains, the freshness of the air. But it's more than that.

Is the world outside, sweet, as it is inside? I see those Tibetan eyes smiling at me. I feel I'm home. I'll be okay. I love you. the language spoken, and somehow

FREILICH

U.S.A.

HIMACHAL PRADESH — 9051 ©
Photo — V.B. Anand
The Visual Information of India

Postcard I wrote to Mom and Dad the day I arrived in Dharamsala.

❧ *Piece 11* ❧

Settling In

❦❦❦

S leep came easily at the Rising Moon. The next morning, Tse-wang helped me load my bags into a white minivan (Maruti Suzuki, the standard local taxi) which would carry me two kilometers up the steep and winding road to Gangchen Kyishong, the Tibetan enclave where I would start my job at the planning council.

When Tibetans fled the Chinese invasion of their homeland in 1959, the newly independent government of India had granted the refugees land on which to resettle. There, the Tibetans established institutions of governance and cultural preservation. These administrative institutions aimed to carry the refugee population through the unavoidable hardships they would face during an indefinite but presumed-temporary stay outside their homeland, and also to maintain political cohesion and cultural integrity until their eventual return.

Large residential settlements were built in the south of India, where Tibetan refugees re-created their major monasteries and developed agricultural communities around them. The Dalai Lama and his governing administration settled in the northern state of Himachal Pradesh, above the Indian town of Dharamsala.

The Dalai Lama began almost immediately to introduce modern democratic features into the administration of the exile community. He quickly developed the intention to abdicate his own temporal power and transfer it to democratically elected officials. This turned out to be more challenging than one might expect. A devoted Tibetan populace resisted His Holiness's attempts to step down. He finally succeeded in 2015. At the time of this writing, the Dalai Lama has no role in the governance of Tibet in exile: Authority is vested in a democratically elected parliament, a prime minister, and a cabinet. When I lived in Dharamsala, however, these institutions were still in development and His Holiness still held an official role.

Gangchen Kyishong, fondly shortened to *Gangkyi* by its residents, sits halfway up the hill between lower Dharamsala's Kotwali Bazaar, frequented by Indian and long-term Western residents, and upper Dharamsala's McLeod Ganj, frequented by Tibetans and travelers. Gangkyi was home to the Tibetan administrative Departments of Religion and Culture, Home, Education, Finance, Security, Information and International Relations, and Health as well as the Planning Council and the Kashag (Cabinet of Ministers). The Library of Tibetan Works and Archives was also located in Gangkyi, along with its affiliated art school, where young Tibetan men were taught to paint sacred wall hangings called thangkas.

Gangkyi was to be my home for the next undetermined number of weeks, perhaps a couple of months. I had been hired to help the planning council establish a revolving loan fund in exchange for free lodging at the Tibetan Library where I would be given a room among the library staff, thangka painters, and dharma students. While there, I intended to study Buddhist philosophy as well, and maybe learn enough Tibetan language to laugh at more jokes. I'd attend classes in the morning and work at the office in the afternoon.

The head of the planning council greeted me with a warm handshake and immediately called one of the younger staff

members to pour me a cup of sweet milky tea from a tall red thermos decorated with pink peonies and an aluminum handle, Chinese made. I would not be expected to work that day. "Take a day to rest and get oriented. Tenzin will show you to your room."

I would soon discover that about twenty-five percent of Tibetan men and a significant number of Tibetan women were named Tenzin. This is also His Holiness the Dalai Lama's ordination name and one that he grants to anyone who requests that he give them a name.

This particular Tenzin, a well-dressed, clean-cut Tibetan man in his mid-twenties, led me through a meandering complex of buildings nestled into the steep hillside. We passed the grand temple-like library building where an old woman was doing *kora*, counting her *mala* beads and muttering mantras as she circumambulated the building.

Tenzin carried my duffel bag—the strap slung easily over his shoulder—up several flights of uneven stairs through scattered concrete dwellings, some with corrugated metal roofs, others with flat concrete roofs awaiting the addition of another story. I followed him up the stairs, my backpack heavy on my back, my legs and lungs straining. We continued upward. Past the solid brick edifice of the thangka painting school. Past the communal water tap where a young man crouched with his pant legs rolled up to the knee, washing steel cooking pots and plates and two white porcelain teacups with delicate pink floral designs, edges chipped. Past two outhouses. On a covered veranda, shaded and kept dry by a corrugated awning, a young man sat cross-legged on a wood-frame bed, painting a canvas propped in front of him.

Tenzin led me still farther upward to the very topmost building of the complex. Beyond this, the path continued another few kilometers, always uphill, through the forest to McLeod Ganj, the Tibetan commercial center, and to the Dalai Lama's residence, the main temple, and to crowds of backpack travelers from Europe and Australia. But that exploration could wait a few days. After so many days of travel, living out of a backpack, and treading lightly in other people's places, I was eager to settle into my new home.

The four-unit poured-concrete dwelling was built into the hillside and surrounded by tall pines. My room was one of two on the downhill side. It was dark and cool and greeted us with a rich fragrance of rain—well, mildew actually. On the earthen back wall, a previous resident had painted a Tibetan flag. Red stripes radiating like sunshine attempted to warm the damp cave of a room. I prayed for their success but felt doubtful. It would take a lot more than a sunny painting to dry this dampness. A single bare bulb hung from the ceiling in the center of the room.

The tiny front room was light and airy by comparison. Its window faced downhill, allowing light to filter in above the tree-tops as the thickly forested hill receded toward the valley. This was my kitchen, but it was also the only room with natural light so, in coming weeks, I'd study Tibetan at a desk by the window there. I'd flip through my thick Chandra Das Tibetan–English dictionary, intrigued no end by the wonderful way in which Tibetan words are constructed from component bits of meaning pieced together like patchwork. Learning this language felt like a treasure hunt.

Next to the main building was a smaller building—a shared outhouse with two one-meter-square closets—one enclosing a squat toilet, the other bare, with a drain in the concrete floor and a waist-high faucet for filling a bucket with water and pouring it over oneself to bathe.

My next-door neighbor was a Western woman in her sixties (British? American? Australian? I can't remember.) who had been helping the Tibetan refugees, especially the children, since they first came into exile in India. She seemed completely at home in her damp little room. She dressed in a long Tibetan *chuba* with traditional apron, her long silver hair gathered in a single braid down her back. Many adults in the community remembered her kindness from their childhood at the Tibetan Children's Village just after they'd come into exile.

Upstairs, a Korean woman studied Buddhist texts. From the threshold of her doorway, the fragrances hinted of another exotic land. It was as if she'd somehow brought the entire olfactory dimension of Korea along with her and kept it there in her room.

She'd carried cooking ingredients from home and had preserved a variety of pickled vegetables in jars set on her windowsill. The room smelled of spices I'd never encountered or imagined, nothing like the Indian and Tibetan aromas of other rooms. Walking into her kitchen, or just standing at her doorway to ask a question, felt like entering another reality. That's how powerful smell can be, how connected to memory and emotion. I think that's why lighting musky Tibetan incense can make it so much easier for me to enter a meditative state . . . and why mildewed books from Dharamsala still warm my heart and bring back memories even now, decades later.

I didn't last long in that damp room, four weeks maybe. As it became clear that I'd remain in Dharamsala for at least a few months, my yearning for dry sheets and sunlight overcame my shyness, and I requested to be moved to more favorable accommodations when they became available. The room I moved to—still in the library complex, still a poured-concrete box—was the most exquisite home I could have imagined. Filled with sunshine, it offered a panoramic mountain-and-valley view to die for and neighbors who surrounded me with love. Home became even homier.

My neighbors were Tibetan employees of the library—lay people with their families, as well as monks. They were administrators, dharma teachers, translators, and recorders of oral history. The community also included thangka painters and thangka painting students—Tibetan men in their twenties who would become dear friends and sometime lovers—and a handful of foreigners like me (from Korea, Japan, Kenya, all parts of Europe, Australia, South and North America) studying Buddhist philosophy, engaging in cultural research, or volunteering as teachers or library assistants.

I settled happily into my new community. My days were divided between morning language and philosophy classes and afternoon work at the planning council. I had been asked to administer a loan fund for economic development projects, but the fund had not yet been activated. In the meantime, I helped write project proposals. Work was okay. I fulfilled my tasks responsibly. But my enthusiasm

bubbled over for the classes, the mountains, the monasteries, and the community. I could feel new pathways forming in my brain as I struggled to make sense of the melodic language. My world view was elegantly dismantled each morning in Buddhist philosophy class. Within two weeks, I decided to stay through the winter. In another month, with loan-fund activation nowhere in sight, I committed to a year-long project. I would work with a retired Indian census official to design the first demographic census of the Tibetan exile population.

❄ *Piece 12* ❄

Making Connections

A lex was a Russian thangka painter in his forties studying under the great thangka painting master Sangye Yeshi at the library. A decade and a half older than his Tibetan classmates, Alex had been born in Lithuania but called himself Russian. Quirkily fluent in Tibetan and English, he was an insatiable flirt in any language. A fine painter and scholar of Buddhist iconography, Alex would go on to teach Tibetans about their own traditional art at the Tibetan University in Sarnath, India. He had been raised in the intellectual resistance circles of the 1960s Soviet Union, where love, sex, art, culture, politics, and philosophy mixed clandestinely and were intensified in the mixing. After that, he'd lived in Siberia with a Buddhist lama before moving to India to study Tibetan painting.

Alex set his eye on me within hours of my arrival. Every new female was worth a try, no?

I can't remember what he said or asked but within a few sentences he was introducing me to Migmar, an introduction that nudged me along the trajectory that was changing my life's path.

The conversation (monologue, actually) went something like this:

"Where are you from? From America, ah! You *must* learn Tibetan. A very good thangka painter, Migmar, one of our best students, he wants to learn English. He can teach you Tibetan. He's from Lhasa. Very good Tibetan! Come!"

Alex wrapped his arm around me and practically carried me up the hill, past the communal water tap and the outhouses, to Migmar's humble room.

Tiny terra cotta cups of color were scattered on a low table next to the single bed that took up a third of the room. A canvas, stretched on a homemade wooden frame, was suspended almost upright on the mattress by a string hooked to a nail in the wall above the head of the bed. Jars of colored powder filled shallow shelves recessed into the opposite wall. At a small electric burner in the corner of the room, a young man was stirring some liquid that gave off an acrid smell. (This, I would later learn, was an animal-skin glue used to bind the mineral pigments.)

A ruggedly handsome Tibetan man in his mid-twenties sat cross-legged on the bed facing the canvas. His long black hair was gathered in a neat ponytail that trailed down his back. Tibetan-language Voice of America played on a radio while Migmar focused on his painting. Inclining his head ever so slightly to the left, he leaned in and touched a delicate brush to the canvas. Steady as a surgeon, he painted intricate golden patterns onto a flowing green ribbon that draped the shoulders of a graceful androgynous figure.

He had kind, humble, honest eyes, this Migmar. I liked him immediately. A decade before we met, Migmar had fled his native Lhasa for the freedom and opportunity of India. Already a promising teenage thangka painter at the time, he'd undertaken further study in Dharamsala under the master Sangye Yeshi.

"*Tashi delek!*" Alex spoke the greeting with a jovial, intimate audacity. He mixed English and Tibetan freely, both broken but somehow eloquently fluent, with no self-consciousness whatsoever. I envied this quality that allowed him to converse easily in any language without trying to be perfect, unconcerned about mistakes or what others would think. And there was an unwavering

undercurrent of respect—devotion, even—beneath Alex's light-hearted, bawdy banter.

The divine figure taking form on Migmar's canvas that day was the personification of compassion. Known in Tibetan as Chenrezig, in Sanskrit he's called Avalokiteshvara. I had read of this four-armed being of light and knew that he had a special relationship with the people of Tibet. According to a popular Tibetan origin story, a monkey and an ogress gave birth to the Tibetan race. But that monkey was no ordinary primate. He was actually an incarnation of the buddha Chenrezig. Tibetans think of Chenrezig as the patron saint of their mountainous land and consider the Dalai Lama to be a flesh-and-blood version of this buddha, an earthly manifestation of the selfless, unconditional compassion of all enlightened beings.

There are hundreds, if not thousands, of "deities" in the Tibetan Buddhist pantheon. Though diverse in appearance, each represents enlightened mind, the full liberation and expression of our capacities as human beings. Seeing an image of any of these deities is believed to plant a seed of enlightened potential in the minds of viewers or, better, to activate the seed of enlightened potential that is already present in each viewer. The Chenrezig that Migmar was painting radiated selfless, unconditional compassion. The warmth of that compassion seemed to permeate him as he painted.

Migmar looked at Alex affectionately, his gaze blending the respect appropriate to an elder with the patient amusement with which one might watch a naughty nephew play. He glanced at me with shy, gentle, curious eyes as Alex explained that I would want to learn Tibetan (a presumptuous assumption but actually true) and that Migmar would do well to improve his English and that I would be a good teacher. Of course, he had no way of knowing whether I'd be a good teacher or a diligent student or whether I'd even stay around for more than a week. But Alex was prescient, in addition to being an unflappable flirt. No harm done if the new partnership failed, but lots of potential benefit for all of us if it succeeded.

Migmar and I began meeting three nights a week to exchange English and Tibetan conversation practice after work.

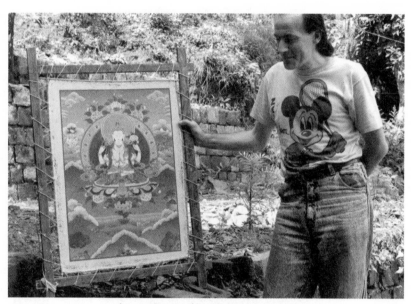

Alex with one of his thangka paintings.

❀ *Piece 13* ❀

A Room with a View

M y new, bigger, and brighter room contained two single beds and two giant windows, revealing mountains and valley. I slept facing the mountains, so I could wake up each morning to the most beautiful view in the world. The Dhauladar Range filled me with awe. My first breath in the morning was a gasp of appreciation. Such majesty. Sheer granite faces soared skyward from behind greenish-brown hills. From late fall, snow would cloak these mountains only to dissolve again with the first monsoon rains of summer.

My second bed served as a couch. Actually, all beds in Dharamsala homes doubled as couches before bedtime. Many were covered with thick wool carpets woven with traditional Tibetan motifs, but mine got by with a printed cotton bedcover. My room's second large window opened onto the expanse of the Kangra Valley, dotted with villages, towns, and farms. Nechung Monastery was just below this window, greeting each day with the sounds of horns, bells, cymbals, and chanting.

In the center of the room was a desk with three drawers. This is where Migmar and I sat across from each other for our language exchange, making awkward conversation as best we could.

A small kitchen adjoining the main room doubled as a foyer. The front door opened onto an outdoor corridor, which led to the bathrooms I shared with my neighbors. My kitchen sink was a large basin molded into a poured-concrete countertop. A hole in the bottom of the basin let the water flow through a short length of pipe then drop into a drain in the floor below. I had running water—cold only—from a tank on the roof that was filled twice a day when water was delivered. Sometimes the tank went empty—most often during monsoon when plenty of water fell from the sky but little flowed through our pipes. Rumor had it that the local plumbers periodically broke the pipes so they could be called upon and paid to fix them. But it's also quite possible that when fixed or first installed, the pipes were held together so tenuously that it didn't take much to break them again.

I gazed out the kitchen window, as I stood before my concrete sink brushing my teeth. While my main-room windows faced outward toward mountain and valley, my kitchen window faced into the community. I could see the shared water tap where my neighbors gathered to wash their faces and brush their teeth outside. A morning ritual, usually so private in the world where I grew up, was conducted here in public. Later in the day, cooking pots and laundry would be washed at the shared tap too. As public blended with private outside my window, long-held demarcations began to fade like the chalk lines of an old hopscotch pattern washing off the pavement of my mind. Still, I continued to brush my own teeth indoors.

Spiders became my regular roommates, much more welcome than the occasional scorpions who came to visit. The big spiders would appear as if by magic, beamed in one day to a spot on the wall where they would remain for days or weeks, looking as if they'd always been there and would always remain. While there, they seemed never to move or else would creep very slowly for just a few inches only to settle into stillness again. Then one day, they'd be gone just as suddenly and inexplicably as they'd appeared. Some people were bothered by the spiders on principle, but I wasn't. We had an understanding, I suppose, and lived easily together, each

with our own territory and rhythm. Our unspoken boundaries held well. Never even a spat. For me, these big spiders were like trees—and seemed almost as rooted until they disappeared without trace.

The smaller, quicker spiders were more startling. Sometimes they appeared in my concrete sink as I washed dishes. I tried to lift them out of the sink to save them from drowning but, invariably, I regretted the attempt. I can't tell you how many spiders I've apologized to for inadvertently amputating their legs in my attempt to rescue them. I'll be making amends for several lifetimes.

I always had a soft heart for creatures. I remember my parents handing me a can of insecticide and directing me to kill the flies in our backyard before guests arrived for a barbecue. I must have been ten or twelve years old. Tears streamed down my face as I obeyed my parents' instructions and sprayed, muttering through gritted teeth, "But why can't we all live in peace?!"

Fortunately, motivation counts when it comes to karma. For a negative action to be complete in a karmic sense, four characteristics must be present. The action must be directed toward a particular object. (I'd have to have a particular bug in mind.) The actor must have an intention-carrying thought. (I'd need a desire to do harm.) The actor has to take action in line with that thought. (I'll get you, damn spider!) And the goal must be achieved. (Intended target hit.) Luckily for me, I had no such intention toward the spiders in my sink. Unluckily for the spiders, they still lost their legs.

❧ *Piece 14* ❧

Dharma Class

❖━━━━━━━━━━━━━━━━━━━━━━━━━━━━━━━━━━━━━━❖

Tibetan Buddhists have a practice of walking clockwise around sacred objects. They believe this practice builds up stores of positive energy for future good fortune and supports their journey toward enlightenment. The Library of Tibetan Works and Archives had become a focal point of this walking practice in the Gangkyi neighborhood. Surrounded by eight dome-shaped shrines (stupas) and filled with sacred texts and icons, the library was a repository of scholarship, scripture, and oral history from a time before the Chinese occupation of Tibet. Almost everyone who passed by took the occasion to pay some respect and earn some merit by walking around it in the proper direction. Elderly Tibetans spent large parts of their day circumambulating the library. Even busy students and office workers, who might not have time for full rounds, would choose a path around the library that kept the sacred building on their right as they passed. In this way, everyone accumulated bits of good karma in their normal course of business. Dharma practice permeated the most ordinary of activities.

Every evening, the whole community gathered around the library. People of all ages chatted as they circumambulated.

Thangka painters played hacky sack out front, laughing as they circulated the blood in their all-day-folded legs.

Six mornings a week at a quarter to eleven, I climbed three steps to the library's wide front porch and entered through its massive and elaborately painted doors. It was time for Geshe Sonam Rinchen's class on Buddhist philosophy, my last class of the morning before an afternoon of office work at the planning council.

The cavernous lobby of the library had an air of antiquity even though the poured-concrete building was barely twenty years old. It was dark, cool, and musty with monsoon. As my eyes adjusted to the low light, I felt my energy adjust as well, from the conspicuous radiance of the outside world to a subtler inner alertness.

Black-and-white photos lined the walls along two flights of stairs leading up to the classroom. Pictures of monasteries in old Tibet alternated with scenes of those early and difficult days in exile in India. Many Tibetan refugees, including highly respected members of the community, had worked on road crews, breaking stones by hand to pave high mountain transit routes. Living conditions were rough in refugee camps, and the warm monsoon rains at altitudes lower than they were accustomed to brought unfamiliar diseases against which the Tibetans had no immunity.

Opposite the photos, the bars of an iron stair railing bent to form auspicious symbols—lotus flowers and endless knots—painted in green, yellow, and red. Dharma everywhere.

On the second floor, I followed the hall past the mail bin to the classroom. I removed my shoes and added them to a pile in the vestibule outside the curtained doorway.

Bending to lower my head a bit, I pushed the door curtain aside to enter the sunny classroom. Young Tibetan men, recent arrivals from Tibet, bent the lowest as they entered. They came to class for the English training as much as for the dharma—perhaps more—and to meet Western girls, of course. None of these aims contradicted each other. In fact, they were mutually supportive. The young men wanted to access the world through English, reconnect with their cultural roots, and have an adventure. The Western women, on average a bit older than the newly-arrived Tibetans,

wanted to connect with the Tibetan culture and dharma, learn Tibetan language, and have an adventure. Everyone was on the same page.

Windows on two sides of the open room let in lots of light and a refreshing cross draft. Forty or fifty flat foam cushions covered the floor. These thin squares provided minimal comfort as we sat on the thinly carpeted concrete to receive teachings. The cushions at the edge of the room (where you could lean back against a wall) and in the first row (where you could focus most closely) filled first, followed by all the spaces in between. Remarkably skilled at delivering traditional material to contemporary ears, Geshe Sonam Rinchen always drew a full house. When the house got fuller, knees got closer.

Some students folded the back of their cushion to put a little more height and softness under their bum. I folded my wool shawl and sat on that, until a cold draft made me drape the shawl over my shoulders. Wool shawls are a wonderfully versatile Himalayan accessory. I carried one everywhere and used it for everything. Besides wrapping it around my body for warmth and putting it under my bottom for cushioning, I often used the shawl to dry my hands after washing up at the corner sink found in every Indian eatery. I'd pull it over my head to preserve modesty in rural villages and Muslim neighborhoods. And, all too frequently, I'd grab an edge to cover my nose and mouth and protect my lungs from dust and fumes spewed by a loudly passing vehicle.

In class, few of us Westerners could sit with our legs crossed for the whole hour. Fidgeting was rife, especially for a master fidgeter like me. But no matter how much I might shift positions during class, it was important to start out sitting cross-legged. If I made the mistake of gathering my knees to my chest while the class was still filling, there'd be no space to relax them later without resting them on my neighbor's knees, a prospect sure to lead to an uncomfortable hour.

Some newcomers would stretch their legs out in front of them with their feet pointing directly at the teacher. We regulars would try to alert them to their faux pas as our faces reddened with

embarrassment. Pointing feet at anyone is a disrespectful no-no in most of Asia. Nevertheless, some oblivious travelers would lie down during class and look up toward the ceiling while their feet pointed straight toward Geshe-la.

Six days a week at eleven o'clock sharp, Geshe Sonam Rinchen's translator, Ruth, came through the curtain and held it aside for Geshe-la to enter as we all scrambled to our feet, hands folded, hearts open, eyes alight. Geshe Sonam Rinchen was a solid man of sixty with a round shaved head and a wide smile. He had received his *geshe* degree, the equivalent of a PhD in Buddhist philosophy, at Sera Monastery, one of the great monasteries of the Gelugpa school of Tibetan Buddhism reestablished in Bylakuppe, India. Like many other distinguished teachers, he'd spent his first days in India enduring horrendous conditions and fending off illness. Geshe-la, or Gen-Rinpoche as Ruth called him, was a vibrant, engaging teacher. He was able to meet an international audience of travelers and refugees right where they were, even while delivering ancient teachings in full accordance with tradition.

He surveyed the room and nodded approvingly at the students gathered there to learn. Then he turned to face a thangka at the front of the room, rearranged his maroon robe and bent to touch his hands, knees, and forehead to the floor three times. We watched with rapt attention as Geshe-la stood up, re-wrapped his robe, and climbed onto a raised platform to take his seat.

Now it was time for the rest of us to make our prostrations, a method of expressing respect to the teacher and putting one's mind into a receptive state for the teachings. Three times we dropped to our knees and touched our heads to the floor, some more gracefully than others.

Ruth took her seat on a low platform to the left of Geshe Sonam Rinchen's higher platform. Ruth was our bridge to Geshe-la's vast spiritual knowledge. An Oxford-educated woman born in Ireland to German Jewish parents, Ruth had taken Geshe Sonam Rinchen as her teacher fifteen years earlier and had been by his side ever since, translating and assisting. She led us in daily prayers, chanting in Tibetan as the class did our best to sing along.

I can still hear Ruth's reedy voice in my head now, a quarter of a century later.

Lama dang gonpo jetzun jampalyang la chag tsal lo . . . Homage to my guru and protector Manjushri.

This day, we would continue our study of Aryadeva's *Four Hundred Stanzas on the Middle Way*. Aryadeva was a disciple of the great Buddhist philosopher Nagarjuna, who founded the Madhyamaka school of Mahayana Buddhism in the third century CE. Madhyamaka means "middle way" and refers to an understanding of reality in which all phenomena are conditional and empty of any inherent essence. Things (and we) exist but only in relation to other things, not as essentially separate or permanent entities.

"We were discussing from the point of view of the object on which the disturbing emotions focus and establishing that that object is not truly existent, and also looking at the consciousness, the awareness—or perception itself—which, too, is not truly existent. To attain liberation, we must understand reality," Geshe-la said in Tibetan, and Ruth eloquently conveyed in English.

The mixed class of Tibetan and foreign students listened intently to both languages. Some listened to the language they understood best, seeking only to absorb the philosophical material. Others listened primarily to the language they were striving to master. I thrilled to the melodic Tibetan tones. The notes and cadence of the Tibetan language resonated deep in my bones. I understood scattered words. And after a few months of study, I began to follow bits of Geshe-la's tangential personal stories about life in the Buxa refugee camp in West Bengal, where he had spent his first several years of exile, from 1959 through 1967. I gradually gained a conversational command of colloquial Tibetan, but my formal Tibetan never got good enough to derive much meaning from the philosophical arguments in Tibetan. I counted on Ruth's brilliant translation for that.

Ruth was able to understand and interpret Geshe-la perfectly, having devoted her practice to conveying his teachings. She once explained that in order to be an effective and reliable bridge, a

translator needs to be both accurate and elegant. Her job was to convey meaning, not just words.

"To translate meaning well," she said, "it's not enough to know the language you're translating from. A good translator also needs to have a thorough grasp of the philosophical context behind the material. This assures that the meaning conveyed in your translation will be accurate. Then, just as importantly, you need a rich vocabulary and an elegant fluency in the language you're translating *into*. When you speak, you need to speak in a normal vernacular, so that the meaning you convey can be well received by listeners. A passionate translator must love both language and meaning. They must win the trust of the person they're translating as well as those to whom they're delivering the translation." Ruth accomplished this task like few others. She imbued her precise translations with heart and humor.

Through the years, Geshe Sonam Rinchen had picked up some English as he listened to Ruth's translation of his words. Sometimes he would challenge her, accusing her of getting something wrong or leaving out some content. She defended herself with confidence as Geshe-la interrogated her. Geshe-la's corrections were usually wrong. He wasn't familiar with the colloquial English idioms Ruth used to translate—and give appropriate nuance to—his words.

Later, as Geshe Sonam Rinchen's English improved, his sparring with Ruth became fiercer. Both of them were vehement in their convictions and simultaneously dedicated to each other and the students. No matter how fierce his scowl, Geshe-la's scolding was feisty play. Ruth never had to fear his disapproval. In their twinkling eyes, I could see the love and mutual respect that pervaded their relationship.

"The moment you begin to doubt the illusion, the bonds of worldly existence are shredded to tatters. Taking an interest in what's really going on opens the possibility of escape from the ignorance that binds us to suffering. An intelligent person wants to see things as they actually are and is prepared to face reality. So, what about us? Are we interested in reality?" Geshe-la raised an eyebrow and lay a penetrating gaze on a young man in the

front row as Ruth translated this question. "Aryadeva advises us to develop an enthusiastic interest in reality and to be thrilled by the recognition of emptiness. Are we ready to shred our ignorance to tatters?"

After class, students poured down the stairs and reconvened in a gregarious gathering on the library porch. We discussed the teachings while tying our shoes. I ran off to work at the planning council while others headed to lunch or went home to study. Though not in tatters, I could feel some small tears beginning to loosen the constrictive fabric of my own narrow mind.

❋ *Piece 15* ❋

Where Are You Going?

━━

"*Kabar dro ge?* Where are you going?" asked every Tibetan I met on the road.

It drove me crazy at first. "Mind your own business!" I bristled silently while smiling awkwardly—until I finally realized it didn't matter at all what I said in response. Just as "fine" suffices in America as a reply to "How are you?" a simple "up," "down," or "that way" was a perfectly sufficient answer to *Kabar dro ge?*

Because, admit it, do any of us really know where we're going anyway? We set a general direction, for this moment, for today. And we set off. Then life happens. Obstructions rise up. Opportunities jump out at us. We get distracted. We get sick or we lose interest. We drop everything for a friend who needs help. It rains. And before we know it, we're headed somewhere else.

It's funny what we take for granted in our own language and in our own culture. Spending time living in a place that's fundamentally different from the place you know is the surest way to make your assumptions visible. And it will change you in ways you can't even begin to imagine.

The road and footpath from Gangkyi to McLeod Ganj.

❧ *Piece 16* ❧

Precious Human Life

••

Kotwali Bazaar, Gangkyi, and McLeod Ganj are arrayed like beads strung along Dharamsala's mountainside. There's no flat ground anywhere. Every shopping trip, every visit to a friend or a temple involves a climb up the hill or down. Walking "up" one day, I passed an old monk walking "down." His back was bent slightly, but his gait was steady as he descended the road from McLeod Ganj. He raised his head just before passing me, and his face lit up with welcome. He turned, clasped my hands in his, and looked directly into my eyes. A wordless greeting spoke volumes of how we'd come from such different worlds—his full of unspeakable horror, mine blessed with inconceivable comforts—to meet in this place with a smile of recognition. Two beings on the path, lucky to be human.

A precious human life. In the Buddhist view, we sentient beings are born in various forms and circumstances, and we inhabit different realms of existence, shaped by our choices and actions. This is the law of cause and effect, action and reaction, also known as karma.

Karma is not reward and punishment, as there's no one administering the system. No one is doling out consequences. It's

more like basic physics: If I push a tall lamp from its base, it will slide along the table. If I push it from the top, it will topple. And if I grab the hot bulb with my fingers, they will burn, and I'll feel pain. Causes and consequences.

Karma functions day-to-day, moment-to-moment. With a kind word and a smile, I'm likely to experience a warmer reception than if I scowl. And if we entertain the possibility that consciousness continues beyond this life, then it functions in the long run too. The continuing force of our actions and attitudes directs us to birth in particular forms and circumstances.

Buddhism speaks of six realms in which beings can be reborn. In order of unpleasantness, these are the temporary but oh-so-painful hot and cold hells; the hungry ghost realm of insatiable hunger and unquenchable thirst; the dull and exploited realm of animals; the human realm of desire and dissatisfaction; the demigod realm of power and competition; and the luxuriously comfortable realm of the gods.

On this scale humans are right in the middle, and our particular brand of suffering is the perpetual frustration of our desires—along with birth, old age, sickness, and death. But in terms of access to enlightenment, the human realm is the best place to be born. A "precious human birth" is the pinnacle of opportunity. We humans have the capacity to understand our predicament, to discern its causes, and to choose something different. Those of us who have our basic survival needs handled, enough intelligence and education to be reading this book, and the good fortune to have encountered the Buddha's teachings . . . well, we're the luckiest of all, the very best positioned to untangle the knots of our existence and get free.

So, there we were on that mountain road in India—that smiling monk and I, two very different versions of the precious human birth—joining hands and locking eyes, recognizing each other with a smile.

❈ *Piece 17* ❈

Monsoon

❖━━━━━━━━━━━━━━━━━━━━━━━━━━━━━━━━━━━❖

Never leave home without an umbrella. This was a year-round rule in Dharamsala. The weather could change from warm sun to icy hail in a matter of minutes.

During monsoon season, residents hung laundry out to dry between downpours and brought it back inside as the first drops fell. Racing to unpin and collect clothes-pegs, we hurriedly piled the clothes under our arms as we ran inside. Clotheslines stretched across every living space, and I became accustomed to sipping tea and chatting with friends beneath laundry that was making its slow, circuitous progress toward never-quite-dry.

It was not uncommon for a friendly tea with friends to be interrupted by a shriek of "Oh no! I left my laundry on the line! Gotta go!" This initiated a race along steep and winding paths as raindrops started to fall, arriving home to tear clothes from the line, clothes that had reversed course in the long journey from wet to just slightly damp, which was the best one could expect and the way one became accustomed to wearing clothes from July through September.

The smell of monsoon stays with me even now. I lift a book to my nose and slowly inhale its musty fragrance, the soft homey

scent of mildew. Homey? Yes, it has become so. That scent remains in my books twenty years after leaving Dharamsala. It wasn't so nice when it permeated my bedding and the towel I used to dry off after a sensuous bucket bath. But now it's a sweet reminder of the realest and richest time in my life.

Most Western visitors left the area during monsoon, taking the occasion to visit their families in Europe or to travel to dryer parts of India. I stayed and loved it. Unfortunately, my love of the rain didn't provide protection against the mold allergy that came with it and got worse every year. I struggled to find an effective antihistamine regimen that would keep the itches out of my eyes and throat without putting me to sleep. But I loved dodging the rain, loved the conversations that would occur among strangers taking cover beneath an awning. And I loved the community that stayed behind.

Winter was another time of year when most transplants vacated the premises. Anyone with other options—family to visit, travel to do, dry places to explore—tended to leave town during these periods. Winter and monsoon were my two favorite times to be home in Dharamsala. In those seasons, Dharamsala ceased to be a tourist town; those who remained were declaring their residency, claiming their place in a much smaller community than the bustling one that filled the town in spring and fall.

❋ *Piece 18* ❋

Veg Wallah

⚬⚬

T he slight but sturdy vegetable seller walked slowly through the library complex in the late afternoon balancing a wide basket of produce on his head. His composure never faltered as he navigated the uneven steps with ease. His distinctive call brought us out from our rooms to stock our kitchens. Every few days, we'd walk down to the bazaar and carry loads of fruit and vegetables home in our rucksacks. But the veg *wallah's* house-to-house rounds allowed us to supplement our supplies. With one hand, he held the rim of the basket to steady it as he moved.

Wallah is a Hindi word that refers to a person associated or concerned with any particular activity (usually an occupation or service). It can be paired with any other word to denote any regular activity. There were other traveling vendors who wandered through the neighborhood on foot from time to time: knife sharpeners, umbrella repairers, and others. But this veg wallah was our most regular.

"*Ji!*" (sir) neighbors would call out from their doorway as they spotted him. "*Bhaiya!*" (brother) they'd call again as they stepped outside to meet him. The veg wallah would raise his free hand to the rim of his flat basket, his other hand already holding the

*The veg wallah and me. I'm wearing a chuba
(Tibetan dress) so it must have been a
special occasion like Losar or a community picnic.*

opposite edge, and lift the basket from his head. Squatting with elegant strength, he would lower the basket to the ground without bruising a single one of the delicate, delectable items inside.

Together, vendor and customer selected pieces, lifting and examining each in turn. The delicious assortment changed with the season: sweet oranges, leaves of green spinach, plump bell peppers, and tiny, hot chilies that could bring tears to your eyes. Holding a scale, the veg wallah placed weights on one plate and produce on the other until they balanced, and he named the price. Rupees were exchanged as he retrieved change from the pocket of his loose tunic.

One late afternoon, I was the last customer of the day and the veg wallah looked like he'd had enough. The basket was about three quarters empty, a few heads of cauliflower, a bunch of radishes, and a few *tamaaters* (tomatoes) remained. Could he leave his basket and scale in my room for the night? In my memory, the question is asked, but the veg wallah spoke no English and I had only a few Hindi words. We shared no idiom beyond the names of fruits and vegetables and the mutual presumption of trust. He must have communicated in gesture with a few key Hindi or English words thrown in. (I had become so good at understanding gesture and broken English that I frequently found myself translating conversations from Indian English to standard English for people who lacked that skill.)

"Of course. Why not?"

I hosted that basket frequently over the next three years, while I lived at the library in the big room with the spectacular view and an abundant kitchen floor. We knew nothing of each other's lives, the veg wallah and I, though he knew more of mine than I did of his, since he passed through my neighborhood most days and entered my kitchen each evening. In the morning, Chandra (for such was his name, I learned years later) would knock on my door, come into my kitchen, add fresh produce to the basket, place a loop of cloth on his head, and lift the basket to rest on top of it. Then he regally descended the stairs for another day's work.

❦ *Piece 19* ❦

Insiders

━━

Tibetans love picnics, festivals, and ceremonies of all kinds. Besides being fun occasions to commune with friends and neighbors, each of these events is an opportunity to increase one's store of merit, fuel for a better rebirth and for the journey toward enlightenment. My Tibetan neighbors always seemed to know in advance when any of these occasions was about to occur. They were connected in some mysterious web of communication that invariably put them in the right spot to receive blessings and enjoy festivities whenever the occasion arose. They trudged up hills before dawn to get the best seats at assemblies, their tiffin-boxes and thermoses already filled with freshly cooked food and hot tea. They lined the road for hours to catch a glimpse of His Holiness the Dalai Lama's arriving or departing motorcade.

There was no email, no social media, just good old-fashioned village communication. I'm not sure whether it was word-of-mouth or telepathy or some combination of the two, but however it worked, I was out of the loop. I often learned of events too late when neighbors would ask, "Did you go? Did you see? Wasn't it wonderful?" *Couldn't they have asked before?* I fumed. But they probably assumed that I, too, was connected to the same mysterious web.

There was one recurring event I did learn about in real time: the trance of the Nechung Oracle. Nechung Monastery sat just below my room, and the State Oracle of Tibet resided there. In addition to offering blessings to the masses, the State Oracle was consulted on matters of national importance. This is the oracle who told the Dalai Lama it was time to flee into exile in 1959 when his ministers were weighing the danger posed by Tibet's occupiers.

I was roused out of bed by loud horns and drums beating beneath my window whenever the medium went into trance. Sometimes it was scheduled. Other times, it just happened. Either way, the community got the announcement through their mysterious network. A crowd would be gathered before I, alerted in a noisier and more mundane way, got myself to the temple, rubbing sleep from my eyes. I made it in plenty of time to watch the frantic scene. Zealously protecting the medium from stampede, monks brandished sticks to beat back the devotees who pushed forward to bathe in the oracle's energy—and to grab a ball of roasted barley dough believed to contain his blessings.

I remember standing on an empty roof with my thangka-painter friend Bhuchung one morning when a crowd was clamoring to get their hands on the little balls of blessed dough. Gazing down on the swarming crowd, Bhuchung lamented, "It's embarrassing. Look how mindlessly and selfishly they fight for the symbol of blessing. Don't they know the blessings are *inside*? We Tibetans should know at least that much."

I was born with an innate sense that all answers and resources are within me—and then I proceeded to look outside myself for rules, guidelines, models, and validation. I'm a Six on the Enneagram, a popular personality-typing system useful for understanding the motivations and defense systems behind human behavior. We Sixes are hyper-responsible and afraid of making mistakes. We yearn to feel safe and secure, so we learn the rules of whatever system we find ourselves in really well. With so much attention

placed on external frameworks and our place in them, it's a constant challenge for us to access our inner knowing.

Despite this inborn challenge, or maybe because of it, something in me has always valued inner guidance and has struggled to find it. My first sense of religion and one of my earliest inklings of identity in my interfaith family was: *I'm not Christian.* As a child, I rebelled spontaneously against the concept of an external God and what I saw as arbitrary explanations and rules, both of which required reliance on external doctrine. I recognize now that Christianity can be viewed very differently and can point its faithful toward inner work (especially in its mystic manifestations), but that initial impulse was indicative of my life's direction and eventual spiritual orientation.

Tibetans call adherents to their Buddhist faith *"nangpa,"* which means "insider." This term is not meant to separate an in-group from an out-group. Rather, it emphasizes an orientation toward inner inquiry and practice, a journey toward inner liberation. Buddhists search for answers inside the individual mind and in the nature of phenomena.

During Buddha's time, the existing religions in India focused on external rituals and rules. A rigid caste system provided a social order in which every person knew their place. Physical austerities were common among spiritual aspirants, and the Buddha-to-be, Siddhartha, tried many of them before his epiphany under the Bodhi tree. The liberation he finally found was internal, and his subsequent teachings departed from prevailing norms. He eschewed practices of self-mortification like fasting and sleeping on thorns. He rejected the social stratification of the caste system and abandoned spiritual asceticism. He taught the Middle Way. In the Buddha's view, *everyone* possesses the seed of enlightenment and the potential to realize its fruition—regardless of caste, wealth, health, gender, or any other condition.

Our work is to dismantle the internal structures that cause us to react erroneously to external events. The transition from suffering to freedom can only occur in our own minds and in our relationship with the fluid external world. Our attention and attitude are key. Our work is an inside job.

Still, external conditions also matter. Though provisional, they function. Until we're enlightened, our minds are materially influenced by factors in our environment and by the activities we engage in. By performing rituals and doing practices, we can harness the power of stimulus and response. With these ideas vaguely in mind, I started to get curious about the Buddhist ritual of taking refuge in Buddha, Dharma, and Sangha. Might a traditional commitment ceremony hasten my growth and expand my heart?

❈ *Piece 20* ❈

Refuge and a New Name

G eshe Sonam Rinchen inspired me every morning in class. And his teachings were beginning to seep into the activities of my days, coming to mind as I met with friends and colleagues, evoking kindness and curiosity as I gazed at the mountains or the sky or an ant crossing my path. My edges were softening and my mind opening. I'd attended dharma class every day before work and listened to Geshe-la attentively for the three months since I'd arrived, but I hadn't had any personal conversations with him yet. Given my lifelong trepidation around authority figures, I would likely not have approached him on my own. But I wanted to deepen my relationship to the teachings. I wanted to formalize my commitment to inner transformation by taking refuge in the Buddhist path.

If it had been up to shy little me on my own, I might well have done it silently, inwardly, without telling anyone. But remember Alex, the Russian flirt who introduced me to Migmar and connected me to thangka painters? Alex's forthrightness served me again.

Bold friends like Alex can intimidate us introverted, I'll-work-it-out-on-my-own types. But they also push light and air through otherwise unnoticed cracks. They provide wind to fan our inner

flame. They help us overcome our own inertia. This can be a good thing, as long as we remain true to our own course and avoid the pitfall of detouring onto theirs. Alex played this role for me. He provided just the right amount of push to overcome my tendency to procrastinate, to wait for an ill-defined list of prerequisites to be met before I reached out.

I told Alex I was interested in taking refuge, and the next thing I knew, I had a private appointment with Geshe Sonam Rinchen to formally enter the Buddhist path. To be completely honest, Alex had to physically walk me over to Geshe-la's door, past the mangy dogs sleeping on the stoop, and speak to the attendant in Tibetan on my behalf as I stood by, awkward and dumb. I smiled but not too much. Looking at my feet, looking sincere, I hoped I was conveying appropriate respect. Alex explained that I wanted to take refuge with Geshe Sonam Rinchen and asked the attendant when I could come. The attendant promised to speak with Geshe-la and Ruth and get back to us.

A few days after Alex secured my appointment, I approached Geshe Sonam Rinchen's door again, solo this time, a bag of oranges and packaged biscuits in my hands as an offering. Should I have brought more? Perhaps, but this is what I'd seen people offer—simple, readily available delights. It was what people could afford, and maybe it was also a reminder that the stimuli of joy and gratitude are not extraordinary. They are all around us all the time, ready to be given and received. I knocked on the door.

Geshe-la's room was tiny. A cramped entryway led to a small kitchen on the right and a sitting room on the left just big enough to hold a single bed, a corner table, and a bookshelf. There was only enough space on the floor for a single-bed-sized carpet. (Tibetan rugs serve as warm, cushioning decoration on beds and chairs, so their sizes are often distinguished by the surface they rest on: "seat rug" or "bed carpet.")

An attendant took the fruit and biscuits from my hand and led me into the sitting room before retreating into the kitchen to

make tea. Geshe-la sat on the bed, which served as a sofa during the day (as did all our beds). Ruth sat nearby on a cushion on the floor. I made three awkward prostrations in the cramped space, dropping to my knees and touching my palms and forehead to the ground, thankful for the thick wool rug that cushioned the floor. Prostrations, which take various forms in different Buddhist cultures, are a physical expression of respect and gratitude to the teachings. In addition to making three prostrations at the beginning of every dharma class, I'd seen Tibetans make such gestures countless times in front of statues and lamas, or simply when entering temples. Bending one's body and humbling oneself before a teacher is not so much a sign of submission or worship as an acknowledgment of one's own buddha-nature and the teachers who illuminate it. Taking a moment to prostrate mindfully renders one's heart-mind flexible, open, and appreciative.

Next, I pulled a *khata* out of my pocket. The long, white scarf became a flowing waterfall as it unfurled from its accordion folds. Gratitude surged as I remembered the Tibetan friend in Boston who had taught me how to fold a khata. I held it out to Geshe-la with two hands. Accepting my traditional show of respect, he gently lifted the scarf from my hands, raised it over my bowed head, and draped it onto my shoulders. Preliminary formalities accomplished, I settled into my place, cross-legged on the floor directly in front of Geshe Sonam Rinchen, ready to receive a blessing.

The attendant brought in three cups of milky tea in thick ceramic cups. On the same tray, he carried the biscuits and fruit I had brought, now arranged with beautiful simplicity on a Melmac plate.

Geshe-la explained refuge, and Ruth patiently translated words she'd surely repeated several hundred times as if this were the first time she'd heard or said them. The refuge ceremony is a formal welcome into Buddhist practice. It's sometimes thought of as the moment one becomes a Buddhist. In my case, I wasn't looking to *become* anything. I just wanted to acknowledge what was already happening and support its continued unfolding.

Ruth's patience, kindness, and devotion were palpable, and humbling. Could I ever dedicate myself to anything as fully as

Ruth had? Surely not. I was too flighty, on to the next thing before I knew it. I wondered what it would be like to immerse oneself so deeply in a single path. Geshe-la's commanding voice interrupted my wondering. He recited from a *pecha*—the oddly shaped loose-leaf book in which Tibetans print their scriptures—then asked me to repeat some lines in Tibetan.

"I, Leslie, take refuge from now until enlightenment in the Buddha, the Dharma, and the Sangha."

The refuge ceremony is a formal way of setting intention for a spiritual life. In it, we accept the Buddha as our teacher, we accept the Dharma as a valid path, and we accept the Sangha as our guides and companions. It's a statement of priority that declares the spiritual aim as primary and commits us to looking through its lens at whatever life brings us. Like a marriage ceremony, it's not a necessary prerequisite to a life of commitment, but it is an official declaration that gives gravitas to the intention.

Where will I turn in the storm of life for safe harbor and direction? And what is my mission, my highest aim on this journey? The initial refuge ceremony undertaken with a lama is the moment when we sit down with the map of all possibilities, set our destination, and chart our intended route. Like a ship en route, though, we're always drifting off course. Daily refuge-taking is the dynamic navigation system we use to keep us on track. Before each meditation session and at various points throughout the day, we remind ourselves of our commitment and our resources. We use refuge again and again to pull ourselves back into line, to point our bow in the intended direction. It may take a long time, but if we keep re-turning our nose toward our destination, everything we encounter in life will become fuel for the journey.

Every *sadhana* (the script that guides a particular ritual, initiation, or meditation) in Tibetan Buddhism begins with a restatement of refuge, combined with an aspiration of altruistic intention, to undertake the spiritual journey for the sake of all living beings.

Some people associate the refuge ceremony with conversion. For me, taking refuge was nothing like a conversion. It's not like

I'd been something else before I became a Buddhist. For me, it was just a recognition, a clarification, a finger pointing further along the path I was already wandering. Like when you get your car's wheels aligned. You don't change the direction of your wheels to point sideways. You just tweak them to work better in harmony, to move your vehicle forward more efficiently. Just as a wedding ceremony doesn't create a marriage, the refuge ceremony doesn't create a Buddhist. But there is power in public declaration. For me, taking refuge before Geshe Sonam Rinchen and Ruth was a way of declaring to my own mind-stream that the direction of my life's journey, through whatever mundane events would follow, was toward inner freedom and understanding, using the Buddha's teaching as a guide and compass.

I've heard that it's customary for the lama to cut a lock of the disciple's hair during the refuge ceremony, to symbolize becoming a monk in some way, even in the case of lay practitioners. Geshe Sonam Rinchen didn't do that. He simply recited some prayers and asked me to repeat several phrases, inserting my own name in the oaths. He welcomed me into the choiceless freedom of commitment to a shared inner path. The words fit comfortably in my mouth and tasted sweet on my tongue. Warmth radiated from Geshe-la and Ruth, filling the tiny room and flooding my heart with joy.

At the end of the ceremony, Geshe Sonam Rinchen gave me a new name to reflect the realignment of my life. He called me Rinchen Wongmo. Precious Initiate.

Tibetans don't generally have surnames or family names. Each individual carries one or two given names, usually assigned by a local lama shortly after birth. Names can change several times in a lifetime. An individual who becomes a monk receives a new name upon ordination. Tibetan refugees may request a new name from the Dalai Lama when they arrive in Dharamsala. (That's why so many are called Tenzin.) When great obstacles are encountered or significant changes take place in one's life, it's not uncommon to ask a lama for a new name. This shows a deep respect for the power of words and an awareness of the fluidity of identity.

In accordance with Tibetan tradition, when Geshe Sonam Rinchen granted my new name, he highlighted the power of lineage and sealed our connection by gifting me part of his own: *Rinchen*. Rinchen means precious. This piece of my name reminds me of the rare opportunity I have in this human life, to practice, to discern, to make choices, to teach, to give. It trains me not to disparage myself, nor to waste the great resource of being me.

The second piece of name Geshe Sonam Rinchen conferred upon me, *Wongmo*, is more commonly transliterated as *Wangmo*. I changed the "a" in the first syllable to an "o" to encourage accurate pronunciation by English speakers. *Wang* is power or authority. It implies ability and influence. It's also the word used to denote the rituals by which lamas confer the essence of esoteric practices on practitioners. This is commonly translated into English as "initiation" or "empowerment." *Mo* is a feminine suffix, indicating that this particular holder of power is female. So Wongmo can be translated as empowered woman or female initiate. This name challenges me every day to step into what I've come here prepared to be.

Ceremony finished, Geshe-la gestured to the freshly filled teacup in front of me and encouraged me to drink. Ruth passed the plate of biscuits, and we smiled and chatted together like three old friends. As the sun sank low, casting a rosy glow on the world, I offered my thanks as best I could and rose to leave. Outside the door, I slipped my feet back into my shoes and looked fondly at the mangy dogs. The air smelled especially sweet, and the thangka painters laughed as they played hacky sack in front of the library. I walked back to my room with a smile in my heart.

❈ *Piece 21* ❈

Norbulingka

A s part of my economic development work at the planning
council, I was invited to join a day-long tour of Tibetan art-
and-craft centers in the area. The Norbulingka Institute, half
an hour outside of Dharamsala, was newly established and still
under construction. This center for Tibetan cultural preservation
wouldn't be officially inaugurated until three years later. Wan-
dering through the construction rubble, though, one could just
as easily have mistaken it for a decaying ruin. Half-built masonry
walls appeared to be crumbling. Twisted iron rebar protruded
randomly from roofs and pillars. Broken rocks and bricks lay
heaped in piles around the site.

The institute was named after the Dalai Lama's traditional
summer residence in Lhasa—Norbulingka, the jewel park. It
was the brainchild of Kim Yeshi, the Franco-American wife of
Kalsang Yeshi, Minister of Religion and Culture in the Central
Tibetan Administration. A small Tibetan workforce would train
in traditional arts and produce top-quality handicrafts, modified
for high-end Western markets. This scheme would provide jobs
while helping to preserve Tibetan cultural heritage.

Japanese architects Maria and Kazuhiro Nakahara, who had been living in Dharamsala and studying Buddhism, were commissioned to design the complex. In laying out the site plan, they imagined the buildings as an expression of Chenrezig, divine embodiment of fully awakened wisdom and compassion. The Dalai Lama is considered a human expression of Chenrezig. Tibetans believe they live under Chenrezig's care. So why not make this Tibetan cultural center at the heart of the community a brick-and-mortar expression of that same deity and the same ideals? The temple would be his head, and the workshops and offices would radiate like his thousand arms around a pool of water that would be his heart.

The day I visited, women in colorful saris, appearing as if dressed for a festive occasion, carried bricks across the courtyard on their heads. With lengths of silk tucked up at their waists, they delivered their loads to a mason who stacked the bricks with a thick layer of mortar to build the next part of the complex. These migrant workers came from faraway states in the east and south of India. Women in Himachal Pradesh didn't wear saris except for the occasional wedding or holiday. Day to day, Himachali locals dressed in *salwar kameez*, a knee-length tunic over billowing pants, a long dupatta scarf across their shoulders. In this part of India, only the migrant women (manual laborers and itinerant beggars) wrapped themselves in saris—five meters of colorful fabric, over a short, fitted blouse and a long petticoat. This costume, along with their poise, made them appear elegant even while engaging in back-breaking labor.

Judging from the ramshackle appearance of the building site, you wouldn't have guessed that workshops were already functioning inside. But they were. So far that morning, my colleagues and I had visited carpet weavers, woodcarvers, sculptors, and painters. Above the door of this last room, a sign read Appliqué Arts. Below the English was a handwritten Tibetan word I'd never seen before: ཚེམ་ཁང་ (*tsemkhang*, sewing house).

Inside, a circle of young people sat cross-legged on thin cushions around a wide table with pieces of fabric in their hands. Light

streamed through large windows on three sides of the airy room. Glistening black-haired heads bowed over steady hands. From across the room, they seemed perfectly still as sunlight danced with dust particles in the air around them. On closer examination, their needle-wielding fingers moved industriously like voracious silkworms crunching mulberry leaves, transforming raw material into something new.

A Tibetan man in his thirties crouched in the far corner of the room, shuffling odd-shaped pieces of shiny fabric on a blanket he'd spread on the floor. Seeing our team of government staff and Western visitors enter, he rose to greet us, extended a hand and invited us to observe his progress assembling bits of brightly colored silk into fantastical creatures.

Their faces looked half-human, half-animal. They had wild eyes and flaming hair. Bold lines rimmed their features. Embroidered eyes shone with a fierce light. The fabric seemed to pulse with a life of its own. As the artist shifted the pieces, static shapes transfigured into living entities. Bits of cloth became beings of light.

I was dumbstruck by them. I didn't know their names, but I somehow knew that these vibrant beings were servants or messengers or protectors of the dharma, that is to say of wisdom, clarity, and freedom. Without words, these multicolored creatures of light carried the essence of the philosophy I was studying at the library in the mornings. They lived it. They arose from it. They radiated it. They broke through the illusion of separateness to wake me up momentarily to the interconnectedness and emptiness (which is also fullness) of all things. I was flabbergasted.

Step by step, choice by choice, I'd followed the threads of my curiosity and they'd led me here. At thirty-two, I was living in the foothills of the Himalayas, studying Buddhism and helping the Tibetan government-in-exile pursue economic development in the refugee community. And I was standing in this room today, crouching down now to look closer at a blanket on the floor.

These creatures and the shining fabric puzzle pieces that comprised them were imbued with the Buddha's teachings. As I looked at them, I became immersed in their perfection and

felt pieces of my own heart-mind shift into place too. Just as the vibrating sound of the sacred syllable *"om"* encapsulates every word of thousands of texts, these bits of fabric also contained the full meaning of those teachings.

Words are only one way of giving direction, just as a finger is only one way of pointing at the moon. Images are another—partly through their symbolism but more so in their essence. If one examines the images as symbols, and elucidates the symbology with words, one returns to the verbal, interpretive, conceptual channel. An alternative is to simply rest with the symbols, the images, the shapes and colors. There, one receives a different gift, a different form of communication that penetrates the heart and bypasses the conceptual mind. It's like being in the presence of a great master or an awakened one. Like love. Like drinking tea with friends and not talking about anything but connecting deeply, intimately.

I'm not generally a lightning-bolt-from-the-heavens type of person. I live very much in the tangible material world, feet firmly planted on the ground. Growth and realization for me is usually gradual, incremental, and accompanied by lots of questioning and doubt about whether I'm doing the right thing. Except this time.

This time, everything went quiet but the rush of blood in my ears. I'd never felt so aware and so focused. Light filled the room, illuminating only these puzzle-piece beings of silk.

"I'm in!" my heart cried.

"Yes! I accept," as if an invitation had been extended, though none had been spoken.

Did the rest of the economic development team hear me? Wait, were they leaving to tour the next workshop? *Hold up!* I think I mumbled a few words of admiration and tried to form a sentence asking the man in charge where or how I might learn to make these marvelous creatures myself. I did not receive a clear response, and the group was moving on—to the woodcarving workshop, perhaps, or carpet weaving. I had to catch up or I would be left behind, but . . .

I have no recollection of the rest of the tour. It was over for me. My course had been set; my heart was hijacked. I *needed* to

learn to make this wondrous art myself. I would learn to make fabric sing in this way, expounding the dharma with this kind of inspiring force. I would learn to turn colorful pieces of silk into a tangible, feel-able expression of awakening!

My usual uncertainty, my incessant weighing of pros and cons had no role in this decision. Something felt so completely right and sure. Once again, I knew what I had to do even while I had no idea how to do it.

Norbulingka felt very far removed from Dharamsala at that time—at least half an hour away from the library by taxi, an hour by public bus—more when you considered the walk to and from bus stands on either end. A daily taxi would have been way out of my budget even if it had seemed logistically feasible, which it did not. It just wasn't workable from where I was living and studying. And there was no indication that they'd accept a foreign student anyway.

I had to find a local teacher.

I started asking.

I was surprised by the blank looks that met my inquiry.

Most of my Tibetan friends, neighbors, and colleagues had no idea what I was talking about when I described the patchwork thangkas I'd seen. Even the first thangka painters I talked to were completely unaware of the exquisite form of Tibetan textile art I'd just discovered and fallen in love with. Apparently, it was rarer than I'd realized. When the Tibetans had fled into exile in 1959, many large appliqué thangkas were hidden or destroyed. And there'd never been many in the first place. Tibetans who had grown up in exile in India had neither seen nor heard of them.

*Norbulingka Institute for the Preservation of Tibetan Culture,
under construction the day I visited with an economic
development team and fell in love with Tibetan appliqué.*

*Sari-wrapped women share a moment of connection
as they work to build the Norbulingka Institute.*

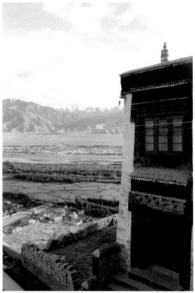

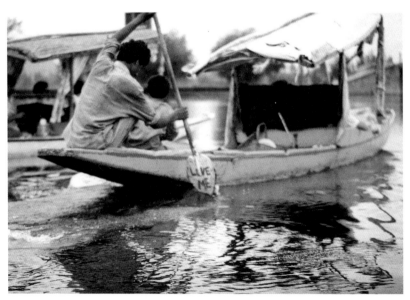

My first visit to India, trekking in Kashmir and Ladakh in 1988.

On the road to Dharamsala, 1992.

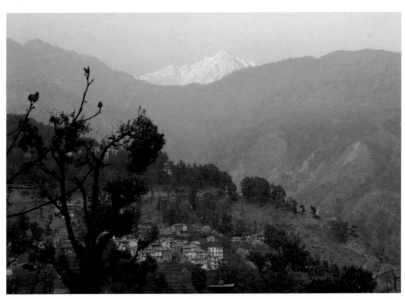

The Dhauladar mountain range—the foothills of the Himalayas in Dharamsala, India. One window of my room at the Tibetan Library faced this direction.

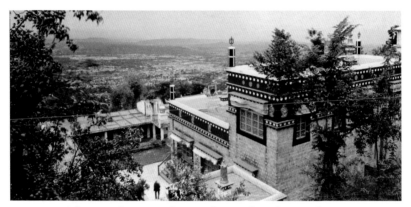

The view from my other window at the Tibetan Library,
looking over Nechung Monastery and the Kangra Valley.

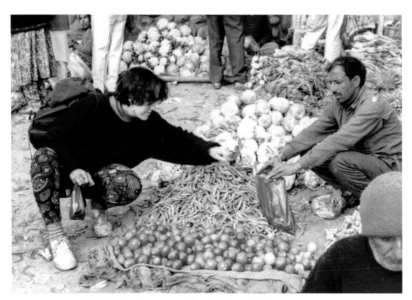

Buying vegetables in Kotwali Bazaar.

*The Tibetan community gathers along the road outside the
Gangchen Kyishong gate to welcome the Dalai Lama back to Dharamsala.*

Outside the Planning Council office, 1992.

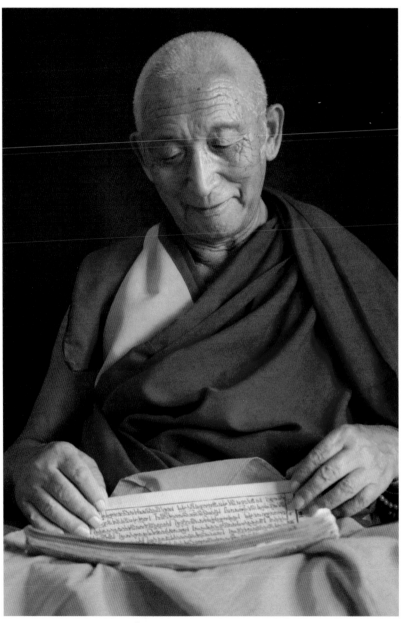

Geshe Sonam Rinchen, 1933–2013.

Library of Tibetan Works and Archives.
In the 1990s, dharma classes were held upstairs in this building.

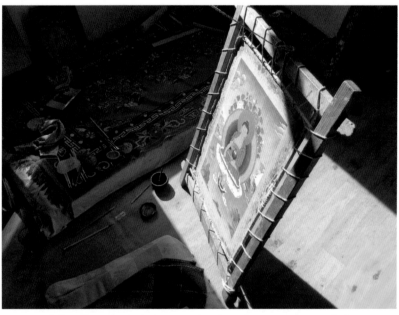

Thangka painting in progress. See how the canvas is stretched
on a wooden frame. Notice the "bed carpet" resting on a thin mattress and the
artist's brushes and other supplies arrayed on the floor and mattress.

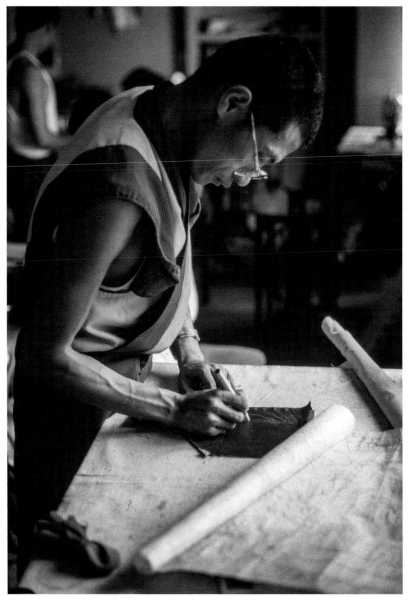

Dorjee Wangdu transfers a segment of the drawing to a piece of green satin. In the foreground, you can see a chalk bag he has used to dust over the perforated drawing onto the silk. Now, he's going over those chalk-powder lines with pen before handing the satin piece to an apprentice with instructions for wrapping the proper color and thickness of cord to be couched to the drawn lines. Photo © Diane Barker, all rights reserved. Used by permission.

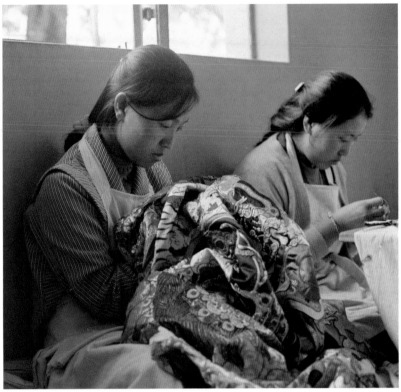

*An apprentice in the tsemkhang stitches along the lines of an
almost-finished appliqué thangka, adjoining pieces to one another.*

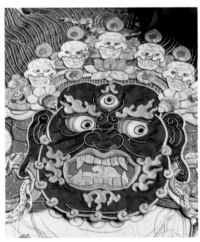

*Embroidery and fabric pieces
come together to build the wrathful
face of protector Mahakala.*

*The ubiquitous Chinese thermos
is extraordinarily effective at
keeping tea steaming hot all day.*

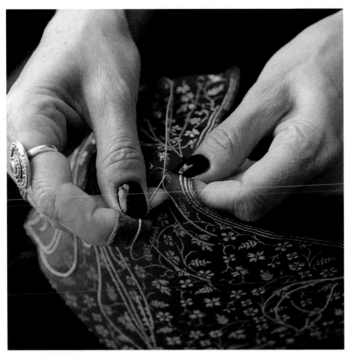

Stitching handmade silk-wrapped horsehair cord onto
silk brocade to define the outlines of Medicine Buddha's robes.
Photo © Rob Varela—USA TODAY NETWORK.

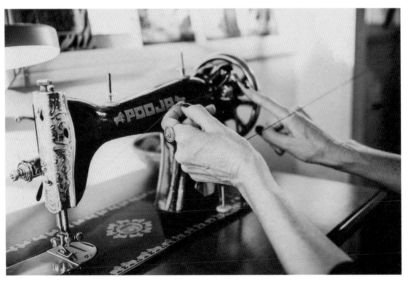

Using the bobbin winder of my Pooja sewing machine
to rotate horsehair and wrap it with silk.

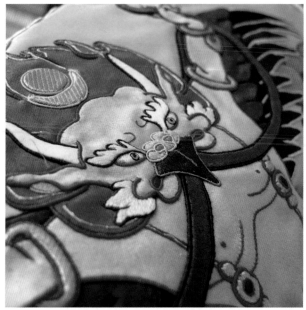

Detail of Garuda from my 1997 appliqué
thangka Buddha and the Six Supports.

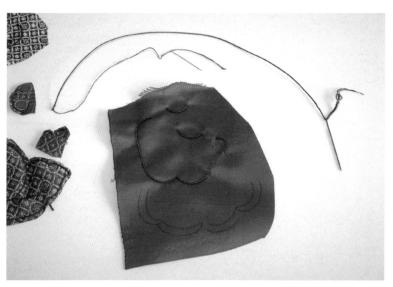

In this photo, you can see how the sewing thread is attached to the end of a silk-
wrapped horsehair cord. The large needle will bring the cord from the back to
the front of the fabric. The fine needle will carry the fine thread to fasten (couch)
the cord to the front of the fabric. The fastening loops will be nearly invisible
since the sewing thread is the same thread that wraps the cord.

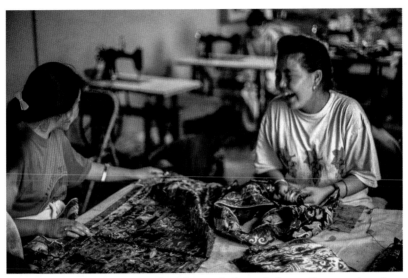

Two apprentices share a laugh as they make brocade frames for some thangka paintings. Photo © Diane Barker, all rights reserved. Used by permission.

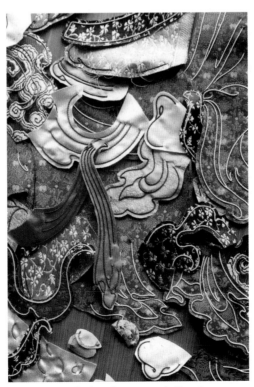

Couched and cut pieces before the edges have been turned under.

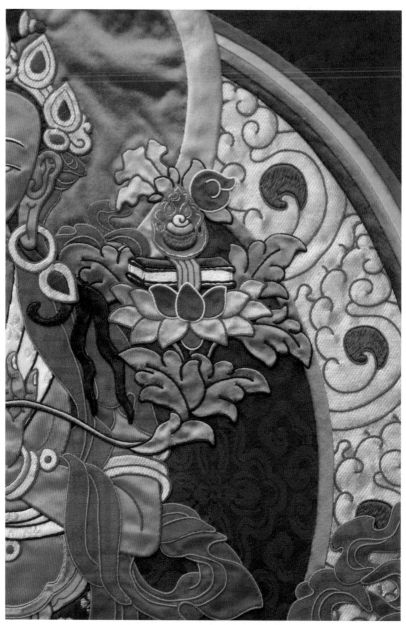

*Closeup of appliqué thangka. Note the layered
quality created by overlapping pieces.*

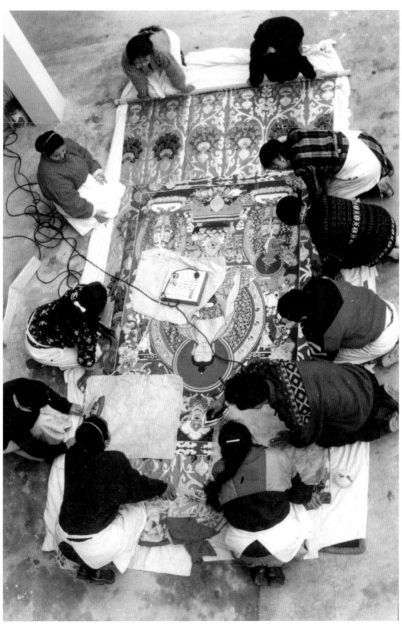

*Tsemkhang apprentices work together to hold
a completed appliqué thangka taut for ironing.*

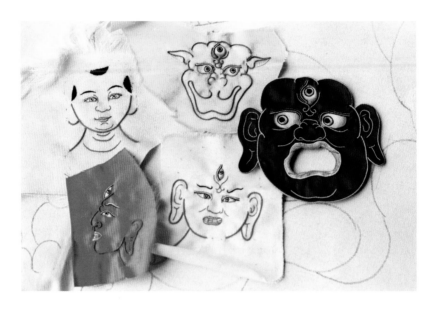

Some of the hundreds of faces I stitched in
the tsemkhang during the third year of my apprenticeship.

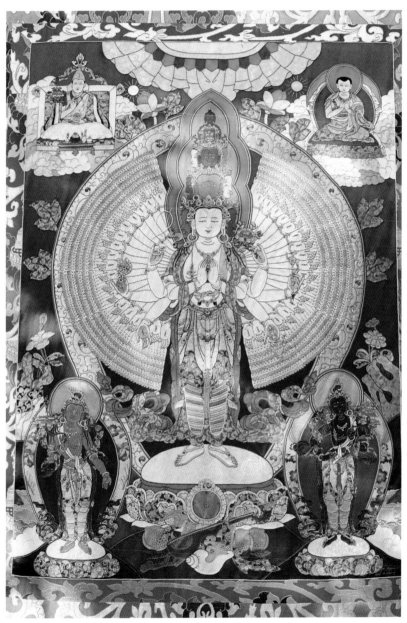

*Appliqué thangka of 1000-arm Chenrezig, embodiment
of compassion, made by Dorjee Wangdu and his apprentices.*

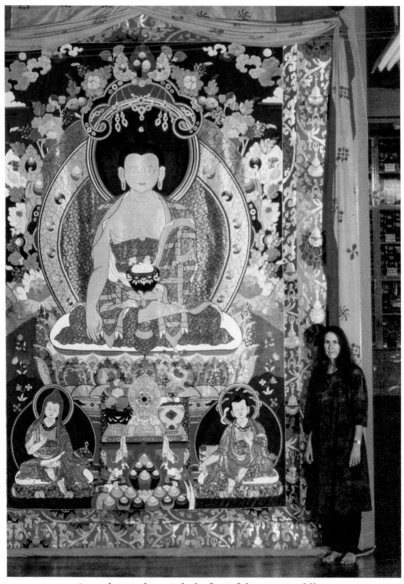

*I was honored to stitch the face of the great Buddhist
philosopher Nagarjuna in lower right corner of this thangka.*

Part Three: WARP

For us, painting and sculpture are the two finest forms of art but, for Tibetans, appliqué and embroidery are an even higher art.

—Glenn Mullin in *Creating Buddhas: The Making and Meaning of Fabric Thangkas*

❋ *Piece 22* ❋

Thangka? Tonka.

━━━

Before we venture further into the world of fabric thangkas, a word about pronunciation: anyone who was a kid or had a kid in the United States since the 1950s will be familiar with Tonka trucks. That's it. You've just pronounced *thangka*. Variously spelled as *tangka*, *thanka* or *tanka*, it's transliterated from the Tibetan ཐང་ཀ and pronounced "TAHN-kuh."

Some say the word *thangka* means "something that rolls up," but I haven't found any support for that translation in my amateur exploration of Tibetan etymology. Others have hypothesized that the word derives from *thang-yig*, which means "written record." This strikes me as more credible. In this view, a thangka could be considered a pictorial or graphic record. Regardless of the etymology, the word *thangka*, as used by contemporary Tibetans, identifies a rollable pictorial form of sacred art. These illustrated scrolls are Tibet's most plentiful and portable art form.

A thangka is a composite art object consisting of a flexible image panel mounted in a fabric frame with a built-in hanging-and-storage mechanism. The image panel of most thangkas is painted with mineral pigments on cotton canvas. Throughout the painting process, the canvas is stretched on a rigid wooden frame.

When finished, the artist cuts the painted canvas free from its rigid stretcher and takes it to a tailor for soft mounting in brocade.

The figures that grace thangkas are expressions of awakening, of fully realized human potential in honest relationship with the world as it is. They are personifications of teachings and practices in the Tibetan Buddhist tradition. Their multifarious forms highlight a vast range of awakened qualities: Avalokiteshvara embodies awakened compassion, Manjushri breathes awakened wisdom, Vajrapani radiates awakened power, and so forth. These divine figures are collectively referred to as *lha* in Tibetan, and generally called deities in English. While each form has a specialty based on vows they made when they were ordinary beings like us, each also encompasses the full spectrum of awakened potential. They don different guises to suit people's diverse temperaments, but every deity in the Buddhist pantheon exists to assist us in generating the wisdom and compassion required to become free from otherwise endless cycles of dissatisfaction and suffering.

In a misleading use of words, the figures are sometimes referred to as gods and goddesses. They are, in fact, buddhas, that is, awakened beings. As embodiments of our own true nature, their only purpose is to liberate us from ignorance and suffering.

Every detail of the buddhas' bodies, their garments, and the instruments they hold in their hands communicates a teaching. Jeff Watt, Director and Chief Curator of Himalayan Art Resources, describes the attributes of Tibetan Buddhist deities as mnemonic devices. Where there are four faces or four arms, they represent the four immeasurable qualities of loving kindness, compassion, joy, and equanimity. Pairs of hands symbolize the two truths of conventional and ultimate reality or the two essential qualities of wisdom and skillful means. Sets of twelve represent the twelve links of causation and dependent arising. Groups of three remind us of the three jewels of Buddha (the teacher), Dharma (the teaching), and Sangha (the community). All of the Buddha's teachings are condensed into potent visual cues. These teachings are absorbed into one's own being through familiarization, visualization, recitation, and meditation.

The Vajrayana or Tantric form of Buddhism practiced in Tibet uses imagination to harness emotional energies and achieve speedy liberation from the misconceptions that cause suffering. This mode of practice grew out of the Mahayana tradition in India in the fifth century and quickly spread to neighboring countries, most notably Tibet. Practitioners of Tantric or Vajrayana Buddhism deliberately cultivate their imaginations with images of enlightened beings, pure lands, flowing blessings, and generous offerings. In visualization, divine figures arise from emptiness like a rainbow and dissolve again into space. Although they may appear external to us, they always merge with us in the end. The point of all these practices is to move us from a muddled relationship with reality to a relationship based in awareness. Thangkas serve as models for the intangible yet infinitely impactful images you can conjure in your mind's eye to free yourself from distorted and limiting mindsets.

To ensure that these images reliably convey their intended meaning and evoke their intended freedom, artists follow scripturally prescribed proportional guidelines to draw the deities. Before drawing any sacred figure in the Tibetan tradition, an artist lays out the corresponding proportional framework and then sketches the image within it.

The standard unit of measure in these frameworks is a finger width—not the artist's finger, nor any universal ideal finger, but the finger of the image itself. Each segment of the deity's body is sized in proportion to that same deity's finger. A hand is five finger-widths wide. A forearm is twelve finger-widths long. An image of the Buddha Shakyamuni seated in upright meditation posture rises seventy finger-widths from seat to topknot. Whatever the size of the image, the height of a face from chin to hairline is twelve times the width of that same figure's finger. Measure your own face with your own fingers, and you'll find this proportion to be pretty realistic. This self-contained proportional system adapts to the production of enormous images, infinitesimal images, and every size in between. The multitudinous deities of the Tibetan Buddhist pantheon are divided into iconographic categories, each

with a somewhat different proportional scheme, each with the finger-width as its basic unit of measure.

The framework brings about consistency among buddha images, but that doesn't mean they all look the same. A thangka is not a copy. It is an original work of art created within a uniform framework. It is the outcome of a disciplined channeling of creativity.

You may have seen thangka paintings framed in brocade in museums, dharma centers, spiritual bookstores, yoga studios, homes, and restaurants. Perhaps, like me, you've been fascinated and inspired by their painted imagery.

The beauty I stumbled on in the sewing workshop at Norbulingka was something else entirely. Although the imagery was similar, the artists in that workshop were making thangkas in a little-known and virtually undocumented tradition. In these extraordinary thangkas, not only the frame but *the image itself* was constructed from fabric.

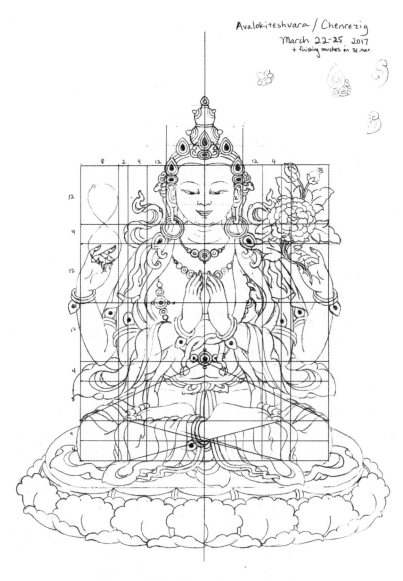

Avalokiteshvara / Chenrezig
March 22-25, 2017
+ finishing touches on 31 mar.

*Chenrezig, embodiment of compassion, drawn
within the bounds of a proportional grid.*

❧ *Piece 23* ❧

Emperors, Lamas, and Silk

Just as I brought biscuits and oranges to Geshe Sonam Rinchen, it is customary practice in Buddhism to make offerings to enlightened beings and spiritual masters in order to increase one's merit or positive potential and further one's progress toward enlightenment. Materials suitable for offering include precious metals such as gold and silver, precious and semi-precious stones, butter (a Tibetan favorite), fine food (especially the first bite), cool water, and lustrous silk. Truly, anything that one values can be offered.

Silk cloth has long been treasured across human cultures, particularly in Asia. So, it's not surprising that silk became an esteemed offering there and was used to create religious images of great material and spiritual value.

Although predated by thangka painting, fabric and textile techniques have been used for several hundred years to render images in rare and special thangkas. The earliest examples were Chinese embroideries and tapestries that reproduced imagery from Tibetan paintings in the thirteenth century. Within a couple hundred years, layered mosaics of silk appliqué were being created inside Tibet itself. No one knows for sure how this artistic evolution occurred, but my hypothesis goes something like this:

Over the centuries, power in Central and East Asia changed hands many times. Han Dynasties in China gave way to the Tangut empire in the eleventh and twelfth centuries. In the thirteenth and fourteenth centuries, the Mongols held sway over the whole region. And from the mid-seventeenth century until the early twentieth, the last imperial dynasty of China was Manchu. Regardless of which nation held temporal power over the region, their leaders often looked to Tibetan lamas for spiritual guidance.

Chinese silk played an important role in maintaining these relationships. Silk came into Tibet as imperial tribute and commercial trade from at least as early as the Tang Dynasty (618–907 CE). A Sino-Tibetan treaty from the year 760 records an annual tribute of fifty thousand "pieces" of silk from the Chinese emperor to the Tibetan court at Lhasa.[1]

Tibet's only indigenous weaving materials were wool and yak hair. Imported silk was significantly more precious. In fact, silk was used as a currency. The price of a horse, for example, is recorded as having been anywhere from twenty to forty bolts of silk, depending on the quality of the horse and the time period.[2]

In an article on patronage and religious practice in China and Tibet, Valrae Reynolds (former curator of Asian art at the Newark Museum and one of the very few people to have written about Tibetan appliqué) describes the flourishing of artistic activity in the eleventh to thirteenth centuries as religious teachers founded monasteries with the support of princely families during the Tangut period. From documents of this period, it emerges that "one of the popular ways to gain religious merit was to donate fine silk for the use of an esteemed teacher of a Buddhist monastery."[3] In this way—through offering, tribute, and commerce—silk satins, damasks, and brocades began to fill the treasuries of Tibet.

When the Mongols took over, consolidating control of China after 1279, they adopted many aspects of the destroyed Tangut court's relationship with Tibet—giving lamas great power over religious and cultural affairs and promoting artistic ventures that

incorporated Tibetan Buddhist themes and styles. The use of silk to create sacred art grew out of these fluctuating Tangut-Mongol-Tibetan-Chinese interconnections.

At some point in this story, textile copies of Tibetan Buddhist paintings began to be produced in China using Chinese techniques of embroidery, tapestry (*kesi*), and brocade. Reynolds notes that these silken images held "greater cachet than the paintings they were copied from . . . [They were] infinitely more prestigious than the painted 'originals.'"[4] So, the prestige of fabric images in Tibet began with imported Chinese textiles based on exported Tibetan paintings.

Art historian Michael Henss explains that these "pictorial embroideries, tapestries, and brocades fall in between established art historical domains in two ways: they cannot be classified as paintings, nor are they textiles in the usual sense; Chinese by technique and origin, but Tibetan by subject and composition, [they were] presented by the imperial court to Tibetan religious officials and visitors, to their monastic enclaves in China and monasteries in Tibet. . . ." Henss also writes that "From the historical background, the regular flow of Tibetan art to China and Chinese art to Tibet between the late thirteenth and the late fifteenth centuries seems still to be underestimated."[5]

By the fourteenth century, it seems the Tibetans were sufficiently inspired by the Chinese textile interpretations of their paintings to begin creating their own original textile masterpieces. To do so, they employed the indigenous patchwork and appliqué techniques they were already using to decorate the colorful tents and awnings that dotted their landscape at festivals and picnics. (Tibetans love their picnics, which can last for weeks!) Appliqué was also used to embellish ritual dance costumes, saddle blankets, and throne covers. In collaboration with Tibet's great thangka painters, Tibet's finest tailors were able to adapt these indigenous stitchery techniques to the more delicate and sacred imagery of thangkas. This was the art form that stopped me in my tracks when I entered that sewing workshop at the Norbulingka Institute one sunny day in 1992.

Textual records indicate that several giant appliqué thangkas were made in the early fifteenth century at Gyantse Monastery in Tibet.[6] And in 1468, the great thangka painter Menla Dhondup was commissioned by the first Dalai Lama to create a giant silk image of the historical Buddha, Shakyamuni, for display on the nine-story thangka wall of Tashilhunpo Monastery.

Production of silk thangkas increased in the sixteenth century and spread throughout the region in the seventeenth and eighteenth centuries. By then, silk appliqué thangkas were being produced not only in Tibet itself, but also in the neighboring Tibetan Buddhist countries of Mongolia, Bhutan, and Ladakh.

When the People's Republic of China took possession of Tibet in the mid-twentieth century, many of Tibet's magnificent fabric thangkas were destroyed, along with many monasteries, texts, and cultural assets. For a few decades, this art form became largely dormant as Tibetans reestablished themselves in exile, and religion was suppressed within Tibet. This explains why my Tibetan friends were unaware of it. In recent years, however, a thriving production has reemerged among the exile community in India and Nepal, and a few large appliqué thangkas have been made within Tibet itself, including the giant Tsurphu thangka project in Eastern Tibet, managed by Terris and Leslie Nguyen Temple.

The prestige of fabric thangkas that began with Chinese textiles based on Tibetan paintings continues today with the uniquely Tibetan pieced appliqué form. In the 2008 documentary *Creating Buddhas: The Making and Meaning of Fabric Thangkas*, Tibetologist Glenn Mullin remarks that while Western culture views painting and sculpture as the finest forms of art, Tibetans regard appliqué and embroidery even more highly. Valrae Reynolds concurs by saying, "It's kind of counterintuitive to the Western idea where painting and sculpture is high art, and something made out of textile is craft. But in the Tibetan sense, an appliquéd thangka is the most wonderful, highest thing that you can create."[7]

Notes

1. Valrae Reynolds, May 1995, "The Silk Road: From China to Tibet—and Back" in *Chinese and Central Asian Textiles: Selected articles from Orientations 1983-1997* (Orientations Magazine, 1998), 146.

2. Ibid., (May 1995), 146, and (April 1997), 188.

3. Ibid., (April 1997), 189.

4. Ibid., (May 1995), 147.

5. Michael Henss, November 1997, "The Woven Image: Tibeto-Chinese Textile Thangkas of the Yuan and Early Ming Dynasties" in *Chinese and Central Asian Textiles: Selected articles from Orientations 1983-1997*, (Orientations Magazine, 1998), 214.

6. Ibid., 214.

7. *Creating Buddhas: The Making and Meaning of Fabric Thangkas,* directed by Isadora Gabrielle Leidenfrost (2008; Soulful Media), DVD.

Part Four: WEFT

In order to work with a teacher, there needs to be a student. We often skip over this: It's easy to waste time going through the motions of entering the room for a face-to-face teaching, but to not really be a student—to just be someone who wants to debate, or to prove something. Often, a real spiritual meeting is not available even though the bows have been made. Yet once a student develops, it is inevitable that a teacher will appear in their life. They create each other.

—Bonnie Myotai Treace, "The Sword Disappears in the Water"

❋ *Piece 24* ❋

In Search of a Teacher

Three nights after I fell in love with fabric thangkas at Norbulingka, I sat across a desk from Migmar exchanging English and Tibetan conversation. In one language or the other—or in some ragged combination that memory has stitched into an elegant whole—I spoke of my yearning to learn to make thangkas out of silk. Migmar said he was familiar with the art form. That was a relief after all the blank expressions my enthusiasm had met in the past few days. Better yet, he knew someone who might be able to teach me.

"I have a friend," he said.

I have no idea whether he said it in English or Tibetan. I just know I understood.

"I have a friend who sews fabric thangkas. He comes from Lhasa like me. He's really good. And I think he wants to learn English."

Oh, this was exciting. Dare I hope?

"Maybe you could trade with him," Migmar went on. "Maybe he could join our language exchange. If you want, I can take you to meet him."

Later that week, Migmar escorted me to Tenzin Gyaltsen's room on the roof of Ghadong Monastery, a small nondescript building at the periphery of our Gangkyi neighborhood. I knew Ghadong as the site of a favorite café that served some of the best veg *momos* in town. I was only vaguely aware there was a monastery behind the restaurant.

Momo (a word which sounds to the non-Tibetan ear just like the word for grandmother) is the pinnacle of Tibetan cuisine. The steamed or fried dumplings, traditionally filled with meat, also come in potato and cabbage variations to satisfy Western vegetarians. Dipped in soy sauce, vinegar, or chili, they deliver a burst of delightful flavor. Add noodle soup, butter tea, and roasted barley and you've explored the entire breadth of the Tibetan culinary world. But I digress.

Ghadong Café was on the ground floor, at roadside. Behind the café sat the tiny monastery and home of Tenzin Gyaltsen's uncle, a modern well-dressed English-speaking layman in his forties who also happened to be the medium for an otherworldly oracle. The Ghadong Oracle was a state diviner less famous than the oft-consulted Nechung Oracle whose morning trances sometimes roused me from bed.

Migmar led me down a dark hallway past the cramped café kitchen and up the stairs. At the top, four rooms opened onto a wide rooftop patio with a stunning panoramic view over the Kangra Valley. Three of these rooms made up a small guesthouse for students and visitors. The fourth, at the far end of the roof, was Tenzin Gyaltsen's. As a teenager, Tenzin Gyaltsen left his birthplace in Lhasa, Tibet, and traveled to India where he was taken into his uncle's care and given this room.

Migmar pushed the curtain aside and tapped his knuckles lightly on the door. A deep voice answered from inside. "*Yar phe.*"

Migmar turned the handle slowly to open the door and poked his head through, confirming that it was okay to enter. He stepped in. I followed shyly, my head bowed as my eyes surveyed the room.

Twenty-five-year-old Tenzin Gyaltsen sat on a flat cushion behind a low, square table just inside the door. Arrayed on the

table were bits of satin, a spool of blue thread, an electric iron, blackened steel scissors, and some golden pieces of resin that I'd later find out were chunks of rabbit-skin glue. Two needles were carefully secured in a small scrap of muslin. Tenzin Gyaltsen worked alone, and his space had an air of orderly refinement.

The compact room was richly appointed compared to many in the neighborhood and was more formal than I had expected. As the nephew of an oracle, Tenzin Gyaltsen clearly had access to more resources than the other thangka artists I knew. Deep blue wool carpets covered two single beds with traditional endless-knot motifs. Plush blankets, green and brown, were neatly folded at the end of one bed. The furniture was dark stained wood. Heavy curtains hung at the sides of two large windows.

As Migmar and I entered, Tenzin Gyaltsen spoke over our shoulders to a monk who had followed us to the door without my noticing. "*Solja sum khyer shok.*"

The young monk scurried off only to return moments later with three wooden tea bowls and a Chinese thermos—red enamel adorned with blue-and-white peonies—full of steaming buttery tea.

Before bringing me to Tenzin Gyaltsen's room, Migmar had told him of my interest in learning to make silk thangkas. Apparently, Tenzin Gyaltsen had expressed a hesitant willingness to instruct me, enough willingness at least to allow us to visit that day. I would be his first student, and I got the feeling he wasn't eager to become a teacher. But I would come to know that he had a strong moral compulsion to serve when asked. And I could see he was tempted by the thrill of learning English.

As we drank our tea, he seemed to be weighing the pros and cons. Comfort would have said "no," but fascination was a strong contender. The desire to learn won the day for both of us. We negotiated an exchange and agreed on a schedule.

Tenzin Gyaltsen would join Migmar at my place for English lessons three evenings a week. And I would visit Tenzin's room three mornings a week for stitching instruction, squeezing the hours between dharma classes at the library and census design at the planning council. This new thangkas-for-English exchange

supplanted my previous Tibetan-for-English arrangement with Migmar. I would have to learn Tibetan language on the job now, while stitching.

My mother had taught me to sew when I was young. As a child, I'd made a few of my own dresses and skirts. A creativity-squelching home economics class in middle school combined with the easy availability of cheap clothes dissuaded me from continuing. Then, fascinated by texture and color, I'd taken up quilting in college. I made a sampler quilt and got halfway through an art quilt of my own design before the same herniated disc that derailed my career in architecture put a damper on my quilting passion as well. Aside from sewing curtains and hemming pants, it had been ten years since I'd last wielded a needle.

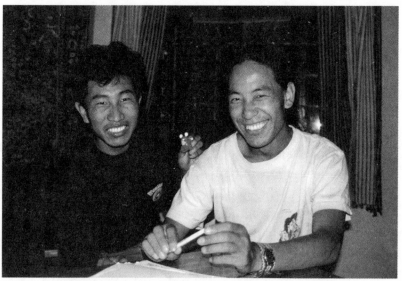

Tenzin Gyaltsen (left) and Migmar (right) having fun during English conversation class in my room at the Tibetan Library.

❖ Piece 25 ❖

My Teacher's Teacher

Around the same time that Tenzin Gyaltsen arrived in Dharamsala as a teenage refugee, the renowned tailor Gyeten Namgyal, a much older refugee, also arrived. Gyeten Namgyal had been the personal tailor to the Dalai Lama before the Chinese invaded Tibet.

When Gyeten Namgyal was just a boy in the 1920s, his father was secretary of the state tailors' guild, which had been established by the fifth Dalai Lama in the seventeenth century. Gyeten Namgyal grew up in the sewing workshop during the time of the thirteenth Dalai Lama, assisting his father and other tailors as they made robes, temple decorations, and giant appliqué thangkas. He showed promise from an early age, winning an embroidery competition against the most experienced stitchers before he was old enough to join the guild.

The thirteenth Dalai Lama (1876-1933) was deeply interested in fine arts. He had a meticulous eye and a keen sense of excellence. All kinds of artists and craftsman honed their skills under his close scrutiny. Tailors received special attention because the thirteenth loved to wear ornate ceremonial robes. The head of the tailoring guild, who served as the Dalai Lama's personal tailor,

was known as *Namsa Chenmo*, the great master of clothes. The position was granted top-craftsman status, second only to the Dalai Lama's personal scribe.

Gyeten Namgyal was appointed Namsa Chenmo in 1939, when he was twenty-seven years old. For the next twenty years, he led the most skilled members of the tailoring guild in creating giant silk thangkas that towered over ceremonies and blessed thousands. In the 1950s, while the Chinese Communist regime was invading and occupying Tibet, Gyeten Namgyal accompanied the fourteenth Dalai Lama to Beijing in an attempt to find a peaceful resolution.

When the fourteenth Dalai Lama finally escaped the Chinese occupation of his homeland and fled to India in 1959, Gyeten Namgyal did not make it out. He was captured and imprisoned. Although his high status and close relationship to the Dalai Lama put his survival at great risk, his sewing skills may have saved his life. He was put to work tailoring clothes for the occupiers.

In the 1980s, as an elderly man, Gyeten Namgyal finally escaped to India and was reunited with the fourteenth Dalai Lama. In Dharamsala, he enjoyed a return to thangka stitching and was able to transmit his skills before he died. Tenzin Gyaltsen arrived at just the right moment to become Gyeten Namgyal's star student, inheriting the lineage of thangka appliqué from its greatest living master.

❈ *Piece 26* ❈

Drawing, Horsehair, Silk, Meat . . . Recipe for an Appliqué Thangka

‒•‒

Tenzin Gyaltsen selected a simple flower drawing for my first project. He pulled a paper from a tattered folder and unfolded it on the table. Just a black-and-white line drawing now, I imagined how colored fabric would bring the design to life. Pink and orange petals would surround yellow centers with embroidered stamens. Narrow green leaves would arc from curving stems. And bits of flowing ribbon would tie it all together. Tenzin Gyaltsen sent me to buy some simple cotton broadcloth in the Dharamsala bazaar. I would have to prove myself before I'd be allowed to work with silk.

I worried about whether my ragged fingers would ever be worthy of silk. I had bitten my nails and picked at the skin around them since toddlerhood. After years of trying, I'd mostly given up any hope of overcoming this impulse disorder. As I pointed to parts of the drawing and asked questions, I took care to use my best finger and to hide the more damaged ones. I was already in the habit of hiding my fingers when I wrapped them around a teacup. Eventually, Tenzin Gyaltsen would have to watch my

hands closely in order to instruct and correct me, but I would delay that moment as long as possible. In addition to the embarrassment factor, I knew it was only a matter of time before a freshly picked cuticle bled on the silk. I would have to be very careful to ruin only my own fabric, never my teacher's.

Thangka painters like Alex and Migmar draw Buddhist deities, symbols, and scenes on the surface of a canvas. Drawing is the first stage of a thangka painter's training. They begin their studies by copying the Buddha's face from their teacher's example. Again and again, they receive the teacher's feedback and adjust their lines within the boundaries of proportional grids, gradually discerning more and more subtle detail and gradually training their hands to follow their mind's intention.

They learn to draw half-closed eyes with lids shaped like an archer's bow. Having mastered the face, they sketch the Buddha's unclothed body repeatedly until the teacher approves the curve of every shoulder, knee, finger and toe. Then they clothe the Buddha, learning to convey the drape of a robe with the line of a pencil. Gradually, over the course of two years, they draw a whole pantheon of sacred figures, developing their own elegant expression within a lineage of proportional schemes.

Only then do they begin to apply colors to their canvas. They fill the spaces between lines with colors made from ground minerals such as lapis lazuli, cinnabar, azurite, malachite, and carbon. Then, they redraw the contours in ink with a fine brush and a steady hand. They dissolve powdered gold into melted glue and apply it to the same canvas, then rub it with a stone to burnish the gold to a shine.

A student of appliqué, on the other hand, begins with color. Most fabric thangka artists rely on trained painters to make the drawings that guide them. In a fabric thangka, the drawing serves as a blueprint for building an image from pieces of brightly colored fabric. The drawing is a template for creating the pieces and a map for putting them together. Appliqué thangka artists trace segments

of their drawing onto separate pieces of satin and brocade. Then they outline, cut, and assemble those fabric pieces in accordance with the drawing.

In an appliqué thangka, there is no canvas for colors and lines to rest on. There is no ground. Rather than applying lines and colors to a canvas surface, an appliqué artist constructs the pieces that intermesh to form the appliqué thangka's surface. Each color is a separate piece of fabric. Each line is a thread-wrapped strand of horsehair or nylon.

Have you ever looked at a hair under a high-powered microscope? Any kind of hair—your own will do. If you have a microscope handy, go look now. Here's what you'll find: your hair is not smooth. It has scales along its surface. Different kinds of hair have different surface characteristics, but all of them have scaly cracks and crevices.

If you have any loosely spun silk thread handy, put that under the microscope too. Or just look at it closely in good light. Pull it apart with your fingers. You'll see that the thread is composed of ultra-thin fibers.

When you wrap that fibrous silk thread around a scaly hair from the tail of a horse, the thread's fibers get caught in the hair's scales. They cling, and the sheer strength of that clinging binds them. The thread remains securely wrapped around the hair. No adhesives are required.

Now, I have to admit it took me weeks of practice to wrap thread around hair. It was a mess the first time I tried it. Tenzin Gyaltsen was patient as I struggled to keep my thread from tangling and the horsehairs from breaking. He taught me how to turn the hair between my right thumb and forefinger while guiding the thread around it with my left thumbnail. My first coils of thread were either spaced out, like the stripes on a candy cane, or bunched on top of one another. Through weeks of diligent practice, my cords gradually smoothed. I gained skill in wrapping the thread tightly and evenly, so that each turn of silk lay neatly

beside the one before it. Once my hands had learned to collaborate with the materials, the thread began to cling to the hair naturally.

It frustrated me when the thread also clung to the ragged skin of my nail-bitten fingers. But at least my fidgety hands were being put to good use now, plucking nubs from handspun thread and discerning flaws in my wrap. My smoothly wrapped horsehair cords had just the right balance of stiffness and flexibility.

Tenzin Gyaltsen showed me how to stabilize fabric by rubbing the wrong side of the fabric with raw meat and melting its grease into the fibers with a hot iron. The meat fat gave the flimsy fabric just enough stability to hold its form as we stitched curving cords across its linear weave.

He introduced me to the Tibetan way of hand stitching, aiming the needle downward along a vertical path, rather than crosswise as Westerners usually do. I adapted quickly, almost as if I'd done it before. Each stitch made a loop that held my new horsehair cord to the surface of my meat-stabilized fabric. Loop after loop, stitch after stitch, I wedded cords to cloth along the lines of my drawing. Tenzin Gyaltsen showed me how to hold the cloth loosely in my left hand so as not to stress it while my right hand pushed the needle through.

Our time together was mostly quiet. At least that's how I remember it. Just the two of us sitting at that small square table, with very little shared language. Handicraft instruction is mostly visual anyway. Tenzin Gyaltsen showed me what to do, and I did my best to copy. I didn't ask many questions. I'd heard Tibetans express annoyance about the Western penchant for questioning. Not wanting to be that *inji*, I became acutely aware of my speech and judicious in my use of the few words we shared. *Inji*, a distortion of "English," was the word Tibetans used to refer to all people of European descent.

Although Tenzin Gyaltsen graciously gave me a cushion at his table, I wasn't sure if he wanted me there. He'd never set out to be a teacher and certainly never expected a strange American

woman to come seeking his instruction. He seemed unsure how to behave with me. And I was equally unsure how to behave with him. I'd never been in such close relationship with a teacher before, working one-on-one for hours on end, with no shared culture and only rudimentary verbal communication. It felt like the room was holding its breath while we worked. But I was so thrilled to be there, so intrigued with every stitch and every ingenious technique that I tolerated the discomfort.

And for several months, Tenzin Gyaltsen tolerated my curious presence. For that I'm grateful. He was and still is the best in his field, a fine artist and craftsman of the highest caliber. Each day that we sat together stitching, the threads of this precious tradition embroidered their marks in me.

❈ *Piece 27* ❈

Losing My Teacher

❖━━━━━━━━━━━━━━━━━━━━━━━━━━━━━━━━━❖

Months later, we stood at the threshold of my apartment. Tenzin Gyaltsen's tall frame filled the doorway, metaphorically blocking my access to the artistic tradition with which I'd fallen in love.

Our working relationship had become almost comfortable over the months. We'd developed a familiar rhythm. But in the past few weeks, Tenzin Gyaltsen had repeatedly canceled our appointments. He had been invited to work with a team of monks on a thangka project headed by a more senior appliqué master in another monastery. When first called away, Tenzin Gyaltsen thought he'd get back to regular work soon. At least that's what I thought he thought. But it gradually became clear that this special project would take him away from his own studio completely for a while, a long while, and my stitching sessions at his side were no longer possible. Unless, perhaps, I could join him on the monastery project . . . I sought an opening into that possibility.

"Can I come sit next to you while you work with the others? Can I watch? I won't be any trouble. I promise." (Our conversation was in Tibetan. Tenzin Gyaltsen never did learn much English.)

Tenzin Gyaltsen looked at me helplessly. He was shy. It would take guts to ask his new supervisor for special treatment. I think

he preferred to lie low, fit in, and fulfill his assigned role as expected. He was not one to rock the boat.

I too wanted to fit in, to be accepted in this culture that was not my own. I took care to show respect and to avoid coming off like a pushy Westerner. But I was also determined to learn this art well and to execute it beautifully, and I would sit with whomever I needed to sit with to do so.

"Please!"

"I'll ask." He finally relented. "I'll ask."

But I wasn't at all sure that he would. And I don't know if he ever did. Tenzin Gyaltsen, exceptionally handsome and a foot taller than most of his friends, was a conservative and respectful young man, who tended toward formality. He wouldn't do anything that could be perceived as improper.

A few days later the answer came back: "No."

I filled in unspoken words in my mind: "You, inji female . . . *You* are not welcome." I'll never know whether these identity considerations really played a role in the rejection. Or even whether the rejection came from the project supervisor. It's possible the rejection was Tenzin Gyaltsen's alone, perhaps stemming from his own insecurity and shyness to ask for something so unconventional. He was, after all, only twenty-five years old and working his first job.

"So, do I need to look for another teacher?" I asked, trying not to reveal the despair I felt. I had found what I was meant to do and was being cut off just as I was getting up to speed, chopped down before I'd had a chance to grow. It had been so hard to find a teacher. I seriously doubted I'd be able to find another.

"Do I need to look for another teacher?"

"Yes."

"Do you know anyone I can ask, anyone else who does this work?"

"No," he replied, "I don't know anyone who can teach you."

So that was that. I was back at square one—with a few horse-hair-outlined cotton flower petals clutched in my hand and desperate conviction in my heart. I felt compelled to spend more time with these silk buddhas. Somehow, I would find a way forward.

❋ *Piece 28* ❋

Like Being Adopted

◆━━━━━━━━━━━━━━━━━━━━━━━━━━━━━━━━━━━━◆

Once again, my path was cleared by a thangka painter. Bhuchung (whose name means small boy and who is, in fact, a man of small stature and kind nature) was the friend who had once lamented the greedy way some members of the community grasped for blessings when the Nechung Oracle was in trance. After Tenzin Gyaltsen dropped me, Bhuchung said he knew another appliqué thangka artist who might be able to help. This one was already a teacher. He had a workshop with apprentices—all Tibetan, of course, but maybe there was a chance he'd accept an inji. His workshop was in McLeod Ganj, right next to the main temple and just outside the Dalai Lama's residence.

Bhuchung had come from Lhasa to India at quite a young age and learned English well. He had a more fluid character than Tenzin Gyaltsen. He saw options. Armed with a traditional skill, he participated in a changing world. He was willing to introduce the inji to the master. We didn't talk much as we trudged up the hill to McLeod Ganj. We were used to hanging out in a group and hadn't spent much time alone together before this day. And I was nervous about the impending introduction, rehearsing Tibetan phrases of greeting and request in my head.

In my rucksack, carefully wrapped, I carried the leaves and flower petals I'd sewn under Tenzin Gyaltsen's tutelage. Their cotton broadcloth was rough in comparison to the shiny silk satin of real thangkas, but my stitches were good. Barely visible. The tender leaf and petal forms were delicately outlined with silk-wrapped horsehair cords I'd made under Tenzin Gyaltsen's watchful eye. It seemed I had a knack for it.

Dorjee Wangdu's Appliqué Arts Centre sat outside the main temple complex, just outside the Dalai Lama's residence. As Bhuchung pushed the door curtain aside and led me through the open doorway, the master looked up from his work. He was about my age, give or take a couple of years. My height, too. He stood at a high table in the center of a spacious room wearing the golden yellow vest Tibetan monks wear under their robes. A long, straight, maroon skirt was cinched at his waist. His long arms were bare.

A low table filled one end of the large room. Seven young women and one teenage boy sat on flat cushions around it, heads down, eyes focused on the fragments of fabric in their hands. Another young woman sat at a sewing machine, her feet operating a treadle that turned a wheel to make a needle go up and down. She stitched long strips of brocade. A toddler scuttled around her machine in a bouncer seat, legs pushing off the bare concrete floor. Sunlight streamed through windows that ran the length of two walls. Fluorescent tube lamps hung from the ceiling adding a cool flicker to the warm sunlight.

I greeted Dorjee Wangdu as politely as I could, using my limited honorific vocabulary. My hang-out-with-the-guys colloquial Tibetan was getting pretty good, but I never really mastered the honorifics. They weren't needed in my social group of young thangka painters and rowdy nomads.

I stood quietly by as Bhuchung described my situation and made my request. He explained that I had begun to learn the art of appliqué thangka and would like to continue, that I was in search of a teacher.

Dorjee Wangdu listened intently as Bhuchung spoke, glancing at me with a casual indifference that betrayed just a hint of

curiosity. I later learned he was reticent to engage with Western drop-ins to his workshop. Luckily, I was not an ordinary inji visitor. I was escorted by a respected junior colleague, and I spoke Tibetan, even if less politely than I should have. On top of that, when I pulled my humble cotton leaves and petals out of my rucksack, I stepped into a decidedly different category. I was not one of those tourists who wanted a traveler's overview or a quick takeaway education. I was serious.

Dorjee Wangdu asked a few questions of Bhuchung, and of me, while he examined my handiwork. We answered politely, smiled very little. The room was hushed, which I'd later learn was a stark exception to the lively melodious gossip and rhythmic music that usually filled the air.

One young woman pulled strands of thread from a strip of satin fabric pinned to the tablecloth, twisting the strands between her palms to make sewing thread. Another stitched a small cloud-shaped piece. These two leaned together and whispered to one another. They exchanged furtive glances and smiles as Bhuchung and I conversed with the master. From across the low table, a younger mischievous-looking girl tossed a crumpled piece of paper at them and gestured for them to shush. Another young woman with the telltale weathered face of a new arrival blushed. The rosy circles on her cheeks almost disappeared as the color in the rest of her face rose to match them.

I imagine this moment was as groundbreaking for them as it was for me. *Is this inji woman really going to sit here and work with us?!*

I told Dorjee Wangdu that I was taking classes at the library in the morning, Tibetan language and Buddhist philosophy. "I would like to come afterward, for the afternoon, every day, for as long as it takes. . . ."

I had decided by then to leave my position at the planning council. The census plan was ready, and there were no funds yet to implement it. I had exceeded my commitment. Besides, the job was my least favorite part of my life in India. I dragged myself to the office every day. Dharma and art were beckoning me, and I felt compelled to heed their call.

Would Dorjee Wangdu let me in? I didn't know if he'd ever accepted a foreigner before.

In the documentary *Creating Buddhas: The Making and Meaning of Fabric Thangkas*, Tibetologist Glenn Mullin says, "To join that art school was almost like being adopted . . . The teacher would give great consideration to whether the student was worth the effort."

"Mm," Dorjee Wangdu grunted affirmatively and nodded. "*Dik song.*" Okay.

It seems he thought I was worth the effort.

"We start our afternoon session after lunch, at one o'clock. Come tomorrow." And so I did, thus making the transition from enthusiast to apprentice, from economic development volunteer to full-time art student, following a strong, shimmering thread of curiosity.

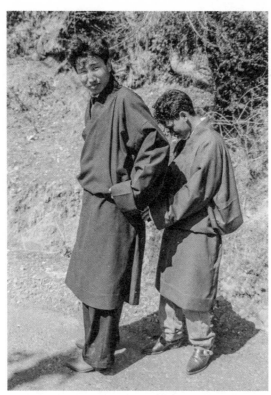

My first appliqué teacher, Tenzin Gyaltsen, and the thangka painter, Bhuchung, who introduced me to my apprentice master.

Part Five: PIECES

*The bad news is you're falling through the air, nothing
to hang on to, no parachute. The good news is there's
no ground.*

—widely attributed to Chögyam Trungpa

❖ *Piece 29* ❖

Step into the Tsemkhang

▸━━━━━━━━━━━━━━━━━━━━━━━━━━━━━━━━━━━━◂

I squeezed into my place at the low table that filled one end of the large workshop. Just fifteen inches off the floor, its surface was covered by a threadbare white tablecloth. Wool mats wrapped in blue cotton softened the floor on three sides. These meager cushions would make long hours of sitting on concrete tolerable. The space between walls and table was just wide enough for me to walk around on the mats and take my seat. Sunlight streamed in from windows that dominated two of the walls from waist height to ceiling. The third wall was inset with shallow shelves. A boom box sat on one shelf, beneath a photo of the Dalai Lama. Another shelf was strewn with ten or twelve cassette tapes and their boxes.

A dozen apprentices sat cross-legged, sock-footed or barefoot, around that vast table, each tending to a small piece of silk satin or brocade, individual contributions to a collaborative Buddha image.

At thirty-two, I was the oldest apprentice and the only inji. My American-bred, chair-spoiled legs could not remain crossed for long before numbness and tingling set in. To keep the blood flowing, I extended my legs and leaned back against the cool concrete wall as I stitched.

As a rule, Tibetans refuse to step over books and bodies because pointing one's feet toward either is considered disrespectful. Words and people are respected as teachers. So, when one of my fellow apprentices had to get up from the table—whether to retrieve materials, use the sewing machine, show Dorjee Wangdu her progress, or visit the loo—her cross-legged Tibetan colleagues effortlessly cleared a path for her. They would lean forward just slightly over their neatly crossed legs, allowing her to pass behind them. But what to do with the sprawling foreigner whose legs spanned the path between wall and table? Sometimes I managed to quickly recross my legs and scoot forward to make space at my back. Other times, I pulled my knees up and squished myself into the wall to make space for her to pass in front. I'd think the path was clear. Then, in a stunning act of propriety that made me cringe for my coarse Americanness, my colleague would reach down to lift a corner of my shawl, where it was piled on the floor next to me, and gently move it out of her way to avoid disrespecting even my clothing with her foot.

If they're this demonstrative in their respect for ordinary people, imagine the respect they show to thangkas, whose images are believed to be manifestations of enlightenment, alive with the energy of the buddhas they represent. Every piece of a buddha-to-be deserved the highest esteem. Reverence permeated Dorjee Wangdu's workshop, harmonizing with gossip and pop music.

Born in Lhasa in 1962, Dorjee Wangdu migrated to India while young and became a monk. Or he became a monk and migrated to India. I don't know which came first. In Dharamsala, at sixteen, he entered Namgyal Tantric College, the monastery responsible for assisting the Dalai Lama in his religious activities. There, he studied Buddhist philosophy and tantric rituals and began to reveal an inborn artistic talent. His older brother was among an elite team of artists who created mandalas with grains of colored sand to support tantric empowerment ceremonies. Dorjee Wangdu did not follow in those footsteps. Instead, he was drawn to fabric. It's not clear where he learned the art of piecing

silk; people speculate it was in a past life. Although he spent some time assisting other appliqué artists, he did not study formally with a teacher. He made his first appliqué thangka in 1978, and his talent was immediately recognized by His Holiness the Dalai Lama who encouraged him to cultivate his innate skill.

A natural collaborator, Dorjee Wangdu grew easily into the role of teacher and team leader, training and coordinating groups of stitcher-students to create masterful textile artworks for Tibetan monasteries throughout India and Nepal and for dharma centers around the globe. A few years before I met him, he had established his *tsemkhang*, the Appliqué Arts Centre, just outside the gates of Namgyal Monastery. Tsemkhang is one of those wonderful Tibetan words composed of bits of meaning. *Tsem* means to sew and *khang* means house, so a tsemkhang is a sewing house or stitchery workshop.

In the tsemkhang, I joined ten young women and one boy who assisted Dorjee Wangdu in fulfilling commissions while learning essential stitchery skills. They were all Tibetan but, in every other way, their origins were diverse.

Dechen had grown up in one of the large Tibetan settlements in south India. Dekyi had decided she wasn't cut out for academics and had dropped out of TCV, a boarding school for Tibetan children located above McLeod Ganj. Yangchen came from Lhasa. Chimey was a nomad from western Tibet who had a lot to learn about settled life. The other girls teased her gently to teach her the custom of daily bathing. Lekshey, also from Lhasa, was the only married apprentice. Her husband was a thangka painter, and their toddler wandered the tsemkhang as we worked. Khandro had been there the longest. Her preteen nephew Tashi was the only boy working in the tsemkhang when I began my apprenticeship. The actual names of my co-apprentices have been shuffled and changed, but not the array of their backgrounds. I was delighted to work among them. I hardly knew what they were talking about, but I loved their warm energy and their easy laughter.

We received on-the-job training in a traditional apprenticeship model. The Tibetans were compensated with room and board,

plus a small stipend for their work. They lived together as family in residential quarters that adjoined the workshop. As a Western woman in her thirties, I was used to having my own space. I "needed" privacy. And I had the luxury of choice. The money I'd saved to travel for a year, which would have barely covered four months' basic living expenses in the US, lasted three years in India, even with yearly trips back home to visit family. I could work a Christmas season at the mall in Los Angeles and earn enough to pay my rent in Dharamsala for a year. So, I accepted neither a room nor the stipend. I simply exchanged my labor for learning and meals. An even trade. And one for which I'm deeply grateful.

Dorjee Wangdu insisted I take two meals every day: lunch before starting work at midday and dinner before running back home in a race against dusk. No matter how swiftly dark was descending, he never let me leave without eating. Over the years, this made me quick and agile at running the rocky paths downhill, determined as I was to make it back to my room at the library before the last light fell. I've never felt safe walking empty roads alone at night anywhere, and Dharamsala was no exception.

Machen-la, the cook, ran the kitchen and prepared tea twice a day. He knew I preferred not to eat meat, and he did his best to accommodate my preference. On momo day, he always made a vegetarian version just for me. Regular meals alternated between chow mein (fried noodles) and *thukpa* (noodles in soup), both made with mutton. Machen-la fished noodles and vegetables out of an enormous stockpot, dodging mutton chunks with his ladle, to serve me a steaming hot bowlful without any obvious meat. He kept his opinion to himself when I discreetly fed whatever chunks might land in my bowl to the tsemkhang dog, Tsundue. It was a game of compromise anyway, since the soup stock itself was made from the meat. We each found our happy place in the game, aware of each other's good intention and knowing that it's impossible to live an earthly life without inflicting any harm. Still, we try, each in our own way.

Everyone at the tsemkhang called Dorjee Wangdu "Gen-la," an honorific that means "teacher." Sometimes, the title is used

to address one's elders, in recognition of the knowledge that any individual older than oneself can offer wisdom from their experience. Although slightly younger than me, Dorjee Wangdu held deep knowledge of a world I wanted to access. Our relationship was more formal than personal. He was my teacher, I his student. I wouldn't think of addressing him by his given name. Looking back, it surprises me how natural it felt to address Gen-la in this way. I was raised with little formality and had attended a university where students called professors by their first names. In the US, I still feel awkward every time I call my dentist or the veterinarian, "Doctor so-and-so," rather than using their first name. Titles are not really part of my heritage. In general, Tibetan culture felt similarly informal. Where any formality might be expected, my missteps were chalked up to my foreignness and easily forgiven. But this title of Gen-la felt like an affirmation. Saying it brought me into lineage, into alignment with my deepest intentions. Like prostrating before receiving dharma teachings, calling Dorjee Wangdu "Gen-la" reminded me of the preciousness of the teacher–student relationship and the rarity of the transmission I had somehow become lucky enough to receive.

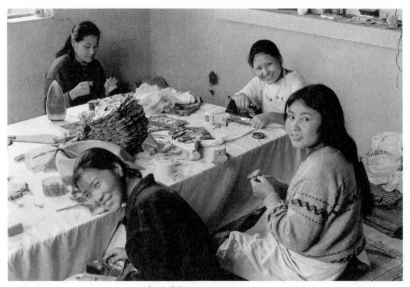

Some of my fellow apprentices at work.

❈ Piece 30 ❈

Wrapping, Turning, Making the Silk Dance

●━

"Rinchen!" Gen-la summoned me to his tall table at the center of the tsemkhang. He spoke firmly but quietly, counting on his apprentices to be alert to his call even as we stitched and chatted and listened to music. Gen-la always called me by my Tibetan name.

I rose from the cushion and found my way out from my place around the big table, carefully avoiding stepping over my colleagues along the way.

"Seventy. Two. Dark red." He handed me a postcard-size piece of yellow silk satin on which he'd traced the lines he wanted me to construct, squiggles that corresponded to the lining of a robe draped over the Buddha's knee.

Where Tenzin Gyaltsen used horsehair, Dorjee Wangdu used nylon fishing line to define the contours of his thangkas. Without wasting words, he specified the diameter of the fishing line I should place at the cord's core (seventy = .70mm), as well as the number (two strands) and color (dark red) of threads I should wrap around it to create the perfect line for this bit of robe, one

of hundreds of puzzle pieces that would come together to form a large thangka commissioned by a monastery in South India.

The drawing had been made by an expert thangka painter, commissioned specially for the project. One of my co-apprentices had pricked holes along all of its lines with a needle, creating a perforated stencil which Gen-la dusted with chalk powder to transfer segments of the drawing to specially selected pieces of stabilized silk.

After reinforcing the resulting chalk lines with pen, permanently marking each silk piece with its respective portion of the sacred drawing, Gen-la would summon one of us apprentices and give us our assignment: "Seventy. Two. Dark red," he said.

I took the roll of .70mm fishing line from its peg on the wall, fished two spools of maroon thread from a box in the corner of the room, and sat down at one of the tsemkhang's four treadle-powered sewing machines.

To a Western eye, these machines looked old, reminiscent of the antique Singers our grandmothers used to use. Maybe you still keep one in the living room for decoration. Maybe you picked one up at a flea market. It doesn't work, but that doesn't matter. You have no intention of using it. By contrast, the treadle-operated sewing machines in the tsemkhang were new and in good working condition. Rather than Singer, they bore names like Pooja and Usha.

I had no idea how to use this machine. It was nothing like the electric sewing machine I'd grown up with or the cheap one I'd bought in college during my quilting phase. Threading the machines was similar to what I remembered, though I would have needed a refresher to follow the thread's path. Fortunately, that wasn't necessary since I wasn't going to sew anything with this machine.

My Tibetan co-apprentices actually used the treadle machines for sewing. They framed paintings in brocade and made robes and ritual apparel for monks. My own training, on the other hand, was focused exclusively on making thangkas, and that sewing was all done by hand. I would only employ the sewing machine

as a mechanical assistant for wrapping cords. The foot-powered bobbin winder would spare my right hand the fatigue of manually turning the nylon core.

A short, blunt spindle extended horizontally from a rubber-rimmed wheel the size of a coin on the front of the sewing machine. Sitting before it, I gathered the ends of two silk threads and lined them up with one end of the fishing line. I tied a knot to hold all the strands together following instructions my colleague Khandro had given me the day before. I inserted this knotted end through the center of an empty bobbin and pushed it onto the little spindle, wedging the short ends of silk and nylon between spindle and bobbin, leaving the long ends of the strands free.

I tied a bobbin case to the free end of the meter-long fishing line. This case acted as a weight to prevent the spinning nylon from flying up and tangling itself in the thread. The free ends of the silk threads were weighted by their spools. I placed the spools in a small cardboard box on the floor next to the machine to keep them from rolling across the room when the thread began to pull.

I moistened my fingertips with some kind of tacky glue and smeared it along the length of the nylon. Unlike horsehair, slick nylon offers the silk fibers nothing to cling to. They need adhesive in order to hang on.

I pushed the sewing machine's flywheel with my right hand, setting it in motion. To keep that wheel turning, I began to undulate the pedal with my feet. It's quite a trick to get and keep the flywheel turning in the desired direction. For cord wrapping, I needed the wheel to turn away from me, in the opposite direction to that normally used for sewing. Khandro had patiently demonstrated and coached me through multiple attempts. Each time I pushed the wheel away from me, it would turn back toward me as soon as my feet pushed the treadle. I was afraid I'd be thrown out of the tsemkhang for being unable to make the wheel turn the right way.

You have to transfer movement up from your feet through a leather strap to the flywheel at precisely the moment when your hand is telling the flywheel which direction to go. If you get the

timing right, the whole mechanism moves in harmony. If not, well . . . you try again . . . and again. When you finally master the timing, it's like riding a bicycle or getting sound to come out of a flute. After a hundred attempts, the same actions you thought you'd been making all along suddenly and inexplicably work.

Just as I was ready to quit that treadle sewing machine in exasperation, my feet, my hands, and the machine seemed to reach a karmic accord. The flywheel surprised me by turning in the right direction. From that point on, it worked (almost) every time.

With the flywheel steadily spinning, I pressed my right index finger on a tiny lever to bring the little rubber-rimmed wheel at the base of the spindle into contact with the turning flywheel. Magically, the spindle began to rotate toward me, turning the nylon fishing line in the same way Tenzin Gyaltsen had taught me to manually rotate strands of horsehair. My left hand had already been well trained in guiding the thread around the turning hair. It just needed to adapt to the higher speed at which the treadle-powered bobbin winder was causing the nylon cord to turn.

How wonderful to be able to wrap cords—longer cords and more of them—without tiring the muscles of my right hand. I pinched the silk thread between my left thumbnail and index finger to guide the thread around the sticky nylon, coating it in color. As thread was pulled onto the spinning cord, the spools bounced and jumped in their cardboard box on the floor.

I paused the spinning from time to time to remove a nub from the thread or to free a tangle. Unfortunately, I have only two hands. A few extras would have served well. Starting and stopping. Untangling and rearranging. Wrapping and turning. My feet kept the rhythm constant, while my right finger pressed and released, pressed and released the lever that engaged the machine to rotate the cord and make the silk dance around it.

❖ *Piece 31* ❖

Teatime

❖━━━━━━━━━━━━━━━━━━━━━━━━━━━━━━━━━━━━━━━❖

Our tsemkhang was nestled into a hillside, right up against Namgyal Monastery at the entrance to the Tsuglagkhang Temple complex and just outside the Dalai Lama's private residence. This was the hub of Buddhist activity in McLeod Ganj, the Tibetan quarter of upper Dharamsala. Every day monks debated, and practitioners circumambulated the temples counting mantras. Several hearty folks laid out mats, donned knee pads, and strapped paddles on their hands to do full-body prostrations on the concrete terrace that surrounded the temple. Some were old, slow, and patient. Others young and quick. Here and there was a Westerner, too. All had committed to repeat this purifying (and physically demanding) gesture a hundred thousand times as part of their *ngondro* (preliminary practices) before engaging in practices of the highest yoga tantra.

Inside the tsemkhang, our practice was stitching. This practice in no way precluded gossiping and singing along with whatever music emanated from the boom box below the Dalai Lama's photo. That box was rarely silent, and it had eclectic taste. I was always surprised by the sound that poured out of it when Dechen or Dekyi pushed the play button. It might be a lilting Tibetan folk song of

love and mountaintops, the bouncy melodrama of a Bollywood show tune, or the pop-rock dance rhythms of Michael Jackson or Madonna. As my workmates chatted and sang, I remained relatively quiet, focused on my stitching. I smiled inwardly as my young Tibetan colleagues sang along with Michael Jackson's "Billie Jean" or Madonna's "Like a Virgin," mouthing sexy lyrics in a language whose meaning was obscure to them.

A few times a month, there were elaborate offering ceremonies in the temple. On these days, the boom box would give way to a raucous symphony of bells, cymbals, horns, and drums that punctuated the monks' liturgy. Although we couldn't see the ceremony from our cushions in the tsemkhang, its vibrations penetrated our walls and resonated with the pieces of Buddha in our hands. After the ceremony, Gen-la's brother or another friendly monk brought us bits of *torma*—towers of roasted barley flour mixed with butter and sugar. During the ceremony, these barley cakes were offered to ethereal beings. Luckily for us, ethereal enjoyment did not deplete the material bounty of the tasty offerings. They made a delicious accompaniment to afternoon tea.

At a certain point every afternoon, like clockwork, Yangchen disappeared from the tsemkhang, only to return five minutes later with two thermoses of steaming hot tea. For Tibetans, a day isn't complete without multiple cups of tea. Machen-la always prepared two pots of warm goodness—an Indian-style sweet and milky tea and a Tibetan-style salty butter tea. Both were delicious and provided the stitching team with much needed midafternoon refreshment.

Po ja chö? Ja ngarmo chö? Yangchen would ask with exaggerated politeness, sucking her breath between words as only Lhasans do. Would you prefer Tibetan tea or sweet tea?

I usually chose the buttery Tibetan tea.

Yangchen supported her right elbow with her left hand in perfect form as she poured the steamy nectar into my cup. Feeling the first warm sip trickle down my throat to my belly, I imagined a stream of blessings filling my body.

❖ *Piece 32* ❖

Hanging Out
with Buddhas

❖❖❖❖❖❖❖❖❖❖❖❖❖❖❖❖❖❖❖❖❖❖❖❖❖❖❖❖❖❖❖❖❖❖❖❖❖

"Is it true that Western people don't believe in ghosts?" Dekyi asked between stitches one day. It seemed she'd been pondering this conundrum for some time.

"Hmm. . . ." I wanted to give her earnest question its due. I took care not to substitute my own opinion for that of all Westerners. Some Westerners believe in ghosts, some don't, I thought, and people can mean very different things when they say they do or don't believe in something like ghosts. Generally, though, our Western culture has positioned science in the space previously occupied by mysticism and religion—even to the point of making science into a religion itself. And science is not very big on ghosts. So, no. While there are a variety of viewpoints, I'd have to say, and I did say, "Most Western people probably don't believe in ghosts."

My reply evoked Dekyi's deeper question, the one that had been keeping her up at night:

"If they don't believe in ghosts," she said, "then what do they say when they see them?"

What *do* we say when we meet phenomena we don't believe in? Can we see them at all?

We see what we habituate to. We see what we have a frame-work for. We see what our beliefs allow. These beliefs are acquired and reinforced by the culture we live in and the company we keep.

There's a popular trope that says we're each an average of the five people we spend the most time with. Business philosopher Jim Rohn popularized the idea, which has been applied to scales of optimism, health, politics, and income. It's a shorthand way of expressing the powerful yet often unrecognized influence that our environment and companions have on our beliefs, our outlook, and our results.

We can dispute the specifics and the inevitability of the five-people claim, but there's no doubt we're influenced by our environment and by the thoughts, words, and attitudes that fill it. So, what if the five people I spend the most time with are buddhas? That's some powerful positive influence!

In the tsemkhang, I was privileged to spend countless hours with Tara, Avalokiteshvara, Manjushri, and other masters of compassion, wisdom, and awareness. Making a thangka is like sharing quiet time with enlightened beings and sages, people who have recognized the true nature of things, people who act out of pure compassion, people who have overcome all negative motivations and reactions. It's like hanging out with the best of my human potential and with the possibility and promise of awakening. We sit together, pass time, and share tea. As I stitch, I become steeped in their fragrance, tinged with their colors. I feel the presence of enlightenment touching me in places words don't reach.

In *Female Buddhas: Women of Enlightenment in Tibetan Mystical Art*, Tibetologist Glenn Mullin writes, "Not only is the simplest of symbols worth more than a thousand words, it transmits experience on a level that words cannot even touch. The Buddhist Tantric tradition took this basic principle to its limit, and through its tantric art developed a complete language for communicating spiritual meaning. Volumes could be written on the symbolism found in even a small Tantric painting. Mystical code is omnipresent and drips from every brushstroke."

Not only from every brushstroke, I would add, but also from every stitch.

I was no expert in iconography. I didn't know what every feature of the sacred images represented (and I still don't). But I felt awash in an enormity of meaning as I sat at the table with Chimey, Dechen, Dekyi, and the others, co-creating buddha images. The imagery communicated without an interpreter, and we participated in the conversation, seeing "ghosts" of possibility that would have otherwise been invisible to us.

The Tibetan word for meditation, *gom*, literally means to familiarize or habituate. In some meditation practices, we sit with a specific heart-opening quality or inquiry, allowing it to permeate our mind-stream and allowing ourselves to become familiar, even intimate, with it.

Thangka-making acts like this too. Not only does the work arouse focused attention, it also engages the artist in a nonconceptual relationship with enlightenment, compassion, and wisdom, while placing attention on just this stitch. In class, Geshe Sonam Rinchen used Buddhist philosophy to open windows of freedom in my conceptual mind. In the tsemkhang, the deities infused nonconceptual understanding in my heart, in my fingertips, and in my bones. Rather than memorizing lists of symbols and meanings, stitching invited me to hang out with the best of myself. On some unspoken, unanalyzed level, I knew that these figures embodied the most potent and potential-rich aspects of my own being. I hoped that a little bit of their goodness would rub off on me.

❋ *Piece 33* ❋

Back to the Drawing

●━━━━━━━━━━━━━━━━━━━━━━━━━━━━━━━━━━━━━◀

G en-la stood at his high table at the center of the tsemkhang, studying the drawing. He glanced back and forth between the drawing and the piles of fabric arrayed about his table: shiny silk satin in a multitude of hues, brocade woven with golden swirls of clouds and flowers. Selecting just the right combination of color and pattern, he traced discrete segments of the master drawing onto bits of fabric.

In building landscapes and figures out of fabric, we weren't attempting to replicate paint and brush with cords and thread. Just as painting is not a substitute for sculpture, appliqué is not a substitute for painting. It is its own unique expression. Yes, we were portraying the same subjects, the same embodiments of our human potential. But we were doing it in our own language, a textile language. Boldness is a strength of this language, and three-dimensional relief is a distinguishing characteristic. Fabric, thread, and horsehair (or nylon) present opportunities to produce textural effects unavailable in a painting.

These materials also have limits that determine how tightly they can be folded and pinched. In a painting, fine details can be rendered with the most delicate of paintbrushes, some composed

153

of just a few hairs. Attempting to render the same level of fine detail in appliqué would mean struggling against inherent qualities of the materials and overlooking their gifts. I explained earlier that the drawings for appliqué thangkas are often produced by thangka painters. Although the subjects are the same, the ideal drawing for a fabric thangka is simpler and bolder than the ideal drawing for a painting. Dorjee Wangdu commissioned drawings from painters who understood this distinction.

To transform a line drawing into an appliqué thangka, we needed to break the design up into little pieces and then put all those pieces back together again. In the process, we'd bring the deity to life with layers of color, pattern, and texture.

Traditionally, drawing transfer was done with chalk powder and a perforated template. Nowadays, there are pattern-transfer papers (also known as dressmaker's carbon paper) that can save time and increase accuracy in copying lines from paper to fabric. But we didn't know that then, so one of my colleagues had spent hours poking needle holes along each and every line of the drawing to turn it into a stencil.

Gen-la positioned a carefully selected piece of fabric under the corresponding segment of the perforated drawing. He took care to align the grain of the fabric with the vertical axis of the figure so that all the fabric would be oriented in the same direction in the finished thangka. This would ensure that pieces of the same color actually appeared to be the same color. If pieces are oriented in haphazard directions, the light hits their fibers in different ways, giving pieces of the same fabric an inconsistent appearance.

"Rinchen, Dechen, *dey shok!*" Gen-la called Dechen and me over from our low table at the end of the room to his high one in the center. He handed each of us a few pieces of fabric with the squiggles he'd just drawn. I got some fluffy clouds in light pink and white satin. Dechen, who'd started her apprenticeship six months before me, received thick pieces of glittering brocade, which would become part of Buddha's robe. Gen-la assigned the pieces according to each student's capability and stage of learning. He told us which gauge of fishing line to take from the wall and

how many strands of thread to wrap around it. We each took our assigned materials to a sewing machine, wrapped our cords, then returned to sit on the cushions around the low table.

I pointed across the tabletop to a strip of satin the same color as my cord. It was just out of my reach. Chimey tossed it over to me. Securing one end of the satin strip to the tablecloth with a needle, I pulled six strands of thread from it and twisted them in my hands to make sewing thread. Three twists to the right, with the strands separated into two groups, then one twist to the left with all the strands united. The twists gave strength to the unified strands. To the beat of Bollywood and between giggles and sighs, we used our hand-twisted thread to stitch our hand-wrapped cords along the lines Gen-la had traced for us. Each playing our part, we created a unique interlocking piece of the puzzle of awakening.

One of my first tasks at the tsemkhang had been to make my own thimble from a scrap of soft shoe leather. This pliable shield on the forefinger of my stitching hand protected my fingertip from the needle's point while retaining the dexterity required to grasp and pull.

Westerners tend to stitch in a horizontal orientation, from right to left or vice-versa. Tibetans stitch vertically, in a line that points toward their body. This Tibetan style allows the wrists to remain neutral and relaxed. A thimble-wrapped forefinger pushes the needle through the fabric. Thumb and middle finger catch and pull the needle to complete the stitch and get ready for the next. With each stitch, the needle is plunged through the fabric on one side of the cord and brought back up on the opposite side. Pulled along this coiling path by the fluid motion of the needle, the thread forms loops that lash the colored cord to the fabric. Because the thread is the same color as the cord, the stitches that secure it to the fabric become nearly invisible.

After I'd stitched cording along the outlines and contours of my assigned clouds, I rose once again from the low table, navigated the padded obstacle course without pointing a foot at anyone, and reported to Gen-la with my completed work. I expected him to

reject it. There were so many errors and imperfections. If I'd been my teacher, *I* would have sent me back to fix them all. But Gen-la rarely did. He simply took each completed piece from my hand, studied it briefly, and nodded. Then, he gave me my next assignment.

Something in me was disappointed by this. I wanted his standards to be higher than mine. But perhaps my work was actually better than I thought it was. This wouldn't have been the first time I focused on minor defects, while others perceived a larger frame. Friends tell me they see my whole smiling face when I fear they're staring at the bald patches in my eyebrows. And they appreciate the grace of my hands while I obsess over a torn cuticle.

Though part of me was disappointed by not being called to greater meticulousness, I am grateful for Gen-la's acceptance. Years of compulsive skin-picking and hair-pulling have shown me that adjusting, repairing, and other forms of "fixing" toward perfection can actually take me further and further away from it. In an effort to remove every irregularity, I wreak havoc on my own skin and face. Gen-la taught me to move through perfectionism rather than being blocked or waylaid by it. Now, years later, this is one of the most important lessons I pass on to my students: only by moving forward imperfectly can we learn and improve.

❈ *Piece 34* ❈

The Deity Has No Shame

Thangkas depict and embody beings whose energies support our awakening. Many of these beings appear in peaceful guise, but our confused minds are anything but peaceful. It takes tremendous effort to disrupt our destructive behavior patterns. Sometimes, ferocious energy is required to destroy the mind's delusions and protect its delicate virtues. This ferocity for enlightenment is displayed in various wrathful manifestations that appear on some thangkas and are employed in esoteric visualization practices.

The first Westerners to encounter Tibetan culture brought back reports of demon worship because they didn't understand the true meaning of the ferocious and erotic imagery they found. Wrathful deities are not demonic. Rather, they represent the energies needed to transform the real demons—the inner demons of our psychological shadow and the external obstructions to our spiritual practice. Their fierce appearance is intended to combat negative forces which threaten dharma practitioners. With stout bodies in a state of arousal, strong limbs, multiple heads, bulging eyes, sharp weapons, and bared fangs, they help us clear the path to enlightenment.

In fact, despite their frightening appearance, these wrathful beings are actually buddhas, donning a guise that our inner demons will respect and fear. They practice "tough love" motivated by infinite compassion.

Because this imagery runs the great risk of being misunderstood—and can be dangerous to people who are not ready or trained to work with it—unguided practice is discouraged. Years of study and mind training are required before a student is introduced to these deities through initiation and detailed instruction from a qualified teacher of valid lineage. For those who are properly trained and empowered to work with these deities, the practice can transform the shadow aspects of human nature into enlightened wisdom.

Early in my apprenticeship, Gen-la was commissioned to create a series of wrathful thangkas for the new Gyuto Tantric College, which had recently been built down the road from Dharamsala, near the Norbulingka Institute. As he did with any project, Dorjee Wangdu divided and assigned pieces of the design to us, matching the intricacy of each segment to an appropriate student's skill level. As the girls sang and laughed and gossiped and drank tea, each dutifully accepted her piece of the ferocious, erotic imagery, knowing it was a blazing piece of buddha energy.

One day I was assigned a penis. This being my first penis, I had to ask Gen-la for clarification on what thread colors should define the various aspects of the erection.

"Gen-la?" I asked timidly, holding out the piece and pointing with my finger to the part in question.

"*Dei parchin margya?* Pink satin stitch here?" I asked for confirmation, averting my eyes and controlling my voice to hide my embarrassment as I indicated the glans of the wrathful image's member.

Gen-la grunted in affirmation.

"And the outline?"

"Dark red."

"On this part too?" I pushed past my shyness to make sure I distinguished the outlines of the shaft and glans with clarity. I did not want to have to return with more questions.

Although he would later disrobe and marry, Gen-la was still a monk at that time. My inji-white face turned as pink as the thread I was asking about. He responded to my questions unflinchingly with clear and concise directions. My embarrassment was my own. The deity was without shame.

I completed my piece precisely and it became part of a grand thangka, one of five, that graced the main temple when His Holiness the Dalai Lama presided over the Gyuto Tantric College's inauguration.

❋ *Piece 35* ❋

Outsider In

❖━━━❖

As the months passed, I became an insider, seamlessly wel-
comed into the tsemkhang fold. By showing up every day
and taking my place alongside my colleagues, I proved myself a
reliable member of the team. For the next four years, I refused
many tempting opportunities to travel. With rare exception, I only
missed work during my annual visits home to California. This
was the only job I'd ever done with continuous alacrity over an
extended period of time, and I was determined to demonstrate
my commitment.

I never made a decision to stay. I simply didn't leave. I never
decided to change careers. Time just passed as I did what I loved.
After a while, I'd been in India and away from any sort of profes-
sional life for so long, it would have been difficult to get back on
my urban planning career track. That's not to say I couldn't have
done it. It just never occurred to me.

I attempted to talk on the phone with my parents every other
Sunday. Sometimes we got a line through. Sometimes that line
dropped after two minutes. And sometimes we were lucky enough
to have a whole conversation. Phone lines were fragile and unreli-
able, partially due to their doubling as trapeze ropes for monkeys.

During one of those biweekly phone calls, my mother asked me when I was coming home. I delicately eked out the words, "Mom, I think I *am* home." I missed ice cream and hugs but, overall, life was good. Joyful, even. I wasn't sure what, if anything, would make me return to North America.

My stitchery skills were expanding rapidly. It didn't seem to matter that I didn't understand much of the conversation in the tsemkhang and couldn't verbalize my thoughts and questions precisely in Tibetan. I was learning a visual and tactile skill. Gesture, demonstration, and expression were essential. Words were optional. Gen-la could speak some English, but he rarely did so with me.

Occasionally, a Western visitor would knock at the tsemkhang door or poke their head through the door curtain. Gen-la would glance up just long enough to identify an inji face then look back down at his work. "Rinchen!" he'd call out, in the same tone he used to give me assignments. He'd gesture almost imperceptibly toward the interloper with his lips or chin. I knew the drill. I rose from my seat, stepped around my colleagues, and greeted our visitor.

I was the first line, the face of the tsemkhang to foreigners. I fielded their curious questions, responding as best I could, all the time knowing that Gen-la had a pretty good grasp of what they were asking and how I was answering. His English wasn't fluent, but he could get by. He was perfectly capable of conversing with the visitors himself. Instead, he assigned the tsemkhang's token inji to attend to her own kind.

When I asked him once why he never talked with our Western guests, he said that most of them were looking for a fast-food learning experience. Few were willing to put in the time and devotion necessary to learn this art well, he said, so why bother talking with them?

I had once been that unknown inji at the door. What if Gen-la had been unwilling to meet me that first day? I never would have gained entry into the apprenticeship that changed my life. How did he know I would be different? How did he see my commitment

before even I knew how strong it was? It's a good thing I had Bhuchung with me that day and that Tenzin Gyaltsen had begrudgingly introduced me to the art, giving me those meager flower petals of accomplishment to demonstrate my earnestness. (If you're reading this, Bhuchung, thank you! Tenzin Gyaltsen, thank you! I am deeply grateful.)

I sometimes wonder how our relationships might have been different had either of my teachers spoken English with me. Or had I been more fluent in Tibetan. I'm not sure whether we were facilitated or hampered by the limits on our verbal communication. The fact that these relationships were formed within limited language parameters gave them peculiar features. We didn't learn much about each other's histories or ideas, didn't know each other's stories. We dealt only with what the moment offered.

While not being able to express oneself clearly can be frustrating, language limitations can also be freeing. I find that a loss of words can open up a space of stillness. In fact, I think it's good for me to be unable to express myself sometimes. If I can relax when that happens, then the energy I usually spend on self-solidifying expression gets freed up for listening and noticing. For wondering and being.

There are so many ways to communicate. The dominant verbal channel tends to out-shout the others. What a relief it is to detach from words for a while, to let concepts fall away and to rest in presence—in the presence of beauty, in the presence of sensation, in the presence of chattering companions, in the simple presence of what is.

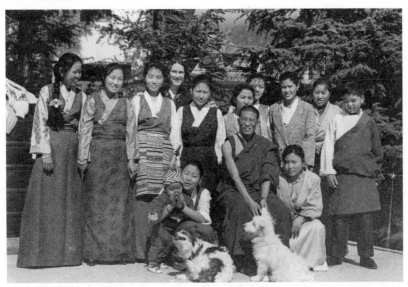

Losar (New Year) photo of Genla Dorjee Wangdu with his tsemkhang
apprentices, circa 1994. I'm fourth from the left, standing in back.

❁ *Piece 36* ❁

Choose Your Poison

⬤━⬤

Piles of silk fabric, some rolled, some folded, filled shelves at the far end of the tsemkhang. All the fabrics came from Varanasi, a northern Indian city renowned for its silk saris. Two Muslim families in that sacred Hindu city had been weaving special fabrics for the Tibetans for generations. *Gos-chen* (pronounced gö-chen) is the Tibetan word used to describe the luscious silk satins and brocades that compose fabric thangkas and frame painted ones. It literally means "great cloth."

Satin, or "plain" gos-chen, is a shiny solid-colored fabric. The term satin refers to the cloth's distinctive weave pattern. On the loom, warp and weft yarns are interlaced in a way that leaves long, uninterrupted floats of warp yarn on the face of the fabric. This pattern produces a glossy surface and a dull back. Satin's natural shine is enhanced by its high-luster fiber content. At one time, all satins were made of silk. In the last half-century, however, satins woven from manufactured fibers, like acetate and rayon, and synthetic fibers, like polyester, have become common. To honor the spiritual value of thangkas, my teachers chose only the finest materials. All of our satin was one-hundred percent silk. The

tsemkhang shelves were stocked with myriad hues of it, which we transformed into pure lands and sacred bodies, clouds and flowers, flowing ribbons, water, hills, and sky.

The garments and robes that adorned the thangkas' deities were pieced from bits of brocade with golden patterns woven into their structure. Metallic weft yarns peeked out from a background of silk to form swirling cloud formations and shimmering floral motifs.

The satins were heavy, similar to the high-thread-count Duchess satin used for bridal gowns in Western countries. The brocades were heavier still. Although sturdy, the fabrics required stabilizing to prevent warping or twisting during the process of drawing, stitching, cutting, and piecing. It's in the nature of woven fabric to be somewhat elastic on the diagonal. In the making of an appliqué thangka, curving lines are imposed on the perpendicular weave, gently tugging it in various directions. Untreated fabric would yield too easily to this manipulation. Pieces would become distorted. To help the fabric maintain its shape, something must be applied to the back of the fabric to stiffen it slightly, giving it more body and more resistance to distortion.

When I began my apprenticeship, Dorjee Wangdu, like Tenzin Gyaltsen, was using meat to stabilize the fabric. He would rub a chunk of raw mutton on the back of silk satin and iron it. A fatty residue would permeate the rear layer of the fabric but not seep all the way through. It stabilized the fabric without changing the appearance of its shiny front.

This may have been an ideal solution in the cold, high, dry climate of Tibet. Or it may just have been the best they had. In warmer, moister climes, like Dharamsala, the meat residue attracted flies, which delighted in landing on my hands as I stitched, annoying the heck out of me. I grew increasingly irritated at their buzzing and at the tickling sensation of their touch as I stitched. I remember flailing my hands periodically—between slow, even stitches—to shoo the flies away as I voiced some impolite

expression of frustration. It was not very conducive to smooth attentive stitching.

Even more to the point, I hated that we used meat. I didn't relish eating it, and I was even more adamantly opposed to smearing it on my fabric. I cut a wide path around the butcher shops in the bazaar where carcasses hung in the open and flies swarmed around them. I had stopped eating most meat in college and, while I could still enjoy its aroma at a barbecue, I was not nearly as tolerant in the sewing workshop.

Many Westerners assume Buddhists are vegetarians. Not so. Meat is an essential nutrient on the Tibetan plateau where fruits and vegetables are scarce. It's a prominent dietary component even in Tibet's eastern fertile regions. Tibetans simply love the taste of meat.

I once watched my colleague Lekshey feed her toddler a spoonful of rice, a bite of vegetable, and then *"sha!"* Mama Lekshey's eyes lit up, and her voice conveyed disproportionate enthusiasm when the sha (meat) was presented to the toddler's eager mouth.

Despite their love of meat as food, even my Tibetan teachers found meat to be an undesirable fabric stabilizer. They were beginning to experiment with alternatives. Boiled potatoes were an early option. Potatoes were readily available and cheap. Unfortunately, clumps of the potato would sometimes break off and make bumps that marred the satin's smooth surface. The stability of the potato starch also broke down with repeated handling of the fabric. Potatoes worked well to keep some brocades from fraying, but they were not a satisfactory stabilizer for satin.

One day, about two years into my four-year apprenticeship, I walked into the tsemkhang after lunch and saw an aerosol can on Gen-la's table, looking very modern.

"It works very well," Gen-la explained as I picked up the can to examine it. He seemed pleased with his discovery.

"Artist's Fixative . . . WARNING," read the label. "Birth defects and brain damage are possible," I paraphrase. "Use only in a well-ventilated area. Keep away from eyes. Do not consume. In case of accidental . . ." You get the idea. This was some noxious stuff.

We apprentices needed to handle our stabilized fabric intimately, turning it in our fingers as we fastened cords along meandering curves. Between stitches, we might rub our eyes, take a sip of tea, a bite of a cookie. And maybe I wasn't the only one to chew nervously on a fingernail as Gen-la inspected my work before giving me my next assignment. There was *no way* we could we use this poisonous spray! I dug deep into my Tibetan vocabulary to translate the label to Gen-la. I spoke more firmly with him than at any other time in my apprenticeship. And, fortunately, I never saw that can in the tsemkhang again.

❊ *Piece 37* ❊

Mastering the Process

Day after day, I took Gen-la's assignments and followed his instructions. He'd call me over to his high table at the center of the tsemkhang and give me a piece of fabric to which he'd already transferred a segment of drawing. He'd tell me what gauge of fishing line to take from the wall and how many threads of which color to wrap around it. I'd wrap the cords at one of the treadle-powered sewing machines and return to my place at the low table to hand-twist matching sewing thread from strips of satin. Between cups of tea, while music played and conversation flowed around me, I'd use my hand-twisted thread to couch my hand-wrapped cords to the lines Gen-la had traced on the fabric.

Once that was done, I'd await Gen-la's approval before proceeding to cut each piece from its surrounding cloth. I'd leave a narrow margin of fabric around the cords, then press those margins under with a hot iron and a bit of glue, thus transforming my cord lines into outlines. Finally, like all the other apprentices, I would return my completed puzzle pieces to Gen-la.

As each apprentice's skills increased, the complexity and prominence of the pieces we were assigned also increased. Some pieces required embroidered embellishment. Others demanded the manipulation of fine cords into tight curves and sharp points.

But no matter how refined our skills became, Gen-la was in charge of the process.

He alone would aggregate our puzzle pieces into clusters. Using whatever was at hand to weigh down corners of the paper, Gen-la unrolled the relevant part of the drawing and laid it flat on his high tabletop. He shuffled our pieces around until every line matched up with its corresponding segment of the design. My flower petals nestled among Dekyi's leaves and were held in a hand that Dechen had stitched. Gen-la overlapped the pieces so that every raw edge was covered by a cord-outlined edge and every color was in its right place. With a trickle of glue, he attached each piece to its neighbors and ran a hot iron over the whole multicolored assembly to cement its connections.

"Rinchen, *shok!*" he called me to his table again and handed me a layered cluster of pieces. For the rest of the afternoon and the following day, I carefully stitched over each of the outlines and through all the fabrics to reinforce the pliant permanency of their arrangement. This cluster of pieces would then be connected to another and another until the whole thangka was complete.

At the beginning, middle, and end, Gen-la controlled the moments when fabric met drawing. He selected colors, transferred drawing segments to fabric, and put the pieces together. Under his guidance, my lines were getting smoother, my stitches less visible, and my turns more precise. Two years into my apprenticeship, Gen-la was rewarding me with assignments of increasing intricacy. From clouds and flowers, I'd graduated to ornaments, bells, robes, feet, and hands. Still, these pieces remained pieces. They were not a whole thangka. I watched Gen-la transfer the drawing. I observed his techniques of assembly. But if I wanted to master the whole process and eventually make my own thangkas, I would need to do it with my own hands.

I loved being part of a team making thangkas larger and more complex than I'd ever be able to make myself. And I loved that our thangkas were destined for monasteries and dharma centers around the world, where they would inspire practice for the benefit of all beings everywhere. But I was also getting antsy

for autonomy. Maybe this was a sign of impatience. Maybe it was my American individualism. Perhaps if I'd waited, he would have transmitted the entire process to me. But I couldn't wait. While still working in the tsemkhang six days a week, I began to work at home on the seventh day and most nights.

I had lots of thangka painter friends who would have been happy to give me a drawing for my first independent project, but there was one problem: Gen-la hadn't yet taught me the special technique for embroidering eyes. My first thangka would have to be eye-less.

My flirtatious friend Alex raised an eyebrow when I asked him to draw me a thangka without eyes. It took some explaining, but he finally agreed when he understood my motivation. Reaching into a metal trunk next to his single bed, he pulled out a rolled-up poster. A bedraggled Tibetan nomad looked out from behind a rock in the black-and-white photograph advertising an exhibition in Budapest a few years earlier. Alex flipped the poster over on his drawing board and started sketching on the back. In the space where a deity's body would normally appear, he drew a vase of rock and ice. A single flower emerged in place of the deity's face. This rock-vase deity was set in a landscape of traditional Tibetan forms. It was perfect.

"Give me some days to fix the lines," he said.

Later that week, Alex delivered the drawing to my room and oriented me to its forms. He explained what each line defined. He scribbled notes to guide me in choosing colors to fill each space—darker in the foreground, lighter in the distance.

The next Sunday, when I carried my vegetables and lentils back from the bazaar, I also brought cotton cloth and sewing thread from a roadside fabric shop. Back home, I pulled out the little bundle of horsehair Tenzin Gyaltsen had given me when I was his student two years before.

As I collected my assignments in the tsemkhang over the next weeks, I dawdled longer at Gen-la's table, taking extra moments to observe his process. Thus began my secret homework to master the entire thangka-piecing process.

❈ *Piece 38* ❈

Horse Tales

❖━━━❖

"Where do you get horse tails?" I asked from the doorway. The thangka painters were playing poker in Bhuchung's room. Tenzin Gyaltsen was with them. He had barely spoken to me since he'd opted out of our exchange and I'd begun to study with Dorjee Wangdu. Finding him socializing with our mutual friends, I jumped at the opportunity to ask for information that only he had.

"Dorjee Wangdu uses nylon in his cords, but I want to use horsehair like you do. Where might I find some?"

"In Mongolia," Tenzin Gyaltsen said without looking up from his cards.

"Um, okay . . . *where* in Mongolia? And from whom?"

Surely, he had a supplier, but he wasn't ready to share his source with me.

I was distraught over the change in Tenzin Gyaltsen's behavior toward me since we'd parted ways. His reluctance to share knowledge perplexed me. I can't get inside Tenzin Gyaltsen's head to know how he really saw the situation—God knows I tried to at the time! But in hindsight, I think his behavior was shaped by a strong tradition of lineage and devotion. For me, an American,

it seemed completely normal to expect to learn simultaneously from two teachers. When Tenzin Gyaltsen told me he wouldn't be available to teach me anymore, I sought out another teacher (asking his permission first), but I didn't mean to discard him. I had been careful not to burn any bridges. Or so I thought. I had no idea that entering apprenticeship with Dorjee Wangdu would exclude me from Tenzin Gyaltsen's unique wisdom. My cultural background encouraged me to draw knowledge from a variety of sources. I admired Tenzin Gyaltsen's exquisite skill. I wanted to learn whatever I could from him, even if he wasn't available to sit with me daily.

Tenzin Gyaltsen, however, had been raised in a master–disciple tradition. I imagine he simply assumed that I had left his sphere of influence when I became another master's disciple. In that worldview, it wouldn't have been right for him to interfere, even when I came begging for further education.

When I approached him with questions about horsehair and fabrics and glues, he balked. He stood aloof, his tall stature making me feel tiny and impotent. I didn't understand what had changed and, in my frustration, my unrefined inji inquisitiveness probably squeaked out like shrill interrogation.

"But where *exactly* can I get horsehair? How do I go about it?"

The poker game paused as Tenzin Gyaltsen turned to look at me.

"Mongolian horses have the longest tails. But any horse will do. . . ."

I listened attentively.

"Approach very quietly when the horse is sleeping. Have your scissors ready. . . ."

Someone giggled from across the table. Even Tenzin Gyaltsen's usually serious eyes shined with mirth. He was taking me for a ride.

(Just to be clear, Tenzin Gyaltsen and the gang were only joking. I've since learned that tail poaching is a serious problem in North America. Perhaps elsewhere too. Please don't do it. Horses need their tails. The guys were tormenting me that day, having a laugh at my expense, but they never actually harmed horses in any way.)

As my usually gentle friends laughed, my face burned with humiliation. I needed horsehair to start making my own thangkas the way I wanted to make them. And I had no idea where to turn.

Dorjee Wangdu had already given me the address of a recreational equipment store in Delhi where I could purchase every gauge of fishing line. But I wanted to use horsehair. Having wrapped horsehair under Tenzin Gyaltsen's guidance and then used nylon with Dorjee Wangdu, I had experienced horsehair's superior qualities. Horsehair was more malleable. It made sharper points and more gracefully undulating curves. It required no adhesive to make the thread cling. I wanted my work to be as refined as Tenzin Gyaltsen's and didn't think nylon was up to that task. The small bundle of horsehair Tenzin Gyaltsen had given me was quickly running out. I needed to find more before it was gone.

Once again, circumstances pushed me to seek support and direction from the people in my community.

My good friends Dhondup and Tsering came from Kham, southeastern Tibet, now incorporated into China's Szechwan province. The Khampas consider themselves the down-to-earth folk of Tibet—welcoming, informal, straightforward, without artifice. They claim that, unlike the more formal central Tibetans, they respect the word "no" when it comes to tea and food. But that's not as true as they claim. They may substitute the simple words *"Tung! Tung!"* in place of the honorific *"Chö! Chö!"* when urging their guests to "Drink up!" But their insistence is equally strong.

We had met during my first Tibetan New Year celebrations, six months after my arrival in Dharamsala. Dhondup was a woodcarver. Tsering sewed traditional Tibetan clothing. As our friendship grew, we became like family to each other. When they moved to Kathmandu a few years later and to another part of India after that, I traveled every February to spend the Tibetan New Year holiday wherever they were. Tsering and Dhondup reminded me a little of my own parents, so welcoming to everyone. There was always space in their small home—always a bed or half

of a shared bed—available for the numerous friends and relatives who frequently popped in unannounced. And for me.

I could write a whole book of stories from my good times with Dhondup and Tsering but, in this one, I'll stick to the thangka-related point: my quest for horsehair.

My Khampa brother Dhondup enlivened every gathering with music from his *piwang*, a Tibetan two-string fiddle played with a bow. Occasionally, he would ask his village mates in Tibet to send horsehair for restringing his bow. It was no trouble at all for him to reach out on my behalf. He sent word to his contacts in Kham: horsehair needed. The next refugee to come from his village to India would pack a recently deceased horse's tail along with his own meager supplies for the journey across the mountains. Upon arrival in Dharamsala, the courier would be treated to a feast and an always-full glass of tea or *chang* (barley beer), accompanied by song, dance, and laughter.

Another horse-tail offer came from two Italian friends, my neighbors in Dharamsala. They worked as trekking guides in Ladakh. Hired horses carried their groups' camping gear and luggage. Would the horsemen be so kind as to offer a tail to a thangka-maker the next time a horse dies? Yes, of course. It would be an honor.

Months later, one dusty bundle of hair arrived in a plastic grocery bag. Another came in a beat-up cardboard box. Both smelled like mountain trails and hard-laboring animals. They'd served their beings well, swatting away flies and other biting insects, signaling the animal's emotions. Now, these tails would serve beings in another way.

"What have you put on my table?" asked Nisha during my next visit to Delhi, crinkling her nose to express disapproval. The affectionate smile I could see in her eyes sent a different message, something like, "You're weird, Leslie, and I really shouldn't let you bring that foul horsehair into my clean Hindu home, but I

love you and you're making gods out of silk and horsehair. How could I possibly stand in the way? But ewww!"

There are advantages to being foreign and thought of as an eccentric with good intentions. You can get away with breaking some norms.

❧ *Piece 39* ❧

Two, Three, Seven, or a Thousand Eyes

When a thangka is painted, the enlightened being's eyes are filled in last. There's a sense of ritual and ceremony around this crucial step of "opening" the divine eyes through which the thangka will gaze upon the practitioners it's charged with guiding and protecting. Statues are similarly brought to life when their faces are painted and eyes filled in. The patchwork nature of appliqué thangkas demands a different approach. Eyes cannot be filled in last because they need to be embroidered onto the face while it can still be held deftly in the hands, before the face-piece is attached to the body-pieces.

As I've examined fabric thangkas in museums and monasteries over the years, I've noticed a small variety of techniques used to fill in the eyes.

In very large pieced-silk thangkas, particularly those with wide wrathful eyes, eyes may be constructed of separate pieces of fabric—white fabric for the whites of the eyes, blue or yellow for the iris, black for the pupil—each color layered on top of the other, placed behind the fabric face, and made visible through a cord-outlined opening.

On most pieced thangkas, though, embroidery is used to build eyes of thread on the surface of the fabric face. In some cases, lines of satin stitch are used to fill in the color. However, I was taught a more exacting technique in which a circular pattern of tiny stitches gives the eyes a lifelike spherical appearance.

Although eyes cannot be embroidered last on any given thangka, eye embroidery is the final skill transferred from master to apprentice at the end of a long training. And the eyes are the feature to which an appliqué artist gives her most meticulous attention.

When Gen-la felt that my skills had advanced sufficiently, he called me over to his table for private instruction. The stitches he showed me were so small I could barely see them. The trick was to catch just one or two threads of the satin weave with the super-fine, super-sharp tip of the needle. When I first tried it, my needle caught only air. But I persisted. I dipped the needle's point into the fabric again. Pushing it all the way through to make sure the embroidery would be firmly planted in the fabric, I brought the needle back up with just a thread or two on its point so that the black stitch would appear like a tiny ink spot on the surface of the satin.

Starting with this tiny stitch, then spiraling around it with equally tiny stitches, I built a round black pupil. Then, threading my needle with turquoise blue thread, I encircled that pupil with more tiny stitches to form the iris. I let my stitches grow ever so slightly longer as I filled in the whites of the divine eyes, maybe catching four threads of satin weave on the needle's point instead of two. I did my best not to let frustration with my uneven stitches and imperfect circles disrupt my awareness of their divinity.

Once the surface of an eye was filled with close-packed spiraling lines of thread, I followed Gen-la's instructions to delineate its edges with the finest cords—red below the eye, black above, plus an extra blue line over the black to signify the sky-like spaciousness of awareness.

Six days a week for one full year, my life was filled with eyes and my eyes were filled with purpose. What a blessing to be working in such a busy tsemkhang, collaborating on so many thangkas, each with multiple figures, each with two, three, seven, or even a

thousand eyes. On my own, I would never have had the opportunity to practice so extensively. Birds' eyes, snake eyes, deer eyes, eyes of snow lions and dragons. Garlands of severed heads hanging from wrathful shoulders. Humans and animals crushed under wrathful feet. So many faces. So many eyes. All helping someone to see more deeply into reality, to examine more closely the nature of their experience. Faces so small they sit comfortably in the palm of my hand. Day after day, eyes, eyes, and more eyes.

When Gen-la was commissioned to make a thangka of the thousand-armed Chenrezig, he recruited every remotely qualified student to the task.

Chenrezig's original name, in Sanskrit, is Avalokiteshvara. In China, he became she and is known as Kuanyin. In Japan, (s)he is Kannon or Kanzeon. Chenrezig is compassion personified. Not the ordinary compassion that we feel only for people on our side, people we like, people we know and love. No, this compassion is vast and unconditional. It shines on every being in every realm where feelings exist. It yearns to relieve the large and the small pains, the fleeting and the enduring pain, conditional pain and that pain intrinsic to existence in duality.

This compassion is not separate from wisdom. It's a full-knowing, all-seeing awareness of the conditions and patterns that bring about the struggle. It sees the web. It sees how beings are caught. It sees their freedom. And it aches with the knowledge that the beings themselves cannot see what it sees; they only see the tangle they're caught in.

Chenrezig is visualized in a multitude of forms: with two arms or four or a thousand, as many as are needed to aid all beings. He will provide comfort, but he prefers to offer freedom, dissolving the net of our delusion rather than working out individual tangles.

With a thousand hands and as many eyes, this particular embodiment of Chenrezig granted eager appliqué apprentices like me a rare opportunity to perfect our skills outlining fingers and embroidering eyes.

Most of Chenrezig's thousand arms were arrayed in a circle of outstretched hands that reached from his knees to above his

eleven heads. As Gen-la transferred the complex drawing to clean white satin, he divided the circle of hands onto ten wedge-shaped panels of a hundred hands each. Each hand had a tiny eye in its palm. Eyes so small they couldn't possibly be stitched perfectly. A circle of thirty larger hands lay in front of these. Gen-la gave me four of them. In front of these, eight primary hands reached out in pairs, each hand forming a mudra that communicated a teaching. I was assigned a couple of these as well. The eyes in these larger hands were more prominent, more distinct, and it was important that they be stitched well.

Later that year, a well-known Tibetan lama with a network of dharma centers stretching across Europe and North America commissioned an enormous thangka of Buddha Shakyamuni flanked by the great Madhyamaka philosophers Nagarjuna and Chandrakirti. Gen-la entrusted me with Nagarjuna's most important features. First, I made the snakes that rise like a hood over his head. Then I stitched the great master's own face, kind and clear-seeing through embroidered eyes. It felt like a graduation project.

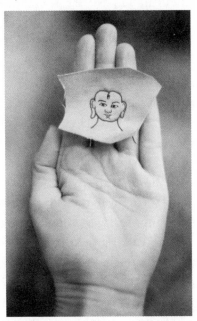

One of hundreds of faces I stitched in the
tsemkhang during the third year of my apprenticeship.

Different Eyes,
Different World

Tsering and I held hands as we circumambulated the large
mound-like reliquary with the evening crowd, whispering
thoughts and observations in each other's ears. Like the people at
the library, those at the monastery where Tsering and Dhondup
were living spent their early evenings walking clockwise around
a sacred structure, talking to friends, keeping fit, and building
up good karma at the same time. The air was crisp, the sun low.
Snow glistened on the distant mountains. The stupa contained
relics of a great lama in the monastery's lineage. It felt good to be
outdoors and part of the community.

On this evening, Tsering walked with purpose, as if our steps
were taking us on an important errand and we had limited time
to get it accomplished. Walking next to her, I felt I belonged to
this place, these people. Some lone circumambulators sped round
quickly—a young man wearing a baseball cap backwards, a young
monk swinging his mala and looking at the ground. One elderly
woman, bent to ninety degrees at the waist, leaned on a cane as
she moved slowly, stooping down with great effort to place small

pebbles at intervals around the base of the stupa, performing a ritual only she understood.

Tsering and I fell in behind another pair of walkers. A middle-aged monk with his woolen robe pulled over his bald head accompanied an inji woman with a cascade of buttery golden curls.

My own hair was dark brown at the time. Now it's laced with silver, but I was younger then. If the sun shone just right, in those days, my hair revealed reddish highlights. I had adopted the Indian beauty-care habit of regular henna treatments to accentuate them. I loved the way the green mud made from natural plant powder caused the barely-there red in my dark hair to make a more reliable appearance in bright sun. Still, any Westerner who looked at me would have said my hair was dark brown. And they'd have called Tsering's Tibetan hair a bit darker, almost black. Since she also conditioned her hair with henna, like so many Tibetan and Indian women, hers had a subtle red sheen too.

I squeezed Tsering's hand and pointed my chin in the direction of the inji woman's glistening golden locks. They were as captivating to me as the sunset. No, more so. Sunsets happen every day, while hair like this is a rare and wondrous sight. Her tresses were amber fields of grain. Wheat and butter and gold. Goldilocks, Rapunzel, and late-afternoon sunshine. In America, she would definitely be called "blonde." A rich golden honey blonde.

How did Tsering respond? She glanced at me and scrunched her nose, perplexed.

"Yes, very pretty," she said, "Just like yours. You injis with your yellow hair. Much nicer than our black hair."

My yellow hair? How could she say that? The color of my hair was certainly closer to Tsering's near-black than it was to this woman's glorious gold.

Or so it seemed to my eyes.

But to Tsering, my hair was yellow. I was an inji, a "yellow head." In fact, *go ser*, which literally means "yellow head," is a colloquial Tibetan term for people of European descent. And that day I realized that, to a Tibetan, even dark hair appears yellow when it sits atop a white person's head. Perception is not objective.

We're not each looking out at the same world through different eyes. Instead, perception meets object, and we collaboratively co-create the world as we look at it—while completely unaware that we're doing it. Aren't we amazing?

Perception is not fact. Colors do not exist inherently but are co-created in our seeing them. And *seeing* is not neutral. Seeing is a biased activity.

"I'll believe it when I see it," we say. Really? Are you sure you don't see it because you believe it?

If things are not as they appear, and if the same object can have different characteristics depending on whose eyes, culture, beliefs, and so forth, are looking at it and from what angle, then couldn't I just as well—without changing or faking anything—be a thousand-armed being of light at the very same moment in which, looked at from another angle, I'm insecure, imperfect Leslie?

The Vajrayana practices supported by thangkas use imagination to align our view with reality. Vajrayana recognizes that what we think we know is usually mistaken, clouded by grasping for an independent self that doesn't exist. It concedes that what we can imagine, if we practice enlightened imagining, could be more real than what we think we know. Visualization of oneself as a deity is, from one point of view, fake-it-till-you-make-it training. From another point of view, it's pure vision of true nature. It's a practice in seeing what's left when stories are removed or replaced. What appears when we slip a different lens onto the kaleidoscopic camera through which we see ourselves and the world?

Visualizing myself as the deity allows me to step into another reality that is simultaneously and equally true—or, perhaps, even truer. It's a reality in which I'm already also enlightened. Yes, I'm the frightened, anxious girl who makes thangkas as best she can, who talks too loudly, who loves to laugh, who picks at her fingers, pulls on her eyebrows, and worries after each encounter that she's taken up too much space in the conversation. I'm the woman who has never kept a regular meditation practice and always thinks she should. I'm the woman who cares deeply about kindness and justice and feels inadequate before all the world's meanness and

injustice, much of it perpetrated by her own government. I'm the woman who speaks of love and tolerance but can't get along with her own mother and barely restrains herself from throwing things at the irritating relative who dominates every holiday gathering.

Yes, all this is true on one level.

And at the same time, with a breath and a shift, I'm space. This Leslie is just a point of view, a continuum of experiences. In this moment, here, now, on this ground, walking around this stupa, with this breath, next to beautiful Tsering, I am joy. I am love. I am awake. I am buddha.

❋ *Piece 41* ❋

Patience—Not!

People imagine that stitching a thangka requires patience. "Oh, what patience you have!" they exclaim when they see my work. "All those tiny stitches. I could never do that! I don't have the patience."

Anyone who knows me, though, knows I'm not very patient. Despite years of erratic meditation practice (or maybe *because* that practice has been so erratic), I get irritated standing in line, irate with inconsiderate drivers, and infuriated with my mother as she reminds me of my fears and imperfections. I'm not a patient person. I *am*, however, a curious person. I'm a person who's easily entertained, who can find wonder in noticing the sensations of my own body, who can take great pleasure in the purrs of a cat on my lap, who can dwell on the colors in a sunset, who—as a child—sat for hours watching clouds slowly transform from the shape of one wondrous animal into another. I think this is the key to my pleasure in thangka-making. It's good luck more than any virtue of patience which, I'm embarrassed to admit, is rather lacking in me.

Patience is one of Buddhism's "Six Perfections," the practice of which will clear the mind for enlightenment. Patience is usually

described as tolerance of undesirable, unpleasant, and unfavorable situations or sensations. But stitching a thangka is neither unpleasant nor undesirable. And it certainly isn't unfavorable.

Perhaps enjoyment of this work requires some capacity for delaying gratification. But that's only to the extent that one considers completion to be the primary gratification, which I do not. I find the work itself to be enormously gratifying. The contact with the fabric, the regularity of the stitches, the focus of the attention, and the company of the deity—each brings its own inherent gratification. Sure, it takes time to finish—time in which it may seem like little is happening. But that time is never spent tolerating the wait. It's like reading *Harry Potter and the Order of the Phoenix* (fifth and longest book of the beloved series) or any other marvelously written, deeply engaging, long novel you love. Do you spend your time reading eight hundred pages waiting to reach the end? Of course not. You are *in* the process, hanging out with the characters, watching the story unfold. If anything, as the end nears, you feel sadness that you will soon have to leave this wondrous world. Stitching a thangka is like that. Although it may look like patience, what I actually experience is love.

Part Six: REVERENCE

*Discovering the sacred within all moments is the
hallmark of awakening.*
—RODNEY SMITH, *Stepping Out of Self-Deception:
The Buddha's Liberating Teaching of No-Self*

❖ *Piece 42* ❖

Can You Make a Thangka for Me?

Once each year, I traveled from Dharamsala to California to visit family and friends. I packed only one change of clothing for these journeys as I still had a full closet of clothes at my parents' house. My homes on two continents called for different apparel anyway. In the US, I wore jeans or leggings, pullover tops, and other items suited to my car-centric Los Angeles life. In India, everything I wore was long, loose, and baggy. Ankle-length skirts, wide pants with elastic waistbands, bulky sweaters, and *salwar kameez* (knee-length tunics worn over drawstring bloomers). Nowadays, many women in India wear jeans or skin-tight legwear under their kameez, but in those days in my small mountain town, it was unheard of. Shoulders and ankles were always covered, and the female form was softly masked.

That I packed little, however, does not mean that I packed lightly. My full-to-the-limit bags were stuffed with merchandise as I boarded the overnight bus from Dharamsala to Delhi and then the plane from Delhi to Los Angeles: earrings, bracelets, and pendants made of silver, coral, turquoise, and lapis lazuli; miniature versions of the *gau* lockets in which Tibetan women

carry sacred substances close to their hearts; woolen shawls; musky incense; a couple of prayer wheels; a ritual trumpet; *tingsha* cymbals; wooden and enameled boxes; all kinds of bags and purses; and colorful Tibetan shirts made by my friend Tsering. The sale of that merchandise would pay my plane fare for the visit, which was half of my annual cost of living.

I usually scheduled my visits in late autumn so I could hold a Christmas bazaar at my parents' house. I've never been much of a shopper myself. In fact, I have few souvenirs to show from my years of world travel. But I seemed to have a knack for selecting items that would resonate with the shoppers and gift-givers among my friends and in my parents' community.

With my mother's help, I arranged the merchandise on long folding tables in two rooms. Mom's Thanksgiving tablecloths mimicked the burgundy color of Tibetan monks' robes, and the whole display coordinated with her harmonious home decor. Mom was the unofficial interior design consultant for the whole neighborhood after all, and I was a budding thangka artist; my display couldn't look like a swap meet! It had to have beauty. It had to have class. It had to please both eye and heart.

On the walls, I hung photos of my home in Dharamsala: my beloved mountains; snapshots of friends at picnic, pouring tea, playing games, painting; scenes from the tsemkhang too. Images that were now part of my daily life looked exotic to the friends and neighbors who attended my bazaar. These same images tugged at my heart and made me homesick for the mountain community I'd return to in a few weeks. (Yes, strange as it was, I felt more home-sickness and culture shock in the US than I ever did in India.)

I bought samosas, pakoras, and other snacks from a local Indian grocery and laid them on the kitchen counter for guests. A huge pot of spicy chai boiled on the stove, filling the house with the fragrance of India—fresh cinnamon, ginger, coriander, mustard seeds, a bit of pepper, loose-leaf tea, and abundant milk and sugar. I also made a small batch of Tibetan butter tea to give curious visitors a taste of the salty broth preferred by Tibetans (and by me). Some daring friends tried it, but few asked for refills.

At my November 1995 bazaar, my recently completed "thangka without eyes" hung on the wall next to my tsemkhang photos. Among the shopper-guests was my dad's travel-and-hiking friend, Carolyn. Dad had caught the trekking bug from me after my first journey to India in 1988. The following year, while I was deepening my connection to the Himalayas, Dad trekked in Peru and was fortunate to connect with a group of compatible traveling companions. Trips with the same group to Nepal and Patagonia followed. A lawyer about halfway between my age and my father's, Carolyn was among them.

She tenderly fingered the shawls, noting the difference between a soft pashmina from Kashmir and a coarser Kullu wool wrap. She chose a pair of earrings for herself and bought some incense as a gift. But more than anything, she was fascinated by the thangkas. She peppered me with questions about how they were made and began to wonder out loud whether she might be able to have one of her own.

"I'll ask my teacher how you'd go about commissioning one," I said. I had never asked Gen-la how he took orders or how much he charged.

"Hmm . . . okay, but . . . well . . . couldn't *you* make a thangka for me?" Carolyn asked.

Could I? I hadn't considered it, and the thought of it scared me. Was I ready? What would Gen-la think? Doubts and uncertainty flooded my mind.

"Uh," I said after too long a pause. "I don't know. I suppose I could. Maybe. Let me think about that."

When I returned to India a few weeks later, Carolyn's inquiry traveled with me. It played in my mind as I continued to hone my skills at the tsemkhang by day and to build practice thangkas at home by night. I started collecting photos and postcards of Buddha paintings Carolyn might like, simple designs I felt capable of rendering successfully in appliqué.

As I prepared to send the collection to Carolyn, my inner over-informer got the better of me. At the last moment, I added one more photo. This was a picture of a large, elaborate appliqué

thangka we'd made in the tsemkhang as a team. I didn't imagine I could make anything like it on my own; I just wanted Carolyn to appreciate the textured appearance of the appliqué and understand that her thangka would not be flat like a painting. I sealed the envelope and walked down to the post office in Kotwali Bazaar to send the pictures on their long way around the globe.

Including that extra photo turned out to be more consequential than I intended. Carolyn fell in love with the complex design and asked if I could make her something similar. The central figure of Buddha Shakyamuni sat on a throne surrounded by animals and mythical creatures, symbolic of the Six Perfections. She had no idea of the magnitude of the project. And to tell the truth, neither did I. A dozen stitchers had collaborated in the tsemkhang to make the thangka in the photo, and I couldn't remember how long it had taken. I made a rough estimate that I could do something similar in six months and asked a ridiculously low price to which Carolyn quickly agreed. As it turns out, I seriously underestimated—by three- or four-fold—the time it would take to finish that piece. In the end, I devoted almost two years to its creation.

The thangka would have to be large in order to contain all its intricate detail. Appliqué needs space to breathe. Each shape needs to be ample enough for the cord to trace its contours and for the edges of the fabric to turn under. The thangka Carolyn was requesting would need to be at least a meter tall. It would reach two meters when the brocade frame was added. Did she have enough space?

"Yes," Carolyn assured me in her next letter.

I shyly asked Gen-la for a drawing, and he lent me one to copy. *I guess I'm really going to do this*, I thought. *Gen-la is giving me the keys!*

Back home, I laid out the drawing on my concrete floor. My only table was much too small to hold it. I rolled a giant sheet of tracing paper over it and taped the edges to the concrete. Squatting here, kneeling there, I scuttled around the drawing tracing each line with painstaking precision till my back ached. I took care never to step on the Buddha.

In general, Tibetan Buddhists avoid placing any sacred object, image, or text directly on the floor. And they never step on or over them either. But exceptions are granted for the practicalities of the creative process. Rules are meant to enhance practice, not to contort it. The point is always respect, and above all else, respect for one's own true nature and for the teachings and teachers that allow one to realize it.

I traced the curving fingers of Buddha's hand as it reached down to touch the ground. In this image, the Buddha is actually touching the throne on which he's seated. This is a metaphor for the sovereignty that his awakening has granted. The throne is supported by lions symbolizing royalty, courage, and nobility.

In a mundane sense, the historic Buddha was born sovereign. He was a prince of the Shakya clan. But from a spiritual standpoint, he attained ultimate sovereignty at the moment of his enlightenment, at the moment when he touched the ground to say, "I'm here." On this ground. No longer blown by the winds of karma. Present. Complete. Awake.

In some way, I claimed my own sovereignty as I touched that drawing with my right hand. I'm here. With this drawing. Blessed by this lineage. Embarking on this project. Present. Awake. Well, not awake like the Buddha, certainly, but relatively and increasingly semi-sort-of-kind-of-awake and at least pointed in the right direction. Ready.

The magical creatures supporting the Buddha in this thangka represent the six perfections, six practices that support enlightenment: generosity, ethical discipline, patience, energetic perseverance, concentration, and wisdom.

I, too, am the beneficiary of perfect supports. I've been held and uplifted by seen and unseen collaborators:

- By my parents, who never questioned (except with actual curiosity) why I was leaving behind the degrees I'd earned—with their generous material and moral support—to wander off to India and study an ancient handicraft instead of engaging in the professional life I had prepared for.

- By my natural inclination to connect with people of diverse backgrounds and languages.
- By whatever magic opened doors for me that are normally closed to outsiders—doors to esoteric teachings and to an intimacy with aspects of Tibetan daily life that visitors normally don't see.
- By the forces that kept this scared little girl safe in her travels and occasionally released her from her fear, if only momentarily, to allow extraordinary encounters to occur—safely.
- By the Tibetans themselves, who nurture a reverent culture that keeps the mysterious and unexplainable front and center (and even manages to explain it), who never stop looking deeper and honoring what is found behind the scenes—and under the disguise of the apparent—inside our hearts and minds.
- By my appliqué teachers—both the one who taught me willingly and the one who taught reluctantly.

It was time to show my stuff.

❧ *Piece 43* ❧

Multi-Colored Weave of Humanity

To make my own thangka, I'd have to buy my own fabric. The real stuff. Dorjee Wangdu sent me off to Varanasi with the names, addresses, and telephone numbers of his best suppliers, men who had been furnishing the Tibetans with satin and brocade for generations. Before Chinese occupation, much of the silk fabric in Tibet came from China, often as imperial gifts. Some of the precious fabric came from Russia, and a small portion came from Varanasi in India. Under Mao Zedong, China had ceased to produce fine handwoven fabric, substituting it with machine-made synthetics. Imperial splendor and sacred art had no place in the communist era, especially during the Cultural Revolution of the 1960s and '70s. This was a boon for the few families who ran satin-and-brocade weaving operations in Varanasi, India. Since occupation, Tibetans in exile have acquired their fabric almost exclusively from these families. And the head of one of them, Hasin of Kasim Silk Emporium, was expecting me one warm February day.

Varanasi is a sacred Hindu city on the banks of the Ganges River in the northern Indian state of Uttar Pradesh. It is

considered one of the oldest continually settled cities in the world. In the morning, before first light, the river awakes with sounds of devotion. Sari-clad women chant praises to Mother Ganga. They float marigolds and candles on the water's surface.

Throughout the day, pilgrims from all corners of India submerge themselves in the river at each *ghat,* flights of steps that lead down to the water at intervals along the bank. Men with cloths tied around their waists, chests bare. Women fully dressed in splendid saris. Unfazed by filth or cold, they are filled with joy at the opportunity to take a holy dip in the great mother.

Not far from the devotees, preteen boys dive in the water and laugh. Men in their twenties practice cricket on the uneven promenade. Other men beat wet laundry on a concrete slab, then lay the river-washed saris to dry in the sun. Five meters long and a meter wide, brilliant swaths of rainbow color adorn the riverbank.

Walking along the river, I passed wandering holy men, of every variety: sadhus, babas, yogis. Some draped in orange. Some naked and coated in ash. Matted hair piled atop their heads or loosely hanging on their shoulders. Some carried staffs, tridents, or snakes. Some crouched together, smoking. One perched on a high step gazing out at the river, gazing inward at the gazer.

Water buffalo roaming the riverbanks felt like kin. I don't know why, but I sensed a connection the first time I encountered them. Their huge eyes were so open and deep. It seemed we'd known each other before.

Varanasi itself flowed around me like a river of everything and everyone throughout all time—at once ancient, eternal, and new in every moment. Beauty and ugliness, birth and death, peace and chaos were woven inextricably in the narrow alleyways of the old city. When I'd visited other South Asian cities as a Western traveler (Kathmandu, for example), I felt constantly singled out. Beggars surrounded me, drawn to my white skin and Western attire, asking for money, *baksheesh,* one rupee, one pen. In Varanasi, though, I was allowed to walk in peace. I was nothing to be noticed. It was clear that the beggars had been there long before the arrival of Westerners and would be there long after. In the

vastness of Varanasi's space and time, I was just one more piece of driftwood floating on the same current as the browsing buffaloes, scurrying rats, mangy dogs, and assorted humans—locals, pilgrims, tourists, old, young, rich, poor, sick, or dying. Actually, all of us were dying.

Many Hindus consider Varanasi an auspicious place to die. To be cremated on the banks of the Ganges, they believe, ensures release from the cycle of rebirth. Ailing and old, they travel to Varanasi to release this life and be liberated. Ram Dass, the Harvard-professor-turned-spiritual-teacher who wrote *Be Here Now*, often recounted the story of his first visit to Varanasi in the 1970s. Seeing all the sick and disabled people, he became so overwhelmed with pity that he fled to his guesthouse and hid under the bed. A few years later, with some time in India and some deep spiritual practice under his belt, he returned to Varanasi and saw it very differently. This time, as he gazed into the eyes of a decrepit woman or a diseased man, he saw them looking back *at him* with pity. They were fulfilling a lifelong dream, having reached Varanasi in time to shed their human body there. They had abandoned attachment to this life and were moving into the next as naked swimmers. Ram Dass, on the other hand, realized he was clinging to every shred of security and identity, kicking to stay afloat, blind to the great flowing beauty that carried them all.

Besides being known as a good place to die, Varanasi is also famous for its finely woven silk saris. Almost all the weavers are Muslim and live in the large Muslim quarter of the city and in outlying villages. While most of these weavers create the saris worn by women all over India, a few make the fine brocade and satin from which Tibetans stitch thangkas. The heavy silk satin and brocade is produced by Indian Muslim weavers neither for themselves nor for the Indian Hindu culture that permeates the city but for Tibetan Buddhists from the mountains. These disparate cultures have been woven together in silk for generations.

The first time I visited Varanasi, I stayed at a crumbling guesthouse on a narrow, winding alley in the old city. My room had a balcony overlooking the river. Although it was February, the air

was muggy, and I was tired from the long journey. It had taken me three days to reach Varanasi from Dharamsala. One night was spent on a bus, another on a train.

With no appointments until the next day, I allowed myself to settle in for an afternoon nap on the hard bed. I left the balcony door open to catch a breeze. I don't know how long I'd been sleeping when I felt the gaze on me. That sensation of being watched roused me from my dream. As I opened my eyes groggily, I saw him staring back at me—a monkey, sitting on my bed, watching me sleep. Yikes! We both jumped simultaneously into fight-flight-freeze mode. Fortunately, neither of us chose to fight. I froze (maybe squeaked a bit, too), and the monkey fled straight out the door. He bounded off my balcony to a nearby rooftop and stopped to stare at me again from a much more comfortable distance. I closed my balcony door and kept it closed for the remainder of my stay, preferring a stuffy room over a monkey roommate.

The next morning Hasin's driver met me in the street outside the guesthouse, standing with proud dignity next to a white Subaru minivan. Wordlessly, he let me know that he had come to take me to the silk.

(Twenty years later, when I visit Hasin today, the same driver meets me, with the same proud and respectful demeanor but now with a familiar smile. To this day, I have no idea how much English he understands—very little, I believe, but he could be hiding perfect comprehension beneath that silent facade. He definitely understands "ATM" now, as Hasin only accepts cash, and the days of queuing at the bank to exchange traveler's cheques are long gone. After twenty-two years with this same driver, I breathe a sigh of warm relief as soon as I encounter his calm grace in that chaotic city. I never learned his name but always refer to him with a respectful "Ji.")

In air-conditioned comfort, we bumped over dusty roads alongside oxcarts, bicycle rickshaws, auto-rickshaws, taxis, cows, and pedestrians. Streets curved and intersected at odd angles, like a scattering of pick-up sticks. The only sense of order was provided by the clustering of trades—all the electrical shops on one

street, the tire changers on another, plumbing supply here, wrist bangles there, chemists all together somewhere else . . . Driver-ji turned the van so many times I lost all sense of which direction we were heading, how far we'd traveled, and whether we might just be driving in circles.

The Muslim silk quarter was tucked away behind the Yamuna Talkies cinema. The alleyways of this neighborhood were too narrow for cars. Driver-ji parked the van at the side of the busy main road and gestured for me to follow him as he turned into a narrow passageway. Children chased each other down the lane. A scrawny cow obstructed our way until Driver-ji convinced her to move with a light smack of his hand on her rump. A man crouched on the ground preparing tea, or was he repairing shoes, or umbrellas? There was so much to look at, but I had to keep my eyes focused on Driver-ji, who walked faster than he drove and was always about to disappear around a corner. If I lost him, I'd have no idea how to find my way back to the street and no clue how to return to my guesthouse. Luckily, I'd developed the good habit of carrying a card from my guesthouse in my pocket. If push came to shove, a rickshaw driver would probably be able to get me back to its vicinity, I hoped.

Driver-ji forged deeper and deeper into the neighborhood. I scurried to keep up, careful not to trip over my own feet or the long *dupatta* scarf I'd draped loosely over my head and around a shoulder to cover my hair.

Then suddenly, we were there, standing before a nondescript doorway. Driver-ji gestured toward the open door, and I understood I was to enter. Other men were present, but I don't remember them. I stepped into the cool inner courtyard of the tall masonry building and was led from there through a room filled with men at desks, reading ledgers, fingers busily punching keys on number pads.

Guided by Driver-ji's wordless gestures, I passed through another door and entered the inner sanctum of silk buying: a square room the size of my childhood bedroom. The floor was covered in white sheets over firm mattresses. No chairs. No tables.

No windows. As I entered this padded cell, Hasin greeted me warmly. "Welcome, welcome."

"Chai," he ordered one of the men. Clearly, he'd done this a thousand times before. By the time I'd arranged myself in a respectful and comfortable sitting position on the mattress-covered floor, another man arrived with glasses of sweet tea on a steel tray. I lowered my dupatta, draping it over my shoulders now and letting my hair show. Although unnerved by how much I didn't know, I was confident I could be at ease here in the inner sanctum. An artist, a buyer, here at my teacher's recommendation . . . I was among friends.

Hasin shared stories of his meetings with Tibetan lamas, opinions on politics, health, and his philosophy of life. On the wall of the padded showroom, he kept a framed letter from His Holiness the Dalai Lama and photos of them together. Another frame displayed a piece of the first brocade Hasin's grandfather had sold to the Tibetans. Hasin's pride was evident. He was proud of his father and grandfather and of the business they started, which he continued to grow and sustain; proud of his long relationships with Tibetan lamas and artists, including both of my teachers; proud of his Muslim faith and practices.

Our conversation was sprinkled with comments like, "Last week, So-and-So Lama was here. He gets all his brocade from me. Special order. Very beautiful. Very complicated. Hard to make . . . Oh, and I just spoke with *Fill-in-the-Blank* Rinpoche, and he's ordering so much brocade. Fifty squares! Fifteen colors." During later visits, Hasin spoke of the many high lamas who attended his son's wedding.

Hasin was also proud of the thousands of weavers and dyers he employed right there in the neighborhood, in dark rooms surrounding his palatial house, and in villages surrounding Varanasi and Sarnath. The family business had made Hasin a rich man. He was hardworking and committed to doing right by his family and his customers. I do not know the extent to which his beneficence extended to the weavers and dyers who worked for him.

As I sat on the cushioned floor sipping a steaming cup of sweet tea, Hasin's helpers—all men—unfurled lengths of brocade laced

with gold and unexpected colors of crisp, shiny satin. I reached forward to touch the corner of one, considering how I might use it, what I might make, when—*bam!*— another length of magnificent fabric landed on top of it, interrupting my reverie.

Hasin and his helpers understood that I was only interested in thangka fabrics. At least, I thought they did. They showed me hundreds of colors of satin and several designs of brocade, but they also unfurled fabrics I had no interest in: saris. shawls, embroideries. I felt bad knowing they'd have to fold it all up again. *Stop. Please.* I thought and tried to say. *You're making extra work for yourselves. I only need brocade and satin, and only a little bit. I'm just one person working alone in a one-room apartment cum studio. I don't have a tsemkhang. I don't have big orders. I don't have much money . . .* I knew I couldn't buy everything that captured my eye. Still, the men unfurled fabric after fabric. They cut off a meter or two of those I chose and folded my pieces neatly in a pile, throwing the rest aside to be refolded later. Hasin brought out a calculator and wrote up my invoice, listing each fabric and the number of squares of it I'd taken. (A square, or a *mukh*, was the unit of measure by which the fabric was priced. Squares were measured by folding the fabric on a diagonal, forming a piece as long as the fabric was wide.) At the end of the day, I headed back to Dharamsala with three thousand dollars' worth of sumptuous material, some of which I still have in my cabinet today.

❖ *Piece 44* ❖

Remembering
the Silkworms

Sacred art is an offering to my teachers and to my possibilities. My care and intention are foremost, but materials matter too. Making that sacred art with the best possible materials elevates the value of my offering. For at least five thousand years, silk has been considered the finest fiber on earth. By making my thangkas from silk, I uphold tradition and keep the rich and tangled relationship among Tibetans, Mongolians, and Chinese alive in my work. Like that relationship, the choice to use silk is complex. The shiny fabric has its dark aspects. Silkworms die for the production of silk thread.

As you read these words, thousands of silkworms are chewing mulberry leaves somewhere in China or Japan or India. The sound of their chomping fills the air. Hungry little mouths provide lumpy little bodies with the fuel they need to manufacture magic. They're caterpillars, actually. The silkworm is the larva of the domestic silk moth, *Bombyx mori*. As the primary producer of silk, these humble creatures provide the material to furnish the most opulent places and adorn the most affluent people around the globe. Economically, *Bombyx mori* is one of the most important

insects in the world. Each of them is like an artist whose work is recognized only posthumously.

After a month of eating and growing, the chomping quiets and the spinning begins. Each caterpillar will wrap itself in a padded cloak of its own making, a cocoon. Fully encased, it begins its transformation from caterpillar to moth as if passing through eons of evolution within a few weeks. Entering their capsules as slithering worms, they might believe themselves (if capable of believing anything) destined to emerge as wondrous creatures of flight. In fact, the emerged silk moths cannot fly. They neither eat nor drink. They simply mate, lay eggs, and then die within five days. Miraculous as the fruition of their transformation would be, human intervention calls these silkworms to a different task, one for which they must sacrifice their lives.

Their metamorphosis is interrupted by humans intent on harnessing the radiance of the cocoon's fiber walls for their own beautification and for the beautification of their world. Why can't these humans wait until the transformation is complete? Why don't they let the creature emerge before harvesting the lustrous fiber?

As the moth emerges from the case he no longer needs, he breaks it like a chick hatching from an egg. Actually, he dissolves a hole in it by secreting a special spit that contains proteolytic enzymes. The enzymes in the spit break the mile-long fibers into segments of random length, seriously reducing the value of the silk threads. To preempt this degradation, the silk cultivator boils the cocoons while the silkworms are still in the pupa stage. Heat kills the pupae, and water makes the cocoons easier to unravel. In many silk producing countries, the silkworm pupa is eaten as a snack—boiled, fried, or roasted and spiced.

The human cultivator who raises this silkworm does not allow the creature's marvelous creation to be lost. She saves the cloak while sacrificing the worm. She may even mourn the worm for a moment. I know I do. The little girl who cried when her parents tasked her with killing flies before the barbecue is still alive in me. The woman who saved spiders from her sink and mourned their lost limbs feels for these silkworms too.

But in ending the worm's life, the silk cultivator also glorifies the worm's accomplishment. She sees the worm's purpose fulfilled. This little creature whose life would otherwise make little impact can contribute beauty and spiritual awakening to the world.

How can I know this? Is it true?

The fiber extruded by the caterpillar's body, the thread created from so many consumed mulberry leaves, will be unraveled into miles of strong and shimmering fiber. These unbroken fibers will be woven into beautiful fabrics. When these beautiful fabrics are used to inspire and liberate, that little caterpillar will have performed goodness otherwise unachievable in his "wormful" incarnation. Through silk—colored with dye and shaped by weavers into fabric and by stitchers into thangkas— the silkworm has more impact than he could ever imagine (if he had the capacity to imagine anything at all). His raw material will combine with the intention of his human collaborators to create art with the power to free beings. In this collaboration, the silkworm's life is enriched with meaning, his karma account is filled with virtue. He has contributed to the liberation of beings in ways he could never accomplish alone.

Is it heartless of me to suggest this interpretation? Am I contriving the teachings on karma to justify killing an innocent being? Maybe. I'm not at all sure. But I do know there's no way to walk through samsara, to walk on this earth, without causing some harm. And I also know my understanding of positive and negative is limited. I cannot see the intricate interconnections of my actions. Where we can create beauty out of ugliness, we contribute to all. Is the beauty created with these worms' lives sufficient good to compensate their loss? Do I have the right to make that choice for them? These are challenging questions. And maybe more important (and more possible) than answering them is continuing to sit with them, remaining open to their teaching and implications, wondering.

The only way to stop causing harm is to become free of the cycle, so that all of one's actions—and one's very being itself—are a manifestation of compassion.

Remembering the silkworms with each stitch, remembering their sacrifice and their contribution, I dedicate whatever beauty I've created and whatever benefit comes from my art and from this book to the freedom and well-being of all beings everywhere, especially to those diligent silkworms without whom my work would not exist.

❈ Piece 45 ❈

Three Syllables, Three Doors

W hether a thangka is painted or stitched, there's one last step an artist takes before mounting it in a brocade frame. He or she marks three sacred points—behind the forehead, throat, and heart of the divine figure—with three sacred syllables. These syllables—*OM, AH, HUM*—symbolize the blessings of the body, speech, and mind of all buddhas and the purification of our own physical, verbal, and mental activities.

OM corresponds to the body and is placed behind the forehead of the deity. Westerners generally think of the mind as living in the head, but when Buddhists use the word mind, they point to their hearts, and that's where the syllable *HUM* is placed. Neuroscientists have discovered that we have neurons in our hearts and guts, so the ancient Buddhists may have been on to something all along. Wherever its locus, the mind is not the brain nor is it limited to rational thinking. The Buddhist concept of mind encompasses all cognition and awareness and all the mental and emotional states that occupy it, as well as all the thoughts, attitudes, interpretations, and intentions it generates. This broad

Buddhist conception of mind includes what other traditions might call spirit and soul. Westerners too would probably point to the heart as the metaphorical locus for *that* mind.

AH is placed at the throat, right where you'd expect it to be, as it corresponds to the voice and the full range of verbal expressions.

Body, speech, and mind are the three doors through which we engage the world. They are the means by which we enact all benefit and harm, to ourselves and to others. We fill our stores of positive and negative karma with our actions and words, powered by our intentions and interpretations.

In meditation, a Vajrayana practitioner visualizes the three syllables at the deity's forehead, throat, and heart. Instead of being stuck behind the figure, as they are on a thangka, in visualization they radiate from within the deity's body of light. These syllables and the written characters that express them are not static, nor are they only symbolic. On the contrary, they are multisensory sound-and-light sources. Just as the visualized deity is not a solid form but a dynamic being of light merely suggested by the static imagery on the thangka, so these letters are resounding syllables vibrating in every cell of your body and throughout the universe. They convey the energy of awakening. They announce and express your liberated potential. As their sounds vibrate with your true nature, their lights stream forth to awaken beings in all directions.

Nectar may stream directly from the deity's body into the meditator's own heart, throat, or crown. In one of my favorite meditations, Guru Rinpoche, the enlightened yogi who introduced Buddhism to Tibet, emits streams of blessings from his *OM*, *AH*, and *HUM* that flow into me as I beseech his support. Although it's *only* my imagination, I always receive a physical experience of loving energy surging into my body with this visualization.

Thangka painters write the syllables directly on the back of a painted canvas. I write them, in Tibetan, on little squares of satin—white for *OM*, red for *AH*, and blue for *HUM*. With a light

dab of glue, I adhere them to the back of my pieced-silk thangka. When we mark the back of the thangka with these three sacred syllables, we indicate a readiness for the same pure enlightening energy of our visualization to flow through the thangka to us and to everyone.

Once the syllables are attached, the thangka is ready to be framed in brocade.

❈ *Piece 46* ❈

Frames of Brocade

━━

The tsemkhang received orders for all sorts of projects—robes for monks, throne decorations for monasteries and festivals, and brocade frames for painted thangkas—in addition to our appliqué projects. The other apprentices worked on these many projects. For my Tibetan colleagues, apprenticeship in the tsemkhang was a job. Their days were filled with useful work, meeting the sacred sewing demands of the larger community. Training was focused on fulfilling that job.

My role was different. Aside from being foreign and ten years older, my intention was specific. I was there to make thangkas and had become increasingly determined to be able to carry on the work autonomously. For me, training was the clear priority. From the beginning, Gen-la seemed to recognize this even more clearly than I did myself. He honed my assignments so that I would learn everything I needed and nothing extraneous. I was tremendously fortunate to have him safeguarding my education in this way.

There was, however, one unwelcome side effect to this approach: Dorjee Wangdu wouldn't teach me to frame the thangkas. He said I didn't need to know it.

Within the Tibetan community, most thangka artists do not put brocade borders on their own thangkas. Rather, they take their finished thangkas to tailors for framing. Even more commonly, painters deliver their paintings to patrons unframed, and the patrons then take them to tailors for finishing. So, in the Tibetan community, an artist doesn't need to know how to frame her own thangkas. Gen-la probably supposed I could bring my completed thangkas back to his workshop for framing when needed.

But I didn't know how long I'd stay in Dharamsala. I knew it was likely I wouldn't live among the Tibetans forever. I loved my life in Dharamsala, but when I found myself irritated with Indian bureaucracy or dysfunction, I'd remind myself I was a guest there and could leave if I got too fed up. Eventually, I'd yearn to return to my own culture, and street-corner thangka-framers are in short supply in California.

Plus, at heart, I tend toward an independent, do-it-myself attitude, perhaps an inheritance of American pioneer individualism. I approached my art as a perfectionist; I wanted to apply the same standard of excellence to my frame as to the thangka itself. Most of the frames I saw didn't rise to my standards. Many thangka-framing tailors valued economy over symmetry. In their efforts to conserve fabric, they allowed seams to interrupt brocade strips with an asymmetry that I thought distracted from the harmony of the image. I needed control of my framing process. I needed to learn how to frame my thangkas.

As it became increasingly clear that Dorjee Wangdu wasn't going to instruct me, I asked my colleague Lekshey to teach me after hours. Lekshey's the apprentice who was married to a thangka painter and whose young daughter bounced around the tsemkhang and learned to relish "*sha!*" My English friend Kate came along, too. Kate was also married to a Tibetan thangka painter. She wanted to know how to frame her husband's thangkas, in case they ever relocated to England and had to manage on their own.

The fabric mountings of early painted thangkas were often very simple. Some were just strips of blue cloth sewn along the

upper and lower edges of the painting. In recent centuries, however, fabric frames for painted thangkas have become more substantial and are usually made with multiple strips of multicolored brocade that surround the painting on all sides. This was what I wanted to learn from Lekshey.

Lekshey invited Kate and me to her home near the library and, over the course of three full days, led us through all the steps of thangka framing. I scribbled down everything she said and sketched everything she demonstrated in a red clothbound notebook with yellow stitching. I still have that notebook today. Even now, twenty years later, whenever I need to frame a thangka, I refer to the copious notes I made during Lekshey's lesson.

Lekshey showed us how to square and re-square the brocade strips that would form a rainbow around the thangka. She taught us to insert a wooden slat along the top edge of the fabric frame and attach narrow fabric strips that serve the dual purpose of suspending the completed thangka from a hook for display and keeping the thangka securely rolled for storing and carrying. She walked us through the awkward process of stitching the painting into the frame without damaging it. We learned to enclose a rod along the bottom edge of the frame, too. This rod provides the rigidity and weight to make the entire thangka—imagery and frame—hang smoothly against the wall.

We finished the assembly with a soft silk veil, much thinner than the heavy brocade of the frame. The veil is called a face cover (*shalgab*-འཞལ་གབ་) in Tibetan, because it hides the face of the divine figure depicted in the thangka. In fact, by draping the face of the whole thangka, it protects unauthorized eyes from viewing the image. I believe this protection was the original purpose of the drape, though it can also protect the thangka from dust. Some images are meant to be seen only by practitioners who have been properly initiated and instructed. To view such images without proper instruction is thought to be risky to the uninitiated viewer, who may misunderstand what he or she is seeing.

For display, the veil is gathered and tucked under a string that runs along the front of the upper slat. When tucked up in this way, it creates a decorative flourish above the picture giving it a celebratory and honored look. Ribbons hang down in front of the thangka and add to the celebration. It's like arranging flowers and putting on our best clothes for a respected guest.

After our lesson, Kate and I tested our newly acquired skills on one of her husband's thangkas. It took us most of a week and lots of discussion about what our notes meant, but we managed it. We stitched strips of brocade into a frame, sewed the thangka into the opening, and enclosed the upper slat of wood. We stitched a straight line across the bottom of the brocade and backing. All that remained was to insert the wooden rod that a carpenter in the bazaar had cut for us.

That final stage of securing the lower rod in the brocade requires four hands to accomplish and, though the deity portrayed in the thangka had four arms, Kate and I each had only two. We needed to work together. It was raining hard that afternoon. Kate's two-year-old son, William, busied himself with some wooden blocks and a spoon in the corner of my small living room.

Kate and I sat opposite each other on the striped rug that rested on the thin, flat carpet that covered the concrete floor next to my bed. (By then, I lived in an Indian neighborhood downhill from the library, in a small cottage owned by a retired judge. This cottage had been his mother's puja room, her home temple, and still had an *OM* molded in relief on the mud wall.) We each held an end of the rod and pulled the string of our makeshift plumb line along its length. We'd made our own plumb line by threading a string through a leather pouch of chalk. Peering at each other along the length of the rod, we adjusted and readjusted until everything was in perfect alignment. If the fabric was not perfectly aligned with the rod, the thangka would not hang smoothly or roll up well.

I reached out my free hand, lifted the string with my thumb and index finger, and let it snap down against the rod. Chalk dust sprayed off the wood and into the air like water from the sprinklers I'd run through as a child in California. The chalk left

a perfectly parallel line along the dowel's surface. We set the rod down, so Kate could mark the ends of that chalk line with pen. These marks would help us align the seam at the bottom of the thangka with the rod when we glued them together.

As William played and rain fell, we used wide paintbrushes to spread flour-and-water paste on the inside surfaces of the fabric below the seam, carefully working it right up into the seam without getting any on the face of the fabric. Then we lifted the rod. Kate held one end of the two-foot dowel while I held the other. Facing each other, we each pulled on the brocade until it was taut, balancing the thangka's awkward weight as we worked. Then we set the plumb line into place again, holding the string against the pen line at our ends of the dowel with one hand, while tugging the brocade this way and that with the other.

Eyeing the line, pulling the fabric taut around the rod, smoothing the fabric against the wood, adjusting the seam to check its straightness, eliminating gaps, bubbles, and crooked bits, all had to be done without smearing any of the wet paste from our fingers onto the front of the luscious silk brocade. The subtle adjustments were endless. Each tug to bring one area into line brought another area out of line. With single-pointed focus, we continued to adjust—gently, subtly—knowing that eventually full alignment would occur . . . and, if we were lucky, would do so before the paste dried! Racing against the evaporation rate, we were grateful for the rain's part in slowing that down.

Lightning flashed. The lightbulb hanging overhead flickered and then died. Darkness fell. The power was out. It was late afternoon, well before sunset, but the sky was dark with storm.

William started to scream. And scream.

Kate and I held the dowel and brocade. We'd reached the point of no return. If we let go now, the paste would dry. The fabric would be ruined, and all our efforts would be lost. Kate's husband might not be too happy with the state of his beautiful thangka either.

One hand reached for a candle and somehow managed to light it. William continued to scream. Kate murmured motherly

comfort but could not let go of the paste-sticky, quickly drying edge of the brocade hanging off the precious thangka painted by William's father. The job had to be finished!

Frantic, yet more concentrated than ever, we smoothed and pulled, quickly yet gently, by candlelight, to the soundtrack of William's screams and pouring rain, until it was just right, perfectly aligned and smooth. Finishing our first brocade frame amidst this cacophony made every thangka frame that came after it a piece of cake. Speaking of cake, after all that concentration, it was clearly time for a well-earned cup of tea and a box of our favorite biscuits!

❋ *Piece 47* ❋

Blessings from
His Holiness the Dalai Lama

It was spring of 1997 when I finally finished the big Buddha thangka for Carolyn and began to think about what was next for me and this art. Who would I make thangkas for? I felt inclined to serve a Western clientele to avoid infringing on anyone's territory in the Tibetan exile community in India. At the same time, I wanted to honor and uphold the tradition as I traveled with it into different environments.

Seeking guidance from the foremost guardian of Tibetan culture, I sent a letter to the Private Office of His Holiness the Dalai Lama. In it, I introduced myself and explained that I'd been studying Buddhism at the Library of Tibetan Works and Archives and learning to make appliqué thangkas at the tsemkhang, more or less on His Holiness' front porch, for the past five years. I had just finished my first commissioned thangka and was getting ready to take my work out into the world, to graduate from thangka school and introduce myself to the dharma centers and art collectors of the West. Might I be able to meet with His Holiness for blessings and guidance as I prepared to cross this threshold? It would be a great honor.

I was stitching in my mud-wall prayer-room cottage a few weeks later when I received the response. I'm not sure whether it was a phone call or a letter. I did have a telephone by then, a "land line," though it might be more aptly called a "laundry line." Its wire lay on my roof and stretched across the courtyard, where my neighbors draped it with laundry and the monkeys used it as a trapeze. As you might guess, service was intermittent.

But I can't remember if I was on the phone or reading a letter when I got the news. The memory feels more like a letter. I was sitting in the window nook at the foot of my bed. Sun filtered through the glass, igniting the warm glow of the earthy terra-cotta colored walls. "Of course, you should have an audience," it said. A date was offered. "His Holiness would like you to consult some other lamas first, to get a wide range of perspectives on your questions in preparation for your meeting." The letter was signed by His Holiness's personal secretary, Tenzin Geyche.

I looked at the date. June 18. My father was scheduled to visit at that time. He would be in town for a few days before we went to trek in Ladakh together. Could he come with me? For this question, I'm sure I phoned and timidly asked permission to bring my dad to my meeting with the Dalai Lama.

"Yes, of course," came the response.

Am I dreaming? asked a voice in my head.

I was accustomed to seeing His Holiness from afar, at public teachings and when his motorcade passed on the road. But it was hard to imagine myself sitting directly across from him having a private conversation. I was delighted and terrified.

Six weeks later, my father and I were escorted through the palace gates and asked to wait in a small vestibule. Were we frisked? My dad says he remembers it; I don't. Scanned with a metal detecting wand? Maybe. All I know for sure is that I was shaking with excitement and apprehension. I was about to meet the man I respected more than any human being on the planet. I searched my mind: *Is there anyone I respect more?* No, no one. And he's a world leader. *I'm meeting with a world leader!*

I had met His Holiness twice before, in group audiences for

volunteers. I'd stood in long reception lines to receive his blessings on several occasions. But this day was different. During those other encounters, I could just bask in His Holiness's glow while other people made things happen. I hadn't had to say or do anything. This time, it was up to me. This saintly world leader was giving me twenty minutes of his precious time. He was going to respond to *my* questions and look at *my* thangka.

I'd wrapped the rolled-up thangka in plastic to protect it from the mist and the ever-present possibility of rain. One of the attendants extended his hands to accept it from me, palms facing the sky, head bowed. He carried the large plastic-wrapped scroll like a platter of delicacies up toward the house. Tibetan men in suits and ties and an Indian security guard with a rifle accompanied Dad and me in the same direction, up the curving asphalt driveway and past a manicured colonial-English-style garden toward the Dalai Lama's residence.

We climbed two steps onto a wide veranda. At the far end, I saw a gathering of Tibetan men, women, and children. Judging from their shabby dress, I surmised they were new arrivals who had recently made the rough journey, on foot and by bus, over the mountains from Tibet. With gentle command, our chaperones directed Dad and me to turn right and ushered us through French doors into a spacious living room furnished with an assortment of chairs, sofas, and coffee tables. Heavily curtained windows lined the walls, alternating with small thangkas. The attendants led us to a beige tweed sofa then left us alone to wait. I perched at the edge of the firm cushion, ready to stand at any moment.

My thangka was hanging in a slightly recessed window. The attendants had centered and leveled it precisely. They'd parted the curtains just enough to frame it the way theatre curtains frame a stage. Dim backlighting made the image glow. I felt proud of my work. *I made that.* Even if I didn't manage to get my tongue untied, at least I had the thangka to show. I willed my nervous hands to stay still by focusing on the sound of His Holiness's voice as he comforted the impassioned pilgrims outside. Despite our

very different circumstances, I could feel their ardent emotions mingling with my own.

I'd just begun to detect a lull in the murmurs when the veranda door swung open, and His Holiness entered the room briskly, tossing the end of his maroon robe over his shoulder as he walked. He was followed closely by his secretary. Dad and I scrambled to our feet, white scarves in hand. His Holiness paused to pay his respects to the new Buddha image in the room, then turned to greet us. Did I try to prostrate? I don't think so. His Holiness usually discourages it, and Dad would have thought I'd lost my mind. I simply lowered my head and raised my two hands to offer the white scarf. His Holiness received it and laid it gently over my shoulders.

"Ya ya," he said, chuckling warmly. He clasped my hands tightly and leaned in to touch his forehead to mine.

His Holiness sat down in the armchair to my right, facing the thangka. As my father and I settled nervously into our seats, His Holiness gazed at the thangka as if he were communing with it. I held my breath in anticipation. When he finally spoke, it was quietly, under his breath and in Tibetan. "Very beautiful. Very well done," he noted, as if to himself. My Tibetan was good enough to understand the words, and my ego was dependent enough to be nourished by the praise. I could have gone home right then, having received what I'd come for—acknowledgment and approval from the supreme caretaker of Tibetan culture and the man I admired most in the world.

From there, our conversation proceeded in English. "So?" His Holiness met my eyes with urgent curiosity as he turned the agenda over to me. I introduced myself and my father and explained that I'd been studying Tibetan appliqué with Dorjee Wangdu and taking Buddhist philosophy classes at the Library of Tibetan Works and Archives for more than four years. Having completed my first solo commission, I was now ready to work on my own and to share my work outside of Dharamsala. I sought His Holiness's guidance and blessings in this endeavor.

"I will be visiting dharma centers in the US," I said. "I hope

to share my artwork with practitioners and, perhaps, enter it in art shows and competitions. Would Your Holiness please guide me in discerning appropriate and inappropriate venues?"

"Hmm . . . What does father think?" His Holiness's penetrating eyes moved to my dad, pinning him playfully on the spot while displaying a great respect for family and birth culture. The Dalai Lama often tells foreigners who are inspired by Tibetan teachings not to become Buddhists. Instead, he encourages us to cultivate practices from our own traditions that tap the universal human potential for kindness and awakening.

"Uh, I'm very proud of her." Dad stammered like a student unexpectedly called upon by the teacher. "I don't understand it much. I'm just a lawyer from California, but I see that it makes her happy." A perfect parental response. Gratitude surged through me, and my face flushed with awareness of my great blessings: the support of my parents, the serendipity that had plucked me out of California and placed me in this living room with His Holiness the fourteenth Dalai Lama of Tibet. It was almost too much goodness for one body and mind to handle.

"Your Holiness," I heard my trembling voice ask, "I know the practice of some deities requires initiation and instruction; I've received some of those initiations from you. But what about my patrons? Should I make sure people have the right empowerments before I agree to make a thangka for them?" Instruction and empowerment serve to protect practitioners from dangerous misunderstandings. I didn't want to put anyone's practice at risk or offend tradition in any way.

"This is not your business," His Holiness replied after a thoughtful pause. "The important thing is that they have a respectful attitude. A good motivation. And you, too. Always a good motivation. This is very important. And respect. Very important.

"Try to persuade. . . ." He turned to his assistant for confirmation that he'd chosen the right English word. "Persuade? *Re wa?* Hmm. Try to persuade them to choose a peaceful deity like Tara or Manjushri. Do your best. But if someone really wants you to make a wrathful image or *yabyum* (an image of male and female

deities in union) . . . if they insist, check their attitude. Do they have respect? Are they sincere? If yes, then okay. You make it. These days, they can find these images anywhere. If you make it with good motivation, it is good for everyone. But if they have no respect, then just say no."

He turned to his assistant again. "Refuse, *re wa*? Yes, yes, refuse. If no respect, then refuse. If have respect, then try to interest in peaceful image. You show them and try a little bit to convince. Then, whatever you make, if respect is there, it's okay."

We spoke of exhibitions, compositions, and where to place thangkas in a home. As instructed, I'd spoken with several lamas in preparation for this meeting. Memory has stitched all the conversations together. But even if these words didn't all come directly from His Holiness's mouth, his bearing encompassed them all. Three qualities repeatedly arose in the lamas' responses: excellence, sincerity, and respect.

Excellence. Do the very best work that you can. Don't be sloppy. Make it as beautiful as you're capable of making it. And charge an appropriate price, only enough for you to continue the work, no more. While stitching, don't think of business or profit. Direct your attention to the excellence of your work and to the well-being of the person who's asked for it and all beings who will see it. And remember, also, the beings who contributed to it—your teachers, the weavers, the silkworms.

Sincerity. Be truthful about what you're offering. Never pretend that a thangka is antique when it's really new. *Why would I ever do that?* I wondered. (This is more a concern of dealers than artists. As an artist, I'm much more likely to be prideful and to exaggerate my role than to pretend someone else did my work. Some years later, though, I did encounter some wealthy collectors who were only interested in antiques. *How sad,* I thought. Thangka-making is a living art. Sacred art is made sacred in humans. Quality seems to me so much more important than age.)

Respect. Put buddha images in high places to cultivate aspiration. Don't hang them in the bathroom to look at while you're sitting on the toilet. Reflect on the teachings and use the thangkas'

presence to encourage your practice. Be ashamed to cause harm in their presence.

I showed His Holiness pieces of the Green Tara thangka I was making for friends who had commissioned it for their newborn daughter. Geshe Sonam Rinchen had suggested the commission, saying it would create auspicious conditions for the baby's future. His Holiness expressed genuine interest in my work in progress. He leaned in closer to examine the green-satin face and partially completed arm that I laid out on the coffee table, pleased and curious as a loving friend or proud parent. The sensation of receiving such sincere interest remains with me even now. As an artist and a teacher, I hope I am giving even a fraction of that experience to others.

"Your Holiness, what are your views on using the artistic techniques I've learned from Tibetan tradition to make non-traditional images?" I was imagining landscapes, perhaps with a small Buddha in the sky. Another lama had already advised me to be careful with such compositions, for my own sake and that of viewers. He urged me always to place the Buddha in a position and context of honor. Maybe I could render scenes from the ordinary lives of ordinary people and reveal the light of their buddha-nature in the shimmer of silk.

"Oh, yes!" His Holiness exclaimed. "And you should make Christian and Muslim images, too. You can speak to your own culture and to the cultures of others through this art. Yes, yes. We are all the same. Human beings. We want love, affection, mother's love. Every religion same. All want kindness. Angels, bodhisattvas same. You make Christian thangkas!"

This suggestion startled me, momentarily knocking me off balance. As a woman of European descent, I guess I represented Christian culture to His Holiness. But my ties with Christian lineage were tenuous at best. For years, I'd heard His Holiness urge Westerners to grow within their own religious traditions, but my heart was Buddhist and felt like it always had been. Getting into the weeds of my religious background didn't seem the best use of our precious time, so I simply nodded, hiding my

uncertainty. I allowed His Holiness's words to trickle into my depths where I hoped they might eventually make some sense. With time, they did.

Although his assignment still unsettles me somewhat, I finally took His Holiness's advice as encouragement to make the Tibetan tradition my own: to take it into my body and into the body of my culture, to carry it into my world and allow it to meet and relate with everything I encounter, within and without. Buddhism did this as it spread from India to other lands, sharing its gifts and insights with other cultures. It morphed and adapted in response to each culture it encountered. In the same way, the appliqué art of Tibet would be transformed as it moved through this California woman. Not only the imagery but also the tools and materials of the art would adapt to the world I met in the times and places that I lived in. His Holiness was teaching me impermanence and interdependence by encouraging me to see myself and the art form I'd inherited as a living, breathing, ever-fluid practice.

While I would continue to look to my teachers for guidance, I could now consider this art my own. I—Precious Empowered Initiate, Rinchen Wongmo—was authorized to connect with my world through the language of Tibetan appliqué. The buddhas and the silks had become my companions. Stitching and sharing them was my practice.

In subsequent years, I made several thangkas for friends and family, for practitioners and art lovers. I experimented with imagery, blending traditional techniques with contemporary photographs, portraits of real people, and still-veiled buddhas in progress like me. The sacred figures of Tibetan Buddhism have woven their way into the fabric of my life. I'm no iconographer. If you ask me to speak about the symbols that appear in thangkas, I have to look them up, to refresh my memory. I never held all those details in my head. And now, several years and thousands of miles away from the Tibetan community, I am no longer surrounded by reminders of the deities' symbolism. But whenever I spend time with these beings, whether in meditation or in thangka-making, I know—on some unspoken, unanalyzed level—that they are the best of me.

They are the most potent and potential-rich aspects of my own being. As I rest in their energy, accompanied by generations of artists and practitioners, I feel enormous gratitude for them and for the path that allowed me to make these images.

Making thangkas, for me, is a way to befriend the buddhas. In the remaining chapters, I'll introduce you to some of my friends.

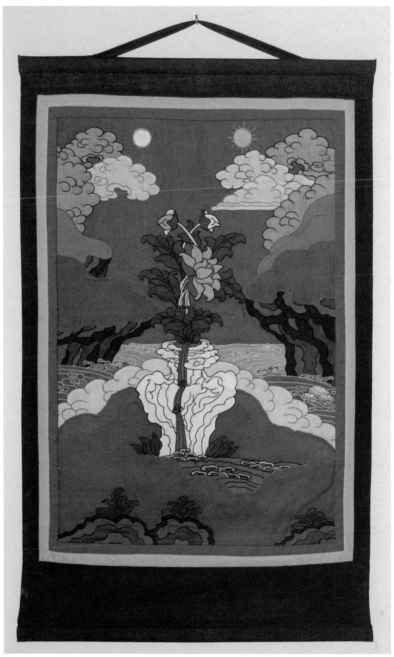

This is the first thangka I made completely on my own after asking Alex to draw me a thangka without eyes. I used simple cotton fabric and thread, instead of silk, for this project and worked on it in the evenings after returning home from the tsemkhang.

Selecting silk satin at Kasim Silk Emporium in Varanasi with my friend, Ani.

My brocade selections, packed and ready to go.

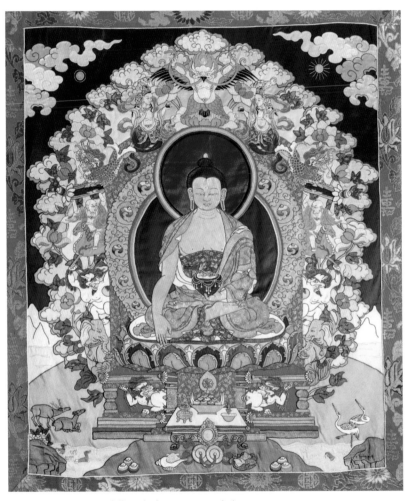

Buddha Shakyamuni and the Six Supports.
Tibetan appliqué thangka completed for Carolyn in 1997.
198 x 127 cm with brocade.

*His Holiness the Dalai Lama with me,
my dad, and my thangka, 1997.*

*His Holiness the Dalai Lama examines pieces
of my Green Tara work in progress.*

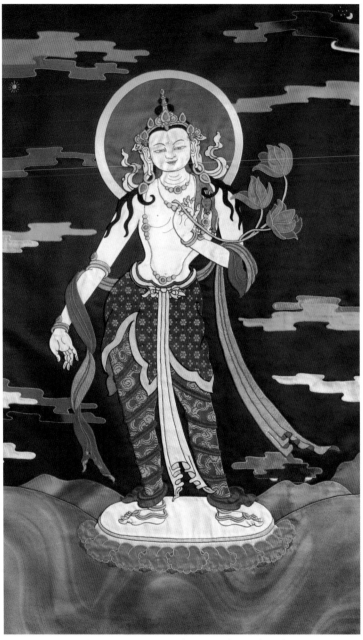

Padmapani, *2004. Tibetan appliqué thangka*
by Leslie Rinchen-Wongmo, 153 x 90 cm with brocade.

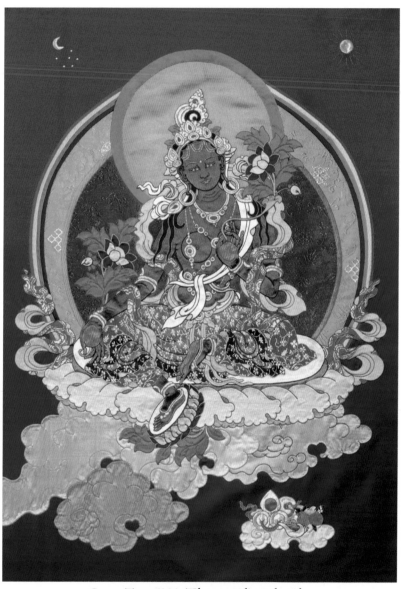

Green Tara, *1998. Tibetan appliqué thangka
by Leslie Rinchen-Wongmo. 78 x 53 cm excluding brocade frame.*

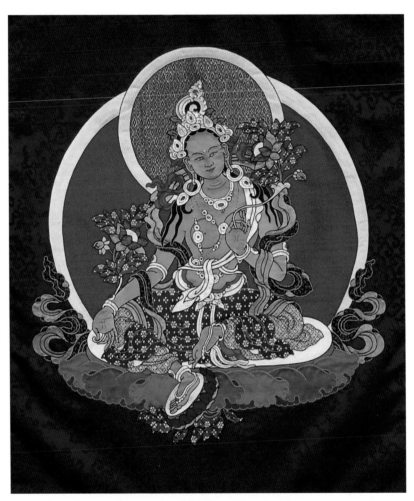

Green Tara, *2008. Tibetan appliqué thangka*
by Leslie Rinchen-Wongmo. 153 x 90 cm with brocade.
The documentary film, Creating Buddhas: The Making and Meaning
of Fabric Thangkas, *follows the process of creating this thangka.*

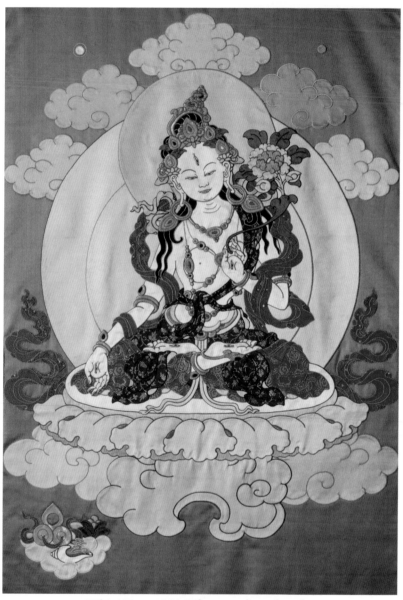

White Tara, *2001. Tibetan appliqué thangka*
by Leslie Rinchen-Wongmo. 147 x 76 cm with brocade.

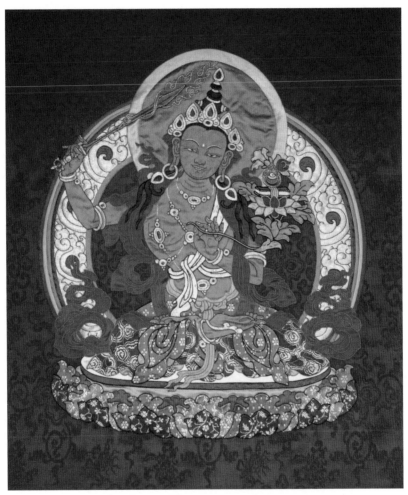

Manjushri, *2003. Tibetan appliqué thangka*
by Leslie Rinchen-Wongmo. 126 x 96 cm with brocade.

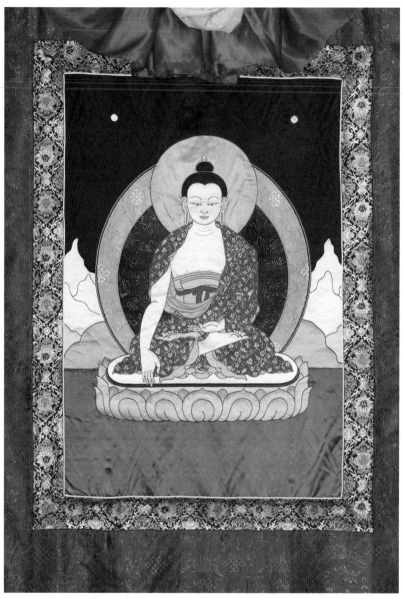

Buddha Shakyamuni, *1999. Tibetan appliqué thangka*
by Leslie Rinchen-Wongmo. 145 x 67 cm with brocade.

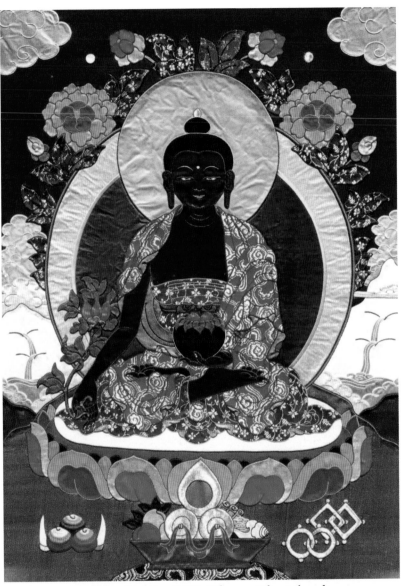

Medicine Buddha, *2000. Tibetan appliqué thangka*
by Leslie Rinchen-Wongmo. Approximately 75 x 50 cm plus brocade.

Lotus flowers and fish detail from artwork
by Leslie Rinchen-Wongmo, 2016.

Lotus, 2000. *Tibetan appliqué*
by Leslie Rinchen-Wongmo. 24 x 30 cm.

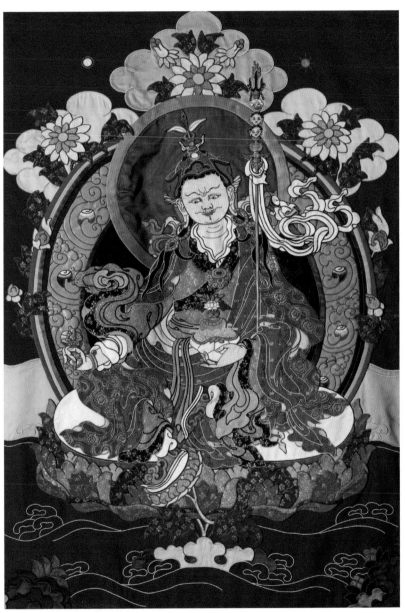

Guru Rinpoche, *1999. Tibetan appliqué thangka
by Leslie Rinchen-Wongmo. 79 x 54 cm plus brocade.*

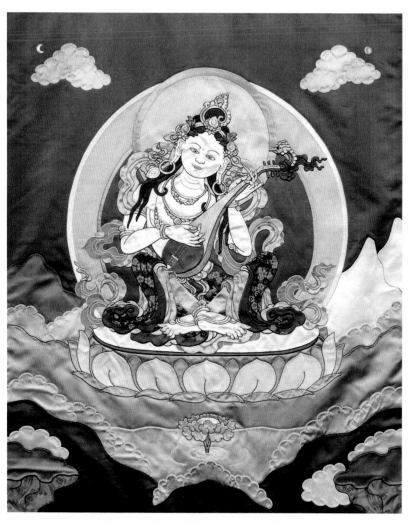

Saraswati, 2001. *Tibetan appliqué thangka*
by Leslie Rinchen-Wongmo. 128 x 77 cm with brocade.

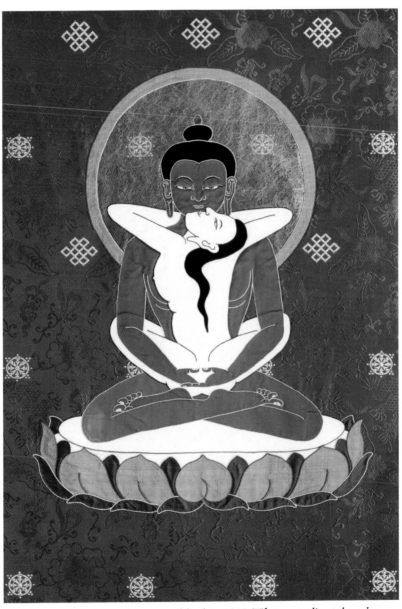

Samantabhadra and Samantabhadri, *2015. Tibetan appliqué thangka by Leslie Rinchen-Wongmo. 132 x 76 cm with brocade.*

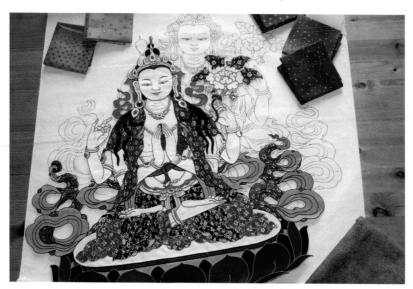

Chenrezig in progress.

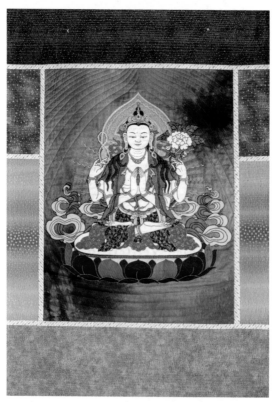

Chenrezig, 2008. *Tibetan appliqué on a quilted
background by Leslie Rinchen-Wongmo. 109 x 79 cm.*

Part Seven: BUDDHAS

Because the minds of ordinary beings are too obscured to receive teachings directly from the Buddha's omniscient mind, he appears in various form bodies according to the dispositions of sentient beings, in order to teach them. Due to sentient beings' different mental inclinations and different physical constituents, various meditation deities appear. All tantric deities are one nature—the exalted wisdom of bliss and emptiness.

—THE DALAI LAMA AND THUBTEN CHODRON,
Buddhism: One Teacher, Many Traditions

❈ *Piece 48* ❈

Padmapani,
My Patience Tester

Avalokiteshvara is the embodiment of all the buddhas' infinite compassion. We met him earlier in his thousand-armed, thousand-eyed form, which provided good practice for apprentices learning to embroider eyes. He is the patron deity of Tibet, known in Tibetan as Chenrezig. He watches over the Land of Snows and incarnates as the Dalai Lama. During the Buddha Shakyamuni's life, Avalokiteshvara manifested as one of the Buddha's main disciples, a bodhisattva who was already enlightened and still fiercely engaged in helping others to wake up too. He played an important role in many of the Buddha's discourses. In the Heart Sutra, the most concise expression of the Buddha's view of the nature of reality, Avalokiteshvara explains the emptiness and interdependence of all phenomena. The ultimate truth of existence is that nothing exists on its own and that everything is interconnected.

Among the many forms of Avalokiteshvara, the two-armed, single-faced form called Padmapani is probably the oldest. Padmapani is often seen in thangkas of Buddha Shakyamuni, flanking

the Buddha's throne opposite another bodhisattva, either Man-jushri or Vajrapani. This figure is also frequently depicted in sculptures; rarely is it seen alone in a thangka like this one.

Padmapani means lotus-in-hand, and his left hand holds the stalk of the lotus. The right hand, opening outward, is lowered in a gesture of granting favors, which also indicates his readiness to help. Draped over his left shoulder is the skin of a wild deer renowned for its compassionate nature.

The couple who commissioned this thangka from me had been deeply moved by the landscapes and light of the American Southwest. Now living in an urban environment, they wanted to bring the warm colors of the desert into their home along with the warmth of Padmapani's blessing. The wife had chosen the deity for the commission. Her husband was in charge of the color palette. He wanted the image to glow like sunset in the Arizona desert. I perused photography books of the Southwest and even took my own photos on a driving trip through the desert the autumn before starting work on the thangka.

After four months of work, I was almost finished. The face was tender, the striped leggings enchanting. I loved the grace of the scarf flowing off Padmapani's outstretched hand. I was pleased with my work. And I was almost done. In a process this long, "almost done" can be deceptive. I always get fooled at this point, thinking completion is just around the corner, maybe only a few days away. When this trick gets ahold of my mind, my work hours get longer and longer. I work more and more diligently, imagining I'll finish tonight if I just put in a few more stitches. No? Well, tomorrow then . . . This goes on for a few weeks until the thangka is truly finished. And even then, there's still the brocade frame to make.

As explained above, Padmapani is a form of Chenrezig, the Buddha of compassion, lord of love. Chenrezig is also my *yidam*, my guide, my main practice, and this was the first thangka of any form of Chenrezig that I was making on my own. It seems Chenrezig wanted to test me as I brought forth his likeness. He chose this "almost finished" moment to start the test.

Light streamed in from the tall window at the end of the living room that served as my tsemkhang. I was married now and living in Milan, Italy. The traffic of Viale Abruzzi rumbled five floors below, making the single pane of glass rattle like a puja drum. Horns honked, reminding me of the long horns the monks played to announce the oracle's trance from the roof of Nechung Monastery, just outside my library room window. Actually, I wish I'd had the presence of mind to hear the connection then. In truth, I was irritated by the rattling windows and the incessantly honking horns, yearning to be back in a place that felt more like home.

I sat on a simple wooden stool from Ikea, assembling Padmapani on a pressboard worktable, also from Ikea. Crusca, my cat, was curled on the yellow sofa, having finally abandoned her place on my ironing cloth after being shooed away countless times.

I'd chosen hand-dyed silk charmeuse in various colors to create the landscape of this thangka. The fabric's soft waves of gradated color were reminiscent of the desert's painted light. I set clouds of this charmeuse against a dark-blue sky of satin from Varanasi. Charmeuse is a softly draping fabric without a trace of stiffness. Perfect for slinky nightgowns but not so good for a wall hanging. Appliqué thangka-making requires fabric with some solid structure, a bit of rigidity to hold its shape. Having rejected meat and poisons, I'd developed a method to stabilize fabrics with a gel-like mixture of methylcellulose and acrylic. I'd spread it on the back of my fabric with the edge of a credit card or expired driver's license. But that method would not work on charmeuse. It was too flimsy, too unstable. The act of stabilizing itself would distort this fabric. A more stable support was needed. So, I ironed fusible interfacing to one side of the silky material, stiffening it from behind just enough to be manageable. It worked but did not completely tame this challenging fabric. Our collaboration—mine with the cloth—felt adversarial at times. To achieve my design, I had to alternately coax and beat the fabric into submission.

Now, finally nearing the end of the project, assembling the last pieces, and situating the deity in his surroundings, I imagined I had made it through. I was free and clear after a long battle.

Happily chanting mantras, I glued the figure of Padmapani onto the assembled background—the dark blue of the sky rising above a swirling brown ground. Thin strips of colorful cloud made the sky glow like the desert sunset my patrons had requested. The brown hills provided stability beneath the deity's feet, while the swirl pattern of their fabric revealed the changing nature of even seemingly solid things. I used a toothpick to apply fabric glue to the back edges of Padmapani's figure, carefully and sparingly. I was pleased. Proud, even.

Plop!

Before I could do anything to stop it, a drop of glue fell from the toothpick in my hand. The small white drop landed, enormous, on the dark blue fabric just next to Padmapani's leg. My heart sank.

I grabbed a muslin cloth and wiped away the glue. Hopeful and hopeless at the same time, I ran to the kitchen, dampened a corner of the cloth and returned with tears in my eyes to wipe some more. There was no way to completely remove the spot. In an instant, my pride turned to despair. My almost-done thangka was ruined. I would have to start over—cut stitches to detach the clouds, the hills, the sun and the moon and then stitch them all again to a new blue-satin sky. But I had only a small piece of that blue satin left in my cabinet. It wasn't enough. I'd have to change the color of the sky and disrupt my carefully crafted sunset palette. I could try to order more satin from Hasin, but that was risky. I never knew if the right color would arrive. And, anyway, it would take several weeks to be dyed, woven, and shipped to me. That path was simply unacceptable.

I stopped work for the day, dejected, dispiritedly chanting a few mantras with no idea what would come next. I lay a sheet over the thangka on the table, and my cat Crusca happily curled up on top of it while I got ready for bed.

I woke in the middle of the night with an idea: clouds in the desert sky, in any sky, are always shifting. Isn't that the Buddha's teaching? Mind's nature is constant, open, luminous. Thoughts and emotions are like clouds—temporary, shifting.

"I'll add a cloud to cover that glue spot!"

And so I did. And did so again when another drop of glue fell the next day.

Of all the thangkas I've made, this (on page 229) is the only one that had glue fall onto the background, and then fall again. Perhaps, Chenrezig, in the form of Padmapani, was teaching me a lesson about the nature of my mind and the workability of clouds.

❊ Piece 49 ❊

Green Tara,
the Swift Protectress

"Tara's a great friend to have on your side," said Venerable Amy Miller in *Creating Buddhas: The Making and Meaning of Fabric Thangkas*, a documentary produced by Isadora Gabrielle Leidenfrost of Soulful Media in 2008. As wisdom itself, Tara is mother of all buddhas. And in her green form, she is the embodiment of enlightened activity. With one foot outstretched, she's ready to rise instantaneously to your support and protection. Beautiful, fiery, unflinching, sure. Green is the color of the wind element, energy, movement, activity.

Tara also illustrates the genderless nature of enlightenment, proving that women are vessels as suitable as men. She has many origin stories. In one, an accomplished practitioner named Princess Wisdom Moon became a bodhisattva. At that point, the monks encouraged her to pray for rebirth as a male in order to complete her spiritual training and become fully enlightened. They believed maleness was an obligatory gateway, a prerequisite, to buddhahood. Princess Wisdom Moon forcefully rejected this idea and, instead, gave a teaching on the illusory nature of sex,

gender, and even personhood. Recognizing the rarity of great female practitioners, she vowed to be female until all beings had been freed from the karmic cycle of suffering. "Until samsara is empty, I shall work for the benefit of sentient beings in a woman's body," she declared. "In practicing the Buddha's teachings, one's form is irrelevant. It is one's determination to be free from the cycle of conditioned existence and one's compassionate concern for the welfare of others that are of paramount importance."

Another legend holds that after working for eons to free beings from suffering, Chenrezig looked out on the ocean of beings and saw that samsara was still full of suffering and ignorance. His despair at the sight brought him to tears (and, in another version of the story, caused him to break into a thousand pieces). Due to the potency and purity of his compassion, lakes formed where his tears fell, one on the left and one on the right. Out of those lakes emerged green and white goddesses, White Tara on the left and Green Tara on the right. They convinced Chenrezig to persist in his promise to free all beings and pledged their collaboration in his cause.

As of this writing, I've made three Green Tara thangkas, including the one pictured on page 231, which was featured in the documentary *Creating Buddhas: The Making and Meaning of Fabric Thangkas*.

❀ *Piece 50* ❀

White Tara,
Live Long and Practice

White Tara, like her sister Green Tara, arose from the compassionate tears of Avalokiteshvara and vowed to become enlightened in female form. She, too, is the embodiment of enlightened activity and the mother of all buddhas. Eyes in the palms of her hands, the soles of her feet, and the center of her forehead allow her to look everywhere, upon all beings, with clear-sighted wisdom and deep compassion. Seeing so much with such keen discernment, she knows just how to help each person in their unique predicament.

White Tara is specifically associated with longevity practices. Human life is precious, and Tara wants you to enjoy its privileges for as long as possible. Why? To collect more toys and experiences? Out of fear of what follows? No, of course not.

From Tara's perspective, this precious life is a training ground for freedom. Are you taking advantage of the facilities? Tara wants to extend your membership in the human gym for as long as it takes for you to wake up. She'll even send you a personal dharma trainer.

I stitched this White Tara (page 232) for my parents after making them wait longer than I should have. They asked to commission a thangka from me as soon as I'd finished Carolyn's big Buddha. While I appreciated their interest, I felt a need to prove myself in the world before accepting their order. Taking a commission from them felt like cheating, like maybe they were just asking because they loved me, not because I was really producing something of value. Later, as other friends and relatives requested commissions, I came to realize that love may be the best conduit for sharing one's gifts. It's what connects us with one another. Rather than resisting the gifts of love, I'm learning to step into the opportunities love opens. That's how White Tara trained me while blessing my parents with a longevity we continue to enjoy.

❈ *Piece 51* ❈

Manjushri, Cutting Through Ignorance

●━━━━━━━━━━━━━━━━━━━━━━━━━━━━━━●

O*m A Ra Pa Dza Na Dhi dhi dhi dhi dhi dhi dhi dhi dhi dhi.* . . .
School children and monks recite Manjushri's mantra
before exams, endlessly repeating the seed syllable *dhi* (a sound
somewhere between dee and tee) with mouthfuls of enthusiasm,
sending enlightening showers of spittle into the atmosphere.
Manjushri is the embodiment of all the buddhas' wisdom. He
is intelligence. He is discernment. Gazing on his visage cleans
the patterned cobwebs of delusion from our eyes. Tibetan school
children learn to recite Manjushri's mantra in order to enhance
their ability to study. Monks and spiritual practitioners request
Manjushri's assistance in cultivating the insight necessary to
understand profound truths and subtle explanations.

Do I clearly see what's going on in the world around me? Not
likely. I look out through a filter created by my conditioning. My
mind projects a hologram on the raw material of the world. It
seems as if my sense organs merely receive what's out there. But, in
fact, I'm continuously creating my vision—recycling old pictures
and beliefs, stacking them like Lego blocks to build this moment's

perception. Manjushri represents our potential to drop the blocks and see through to the base reality, the mere appearance on which we've propped our preconceptions.

Manjushri's flaming double-edged sword cuts through layers of misconception to discriminate between the independent way things deceptively appear to exist and the interdependent way in which they actually exist. Resting on a lotus in his left hand is the text of the Perfection of Wisdom sutra, considered to be the Buddha's most profound teaching on the ultimate nature of reality.

I made this thangka of Manjushri (page 233) for my ex-husband Francesco when we were still married. We had met during my last year in India while I was mulling a return to the US. Rather than returning directly to California as expected, I moved to Italy to live with him and stayed there for nine years. Although our marriage did not endure as we'd hoped, our connection remains strong. Francesco is a beloved friend and an invaluable support to me and my work.

He describes his relationship with the thangka in this way:

"My first encounter with Manjushri happened in November 1999, when I picked up a used book in a small bookshop in Dharamsala, India. It was *Emptiness Yoga*, by Jeffrey Hopkins. Few books have had such a lasting impact on me and, inside that specific copy of the book, the previous owner had left as bookmark a picture of a colorful figure that my companion in that travel, much more expert than me, identified as Manjushri, the Bodhisattva of Wisdom.

"Since then, that figure with his sword and his book have stayed with me.

"The companion of that travel ended up becoming my partner in many more travels and in life. A few years later she made me an astonishingly beautiful rendition of the same figure embroidered in a silk thangka, which is still my most cherished worldly possession.

"I live in a small apartment in the outskirts of Milan, Italy. The place is full of books, and not much else. On the walls, just a handful of photos, and Manjushri. When I had the walls repainted, I picked a color that looked somehow warm and comfortable. Then

I put Manjushri up in the living room and realized that the color matched the tones of the thangka almost perfectly. I am not a visual person and it definitely happened by chance but, still, it looks beautiful.

"The sword that cuts through ignorance and duality often reminds me of another famous sword, the one that Alexander the Great, according to legend, unsheathed to cut the Gordian knot. Sword and book. Destroy and learn. Such important lessons, and such a hard balance to keep in daily life. Sometimes I close my eyes and recall the image of Manjushri in my mind. It always helps."

❋ Piece 52 ❋

The Buddha, the Founder

Buddha Shakyamuni, who lived in India 2,500 years ago, taught the path to enlightenment based on his own experience of having achieved complete liberation from ignorance and suffering. He taught so that we would be able to follow the same path and achieve the same state ourselves, our full potential as conscious beings. In this thangka (page 234), he sits in utter simplicity, legs crossed in the vajra position indicating the firmness and unwavering stability of his concentration. His right hand touches the Earth symbolizing his victory over all obstacles, while his left hand rests in his lap in the gesture of meditative absorption into the true nature of reality.

I designed this thangka based on another thangka in Korzok Monastery in Ladakh. I was drawn in by its simplicity.

After living with this thangka for several years, the couple who came to own it spoke with me about the impact it had on them. The wife said it speaks to her of the great mystery of life and reminds her, in a heart-and-mind-opening way, how much she still has to learn. Her husband, claiming not to have anything profound to say, proceeded to say something I found, on the contrary, profoundly meaningful. First, he said it reminds him of *me*

and of the events through which the thangka came to them, how I went to India and had the experiences I had with the Tibetans. Then he said he remembers where it hung in their previous home and how they'd made a special space for it in their new home, honoring it while also protecting it from direct sunlight. And then he touched the essential point: "It seems to have informed the whole space of the room and the house around it. All the colors and objects we chose later flowed from a natural desire for harmony with the thangka at the core."

And that's exactly what deities do! When we develop a relationship with them and identify with them at our core, then our whole lives and the world around us are shaped by them.

❋ *Piece 53* ❋

Medicine Buddha, Treating the Root Cause

The Medicine Buddha is revered as the source of the healing arts in Tibet. Tibetan healing practices are based on the premise that the fundamental cause of every disease can be found in physical imbalances that result from the mental poisons of ignorance, attachment, and aversion. True healing must be grounded in spiritual transformation. Buddhas (including the idealized Medicine Buddha and the historical Buddha Shakyamuni) are referred to as great physicians because they possess the compassion, wisdom, and skillful means to diagnose and treat the root delusions underlying all mental and physical sufferings.

To expand on this analogy, Buddha is the physician who diagnoses our ailments and prescribes a treatment plan. Dharma is the medicine that cures us, if taken. And Sangha is the nurse who administers the medicine, supports the patient in implementing the treatment, and accompanies the patient on the path to healing. Medicine is only effective to a patient who follows the prescribed treatment. Likewise, dharma teachings are only useful if they're integrated into one's life.

Medicine Buddha's body has the deep blue color of lapis lazuli. Both the stone and the color carry remarkable healing effects. His right hand is in the gesture of granting blessings and holds the stem of a medicinal plant. His left hand holds a begging bowl filled with healing nectar and fruit.

Melissa came to Dharamsala in 1995 to volunteer as a teacher at the Tibetan Medical and Astrological Institute. To Western readers, medicine and astrology may seem an odd marriage but, in Tibetan culture, they're a perfect pairing. Both strive to understand the movements of the five elements —Earth, Water, Fire, Air, and Space—in the body and in the environment. Together they work to bring a person's mental and physical conditions into balance with external factors and influences. Their shared aim is to help human beings maintain their well-being so that they can achieve enlightenment for the sake of all other sentient beings.

There may be more to this astro-medical compatibility, in fact, because some years later, Melissa, a Jewish American doctor, married Phuntsok, a Lhasa-born Tibetan astrologer she met at the Tibetan Medical and Astrological Institute. After several years in Melissa's native Oregon, they returned to India, accompanied by the Medicine Buddha (page 235) that currently hangs in their living room.

Melissa says, "I am always delighted to introduce the Medicine Buddha thangka to our guests. People marvel at the intricate inlaid patterns, the serene expression of the Buddha, and stepping back, the entire calming image as a sum of many parts. It reminds me of my inner and outer journey through medicine. It is a powerful, transcending image." The thangka keeps her connected with the deep healing she wishes for her patients and the vast healing potential of the human mind.

❋ Piece 54 ❋

Lotus Flowers, Unstained by Circumstance

The lotus flower may not look like a deity, but it conveys all the qualities of a deity and is revered as if it were one. In art, deities arise from lotuses, are supported by lotuses, and hold lotuses in their hands.

The lotus represents the ever-untarnished quality of our true nature. Lotuses don't grow in clean fields, pristine meadows, or cultivated gardens. They rise out of mud and murky water. And they emerge unstained by the muck in which they grow. They're said to represent both bodhisattvas (who live in the world but are not tainted by worldly corruptions) and our own buddha-nature, which is never stained (and is, perhaps, even nourished) by the delightful mess in which it finds itself.

In Indian tradition, the lotus is a fount of creation, a source of possibilities. In Buddhist art, enlightened beings sit or stand on lotuses. When a foot is outstretched, a lotus blooms where it steps. There are countless stories of divine beings emerging from lotuses. In the same way that a lotus arises immaculate from muddy waters, enlightened beings arise unsullied from the

messiness of samsara. This world, so full of destructive emotions, is also the place where we can become buddhas, where we can recognize our buddha-nature, where we can awaken from our ignorance and see reality as it already is. This is the potential we all possess, right here where we already are.

I've made a few of these silk lotuses. And each one invites me to recognize that I don't have to wait until everything is perfect, till my life calms down, till my circumstances improve, or till anybody else gets on board. The lotus blooms right in the middle of the chaos. Perfectly beautiful in midst of the muck.

❖ *Piece 55* ❖

Lotus-Born Guru Rinpoche

Padmasambhava, the lotus-born, known in Tibetan as Guru Rinpoche, was invited from India in the eighth century CE to assist in the establishment of Buddhism in Tibet. Through his awesome mastery of tantric practices, he is said to have transformed hostile spirits and negative forces into guardians and protectors of the dharma, clearing the ground for the Buddhadharma to take root in Tibet. For this, Guru Rinpoche is deeply revered by Tibetans. His powerful presence enabled the completion of Samye, Tibet's first Buddhist monastery. Centuries later, the first giant appliqué thangka was displayed there.

In an act of compassion to future generations, Guru Rinpoche hid "treasure teachings" or *terma* to be discovered after his death, thereby extending the duration of his teaching and continually revealing the Vajrayana path.

Fierce, confident, energetic, and unstoppable. Magical when magic is called for. Forward moving yet firmly planted. Imperturbable. Simultaneously relaxed and vibrant. With total certainty and no fear. Nothing disturbs Guru Rinpoche's consciousness because his consciousness already includes everything. All has already been taken into account, so nothing can make him waver

or reconsider. And yet, there's no rigidity whatsoever in his bearing. He's like a clear, strong pillar of light.

Guru Rinpoche (page 237) wears the garments of both kings and monks to demonstrate his royal status in both the worldly and spiritual spheres. His implements, posture, and the swirling elements surrounding him all demonstrate his ultimate attainment of buddhahood through Vajrayana with its accompanying power and energy.

om ah hum vajra guru padma siddhi hum

❀ *Piece 56* ❀

Saraswati,
Melodious Goddess

Saraswati, the melodious lady, originally a Hindu deity, was absorbed into the Vajrayana Buddhist pantheon. She is the goddess of culture—learning and arts, music and poetry. As such, she symbolizes wisdom and beauty, particularly in the form of sound.

Conferring intelligence and memory, she is also associated with Manjushri, sometimes as his consort. She is named for an ancient river, source of her connection with the fluidity of speech, writing, music, and thought.

I made this thangka (page 238) for my dear friend, Deborah, who is an artist, a writer, and a musician. She is also one of the kindest and most insightful people I know. Conversation with Deborah is like bathing in a river of attention and love. This thangka lives in her dining room, nourishing her and her guests. Much like her, it lights up hearts in the heart of her house.

❋ *Piece 57* ❋

Samantabhadra, Always Good

Samantabhadra is called Kuntuzangpo in Tibetan, which means wholly, completely, universally good. He represents the true nature of every living being before any distortion occurs—the innate, naked, sky-like purity of our minds. He is called the "primordial buddha" because his nature is fundamental to every being and exists in every moment of time from beginning to end. Because he never wavers from pure awareness, his experience is completely free from dualistic consciousness and flows seamlessly from a deep and ever-present well of ultimate truth.

In contrast, the experience of ordinary beings arises from compromised awareness and mistaken perception. This obscured state gives rise to the dualistic sense of self and other. From there, the illusory self perceives the separate external world as being filled with the objects of its desire, hatred, pride, envy, and delusion. Emotional afflictions arise, manifesting the six realms of samsara—based entirely on mistaken perception.

By recalling Samantabhadra, we touch our own fundamental awareness, which is not separate from the objects of our experience.

In this thangka (page 239), the male Samantabhadra is in union with the female Samantabhadhri. Tibetan Buddhist images of the deities in sexual union represent the primordial union of wisdom and compassion. The female represents wisdom or insight, the aspect of emptiness. The male figure represents compassion and skillful means, the aspect of clarity. Their union is complete awakening.

❋ *Piece 58* ❋

Chenrezig,
Focus on Just One

Think a little about emptiness.
Arouse some compassion.
Visualize Chenrezig.
Recite his mantra.
Don't think too much.
—GARJE KHAMTRUL RINPOCHE'S
advice to me

Whether in India or the US, twenty years ago or now, I always seem to have too much to do. Pulled by infinite curiosity, I often find myself on the verge of being overwhelmed. It happens for me with dharma practices too. I attend teachings, experience a deep practice and want to add that one to my repertoire . . . or feel that I *should*. There's never a shortage of exciting new practices and activities. And by "exciting," I might even mean watching my in-breath and my out-breath! Tibetan Buddhism is as chock-full of practice methods as our modern world is of opportunities.

To disarm this overwhelm, one of my most precious teachers, Garje Khamtrul Rinpoche, gave me personal advice in 1999 that

I've had to relearn again and again in the ensuing years. Maybe someday I'll internalize the lesson! He said that while Tibetans tend to practice hundreds of methods, based on thousands of deities, the Indian custom was to focus on just one. He added that the Indian approach was probably smarter for householders, and certainly better suited to my easily distracted temperament.

We non-monastic folks have lots of activities and responsibilities to attend to. We have time constraints and, therefore, can't do elaborate practices well. Rather than trying to perform all the rituals, Rinpoche advised me simply to think of Chenrezig—the representation of fully awakened compassion I was naturally drawn to—and recite the mantra in whatever time I had available. One hour or one minute. It's all the same. Oh, and develop a good heart. Don't forget to develop a good heart. What could be simpler than that?

All dharma is included in Chenrezig, Rinpoche assured me. Nothing else is necessary. Chenrezig's wise, compassionate, light-filled form (page 240) includes all the deities, all the teachings, and all the buddhas. His six-syllable mantra, *om mani padme hum*, contains all mantras. Bodhicitta, the altruistic intention to become enlightened for the sake of all beings, encompasses all virtuous motivations. It's enough. It's everything.

Now, try to remember that while the rich and wonderful world keeps throwing opportunities and options in your path! "Simple" to explain and "easy" to practice have very little in common. Or as Yogi Berra is reputed to have said, "In theory, there's no difference between practice and theory. In practice, there is." I forget simplicity again and again. I try to do a million things and forget to do the one thing. By writing this now, to you, I'm reminding myself yet again. Just Chenrezig, just kindness, just *om mani padme hum*.

That's enough. It's everything.

❋ *Epilogue* ❋

Lineage

MILAN, ITALY—FEBRUARY 2008

"Hello, is this Leslie?" asked the woman on the phone. "I just found your work on the Internet and was absolutely stunned. It's exactly what I want to do. I knew there had to be something like this, some way to practice Buddhism with fabric. Can you teach me?"

I listened, unsure how to respond as she continued, "I've been stitching for a long time and anyone who's seen my work knows that details don't faze me. I've been practicing Tibetan Buddhism for more than ten years, too. I *really* want to do what you do. Can I come visit you?"

Louise was in France, and I was living in Italy then. I'd left India at the dawn of the new millennium and moved to Milan to live with my then to-be (and now once-was) husband, Francesco. I'd been quietly making thangkas on my own in the living room of the sunny two-bedroom apartment we shared with his two teenage children. The apartment's windows rattled constantly from traffic on the busy street five stories below. The unfriendly congestion of flat, gray Milan was quite a change from the pictur-esque hills of Dharamsala, where every venture outside my door had resulted in at least one invitation to tea.

269

My art website attracted a few emails a year from women—and the occasional man—asking if I offered any workshops and if I was coming to their area to teach any time soon (their areas being Australia and Guam and Canada and Singapore and all over the United States). I didn't. I wasn't.

I struggled to see how I could ever teach this art to such widely scattered inquirers. Tibetan appliqué work is slow and arduous, to say nothing of the learning process. It was always transmitted from master to student in long-term, residential apprenticeships over the course of years. What could I possibly teach in a weekend workshop? Just getting the hang of wrapping a horsehair with thread could take days . . . or weeks.

The thought of traveling around the globe, responding one-by-one with minimal effectiveness to each of these sincere inquiries, exhausted me. The itinerant teacher role, performed beautifully by many textile artists, did not appeal to me. And tightening baggage restrictions made it ever more difficult to transport materials from class venue to class venue.

My Cancerian temperament required settling in one place and staying. The art requires it, too. It demands endurance and repetition. As Dorjee Wangdu had indicated when he turned injis away at the tsemkhang door, it's not fast-food fare.

But here was a woman who wanted so desperately to learn that she was ready to book a flight to come see me. She was willing to spend a weekend with a total stranger, to absorb whatever she could of this magical craft of making buddhas out of fabric. An American married to a Frenchman, she'd managed her family's life abroad in rotating countries for several years. Finally, they'd returned to France. Her children were growing and didn't demand all her attention anymore. Louise was looking for meaningful work of her own now—something that would unite her creative skills with her deepest longings for connection and purpose.

Her thread of wonder had led her to me just as mine had taken me to the tsemkhang. She seemed to sense that creating these precious images would help her connect with her highest qualities. And more importantly it would allow her to bring a

similar awareness to others. She was hoping to share an experience of the Buddha's presence in the world through fabric art. It thrilled her to think she could give something meaningful to others by doing something she loved.

Louise's insistent curiosity led me to create the Stitching Buddhas® Virtual Apprentice Program and opened the door for other spiritual, creative, fiber-loving, meaning-seeking women around the globe to follow their wonder threads too. In October 2008, I emailed her first lesson. Over the following months, I worked feverishly writing new lessons to keep up with Louise's progress. Soon, I was emailing students in Singapore, Guam, Australia, and the US who were eager to stitch their artistic and spiritual yearnings together. The following year I established an online atelier where students could watch video demonstrations, post photos of their work, get feedback, ask me questions, and connect with each other in community. The Stitching Buddhas Virtual Apprentice Program grew into a six-month course in which students learn the fundamental skills of Tibetan appliqué while creating a silken lotus wherever they live. Students who have mastered the basic skills can tackle projects of increasing intricacy in a continuing membership program and eventually progress, over the course of years, to making their own thangkas.

Most but not all of the women who enter the virtual apprenticeship have some degree of Buddhist practice, or they're interested in meditation. Most but not all of them have some craft background. Several embroider, quilt, or sew. Two are doll makers. One is a beader, another a photographer. Others are completely new to any practice of making. They may feel "all thumbs" at times, yet they stick with it. Something inside them feels nourished and supported by the stitching practice. The fabric calls to them and gives them gifts.

I'm amazed by their resilience and humbled by the difficulties they overcome—arthritis, fibromyalgia, vision problems, etc.—to persevere in this simple and meaningful act of making beauty.

When I started teaching, I made it clear to everyone who would listen that I was *not* a spiritual teacher. "I'm not a lama and not an

iconographer either," I kept saying. "I just make pretty things that happen to be connected to a rich spiritual culture and to profound teachings on the nature of experience and existence. I can teach you to make pretty things with fabric and thread. I *can't* show you the way to enlightenment or tell you what any of it means."

My art teachers in Dharamsala didn't teach dharma. I had other teachers for that. But it was in the air we breathed there. I didn't know if any of that air was still hanging around me, or if enough of it would travel through cyberspace to meet my students as they stitched.

But then something magical happened that increased my faith in lineage: participants in the Stitching Buddhas program began reporting profound experiences. They were deeply moved. As they wrapped a horsehair, as they stitched a lotus, as they strove for perfection and got stuck, as they experienced frustration and resisted the urge to give up, wide-ranging habitual patterns became visible and workable. They felt calm. They felt more connected. They felt the power of lineage. They felt immersed in a flowing river of beneficial activity. And I felt that too.

As a teacher of this art form I inherited so improbably, I'm a link in a conductive chain. I don't know on what medium the power is carried. Is it the imagery? Is it some seed my teachers planted in me? Do the students bring it with their devotion? Certainly, all of these and something more are in play. There's spirit in the handwork and in the nonverbal, visual, kinetic lineage.

Most women I teach have never been to India or Tibet. Many will never go. Like many people and for many reasons, they would find it challenging to interrupt their lives and live abroad for years on end to engage in traditional apprenticeship. They might find it particularly challenging to live in a country without the conveniences they're used to. But something in them calls out for a craft connected with their spiritual practice, for meditation in action, creating beauty that radiates timeless wisdom and touches their heart. I'm continually surprised to learn how meaningful this work feels to my students, how deeply it captivates them, nourishes them, wakes up sleeping aspects of themselves.

The Stitching Buddhas Virtual Apprentice Program has been operating continuously since 2008 and has had students from nine countries and thirteen US states. Although scattered around the globe, the students form a community, you might even say a "sangha." Technology allows us to communicate across great distances with surprising intimacy. Through it and through the art itself, students are connected to each other, to an artistic lineage, and to the deep well of wisdom and compassion from which it springs.

However far apart my students may live, I strive to replicate the tsemkhang experience for them, sitting with them on a virtual cushion, sharing a cup of steaming butter tea as we plunge the needle through our fabric to take the next stitch. I call it a "virtual apprenticeship," though I use the word "apprentice" with some reluctance. My students do not help me fulfill thangka commissions as I did with Dorjee Wangdu. They aren't exchanging labor for learning. But they are engaging in a long-term, progressive, and purposeful skill-building experience that unfolds as they work with devotion on real projects. Their learning is not theoretical and, though often joyful, it is not "just for fun."

Why do I teach? It keeps the gift alive. I was so surprisingly blessed to inherit this art from Tibetans who were under no obligation to teach me. Why did they trust me? What do I owe them? What responsibility came with the gift? It was never stipulated, but I think it came with a responsibility to the lineage and to my teachers—not as individuals to whom I owe something but like relay runners who passed the baton to me.

I take up my responsibility by transmitting, in my own peculiar way, what I've learned from my teachers to the students who are called to me. Some people—a strange and dedicated few—want to learn the ancient art of making buddhas out of silk. And His Holiness the Dalai Lama encouraged me to carry its transformative power to the West. So, I do what I can. Writing this book is one more way of fulfilling my assignment.

My teachers, my students, and I—even you, dear reader—we're all potential buddhas, stitching buddhas and awakening, thread by thread and piece by piece, to our ever-present buddha-nature.

*With three longtime Stitching Buddhas®
students holding a Buddha they created together.*

Acknowledgments

I have been supported in so many ways by so many people throughout my life and through the years of creating this book. It's inevitable that I will miss some names as I attempt to thank the countless people to whom I'm grateful. For that, I apologize. Even if you're not named, please know I appreciate you.

Writing and publishing a book is a long and complicated endeavor. It's easy to lose perspective, to become discouraged, to wonder whether any of it matters. I don't know if I could have sustained my commitment to the project without the consistent rallying and bolstering of my Wisdom Council—Lisa, Ursula, and Maia.

Along the way, I repeatedly forgot and re-remembered to invite collaborators into the largely solitary process. Zhena Muzyka and the writing circle she gathered helped me believe I could actually write. Paul Cash helped me pull relevant strands from my tangled piles of writing and hang them on a coherent frame. Michele Orwin met me every step of the way as I refined and reworked the manuscript, plying the strands into threads and weaving them into story fabric. Judith Cressy helped me polish the rough edges.

I'm grateful for the encouragement and criticism of my early readers. Roylin Downs, Kimberley Snow, Kitty Freilich, Barbara

Cornell, Denise Clemen, Geoff Biggs, Jeanne Biggs, Tammy Plunkett, Kristin Blancke, Nawang Phuntsog, Sarju Sooch, Lisa Wilson, and Ursula Jorch all contributed to the completion and the shape of this book.

I couldn't have found a better visual storyteller than Lisa Wilson to help me select and organize images to bring the story alive.

Much appreciation to the skilled photographers who tackled the challenge of photographing the reflective textures of my art-work: Juan Pinnel, Scott Miles, David Spellman, and two others (an Italian and a Tibetan) whose names I can't locate. Gratitude to Diane Barker and Peter Aronson for their beautiful portraiture of my teachers and to Rob Varela who took the best action shot ever of my hands in mid-stitch. Thanks also to Cory Yniguez for the illustrative line drawings that support the appendix.

My sincere appreciation goes to the people who championed me to others as I sought a path to publishing: Meher McArthur, Jennifer Barclay, Sarju Sooch, Prem Verma, and Paul Cash.

Big thanks to Brooke Warner, Samantha Strom, and the design team at She Writes Press for their support in the last stretch—bringing the book into physical reality. Thanks also to Cindy Rasicot, Barbara Linn Probst, Linda Moore, Isidra Mencos, and the whole community of She Writes Press authors.

And to my publicist, Julia Drake and her whole Wildbound PR team.

Thanks also to my virtual assistant of many years, Lisa Nelson, for helping me get Weekly Wake-ups out to readers every Monday and for providing so much other assistance in her steadfast, no-nonsense way. And thank you to every reader of the Weekly Wake-ups. This web of connection nourishes me at my deepest roots.

Profound gratitude and respect to His Holiness the Dalai Lama and the entire Tibetan community in exile for preserving their rich culture long enough for me to meet it and for welcoming me so warmly into it.

I had no idea when I went to Dharamsala that I would be surrounded by artists. I benefitted from and had a ton of fun

with the community of thangka painters in and around the Tibetan Library in Gangchen Kyishong—among them, Migmar, Bhuchung, Ngawang Chophel, "Pa-la," Kalsang Dawa, Ugyen Choephell, Jigme, Tenzin Ngodup, and of course, Alex.

To my tsemkhang colleagues, whose names have been changed, thank you for your companionship on the path and for accepting my *inji* awkwardness.

Sadhna & Nidhï don't appear in this story but were a huge and loving part of my India life. And Preeti offered me enduring hospitality in Delhi even though she hated the horsehair I carried into her home.

To all my teachers—my many Dharma teachers (particularly Garje Khamtrul Rinpoche, Geshe Sonam Rinchen, Drupon Samten, Ram Dass, and my mystic mentor Bill Bauman) and my thangka-stitching teachers (Tenzin Gyaltsen and Dorjee Wang-du)—I hope I've understood and conveyed your teachings well. I strive to live them as best I can. Any errors or omissions are surely my own.

Deep gratitude to EVERY Stitching Buddhas student who has allowed me to share what I learned. Your questions forced me to hone my explanations and to deepen my understanding. Special thanks to my first student, Louise Burnet-Munoz, for pulling the teacher out of me.

I have the best parents in the world to thank for gifting me a positive outlook and providing unconditional support. Specific acknowledgment goes to Mom for opening the door of my mind to Eastern thought, for being one of my first readers, and for loving everything I create. Huge thanks go to Dad for being willing to travel anywhere in the world to visit me and for believing in me even when I strayed far from the expected path.

My infinite appreciation goes to Francesco Mari, former husband and forever family, for his enduring support and steadiness.

I'm grateful to my brilliant stepdaughter Giulia for her vision and encouragement and am so proud of the person she keeps on becoming. An enthusiastic conversation with Giulia catalyzed the transformation of this book from dream to project.

Many thanks also to my equally brilliant stepson Tommaso, a kind and generous man with whom I've always felt at ease. Tommy shares my aversion to phone calls, which makes each time we manage to talk all the more precious.

To my sister Amy Simpkin, my brother Dan Freilich, and all my siblings-in-law, nieces, nephews, and friends on three continents. Together, you form a resilient web that holds me strong.

Pat and Keller, the best neighbors imaginable, are dear friends who became even dearer in covid times. They and so many good friends listened endlessly to my hopes and tribulations without ever asking, "Aren't you done with that yet?"

I wasn't then but now I am, and I'm filled with gratitude.

❄ *Appendix* ❄

Stitches and Steps
of Tibetan Appliqué

~~~~~~~~~~~~~~~~~~~~~~~~~~~~~~~~~~~~~~~~~~~~~~~~~~~~~~~~

It takes years of apprenticeship and a life of practice to master
the skills of Tibetan appliqué. Although this is not a how-to
book, I feel a responsibility to document the techniques I learned
from my Tibetan teachers so that students of Tibetan art and
culture will have access to them now and in the future.

Some of you will find that understanding the stitches allows
you to look deeper and see things you wouldn't otherwise see.
This will enhance your appreciation of the artwork. A few of you
may try your hand at some of these basic techniques and become
inspired to seek out an apprenticeship or join the Stitching
Buddhas® program to learn more.

I don't expect you to be able to make a silk thangka after read-
ing the following pages, but I would be remiss in my commitment
if I didn't describe the basic stitches and steps that build these
remarkable artworks.

## Cords of Horsehair and Silk:
## *How to Wrap Horsehair with Silk Thread*

Let's start with the horsehair cord. This distinctive piping gives Tibetan appliqué its characteristic texture and crispness.

**Select three strands of horsehair:**
- Pay attention to their thickness. Consider the line you intend to make and its place in your overall design. How heavy do you want it to be? Painters can control the weight of their lines by the placement of their brush and the amount of paint they put on it; appliqué artists vary the weight of lines through careful selection of hairs and thread. Closely observing the hairs before wrapping them, select coarser hairs for heavier lines and finer hairs for finer lines. Line weight can also be varied by adjusting the number of hair strands at the core of each cord and the number of silk strands wrapped around them. Most lines start with three hairs at their core, while the finest lines that trace around eyes and small fingertips may contain just one single hair.

**Prepare your thread:**
Thread is formed of two or three twisted strands. By untwisting them, you allow the strands to lie flat as they are wrapped around the horsehair, rather than forming ridges. This also frees the silk fibers to grasp the hair's surface more securely. You may have trouble separating strands if your thread is tightly twisted, as is most commercially available thread intended for use on sewing machines. Separation is much easier with a loosely spun silk thread like that made in Varanasi, India, specifically for Tibetan artists. If you can't separate your thread, try wrapping with a full thread or use untwisted flat thread or embroidery floss. Your cord may not be as smooth, but you'll get a taste of the wrapping process.

- Break off a length of thread about as long as you are tall. To do this, just hold the spool loosely in one hand and pull the loose end of the thread behind your head with your other hand, stretching both arms out wide.
- Separate the strands of Varanasi silk thread just as you would the strands in a length of embroidery floss. Give the ends a quick counterclockwise spin with your fingertips. They will separate naturally. Hold onto the end of one strand as you slide the other strand down along its length.

**Now, get your horsehair ready and start to wrap it:**

- Line up the three strands of horsehair evenly at one end. Place a small lump of modeling clay or putty on the opposite end of the hairs to hold the strands together and add weight. This will keep them from getting tangled when you start wrapping.

- Grasp the unweighted ends of the horsehair together with a single strand of the prepared silk thread between the thumb and index-finger knuckle of your dominant hand. Let the weighted end of the horsehair hang down. Turn the horsehair by rubbing your thumb along your bent index finger, from knuckle to tip. As the horsehair rotates, it begins to pull the thread around with it, cloaking itself in a spiral of color.

- Guide the thread with the thumbnail and index finger of your nondominant hand, so that it lies smoothly as it wraps around the hair. With each rotation, each new round of thread should lie just next to the one before. Try not to allow rounds of thread to pile up or to stretch out like the stripes on a candy cane. The thumbnail of your non-dominant hand should press the thread into the pad of your non-dominant index finger, just below the horsehair and tightly against it. This will keep the thread under the right amount of tension to wrap the hair smoothly.

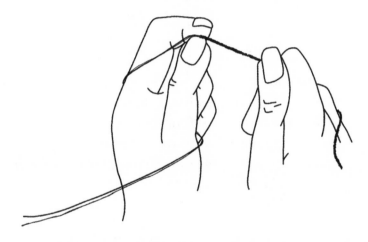

- Once you've mastered manual horsehair-wrapping, you can employ mechanisms to ease the turning and reduce hand fatigue. Turning aids include the horizontal bobbin winders of some treadle sewing machines as well as various bobbin winders that clamp to the edge of a table. Some artists I know even use an electric drill. Any mechanism that will rotate the horsehair in the desired direction can work.
- Continue wrapping until you reach the end of the horsehair. Remove the putty just before you get to it. Break off any remaining thread. The wrap may loosen a bit at the end after you cut it, but it shouldn't unravel. The hair's microscopic scales will cling to the silk's fibers.

*Horsehair seen through a microscope.*

- Put the putty back on the end of the wrapped hairs. Take another length of untwisted silk thread and repeat the steps above to add a second layer of color, turning the hair and guiding the thread to achieve a smooth finish.
- Set aside any remaining thread. You'll use it later to make a sewing thread that matches your cords.

Congratulations! You've made your first horsehair cord! The hair should be completely covered and the diameter of the cord fairly even and smooth. This won't happen the first time you try it, of course. Don't be surprised if your first cord—or your hundredth cord—is riddled with lumps and bumps. It takes practice. Lots of practice. Even after years of wrapping horsehair with silk, I still throw away some of my cords because they don't meet my standards. Have patience and go easy on yourself. Cord by cord, it gets easier and easier.

## *Twisted to Strength*

If you had any thread left over when you finished wrapping the horsehair, you'll use it to attach the wrapped cord to your fabric. This is one of the reasons we make our own cords; When the

thread that wraps the cord is the same as the thread that holds it in place, your stitches disappear just as raindrops merge into the surface of a pond.

Before wrapping the horsehair, we separated a length of thread into individual strands. This allowed the thread to lie smoothly, avoiding ridges, as it was wrapped along the length of the horsehair. Untwisted thread, however, has very little strength. It breaks easily.

The strength of any thread, string, twine, or rope is derived from being twisted in opposing directions. First, two or more strands are twisted separately in one direction. Then they are united and twisted together in the opposite direction.

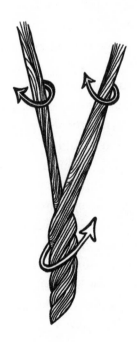

To anchor our cords securely to the surface of our cloth, we'll need to rebuild a break-resistant thread. We could use our original, unseparated thread, but it's generally too thick for this purpose and would result in highly visible stitches—something we'd prefer to avoid!

Instead, let's twist a new finer thread as follows:

- Take a 12- to 14-inch length of one strand of untwisted thread.
- Knot one end of the strand.
- Look closely at the thread. You'll find that this single strand is composed of other finer strands. In the silk thread I use from Varanasi, each of the two principal strands can usually be divided into four finer strands. I split them in half, that is into two pairs of two strands each. The untwisted strand of other threads may split into only two sub-strands . . . or into six or eight. Whatever the case, you will want to divide those in half, so that your primary strand is roughly split down the middle.
- Starting at the knotted end, separate the first inch of thread manually with your fingers.
- Hook that separated section over a needle that is anchored to a fixed cloth. (It can be a tablecloth, a cushion in your lap, or your pant leg.)
- Pulling the strand taut with one hand, use the fingers of your other hand to separate the sub-strands of thread. If you keep the strand taut, you should be able to do this with minimal difficulty or tangling. If you let the thread hang loosely, it will tangle, and you won't be able to separate it easily.
- Holding the newly separated sub-strands in your left hand, in the crook between your thumb and index finger, rub your right palm in an upward motion against them, twisting the strands separately in one direction. (It helps to moisten your right hand slightly to create enough friction to twist the thread. A quick lick of your palm will serve this purpose quite well.)
- Keeping the strands taut with the pressure of your left fingertips against the base of the right palm, turn your right hand so that your fingers point toward the anchoring needle. Place your middle finger between the strands. This finger will keep the strands separated as you pull them back, toward yourself, and position them again in the crook between your left thumb and forefinger.

- Make another upward pass of your right hand against the left and repeat the pullback and repositioning.
- Repeat again for a total of three upward twists of the separate strands.
- Switch hands and hold the two strands together with your right hand, in the crook between your thumb and index finger.
- Now, rub your left palm in an upward motion against the unified strands, spinning them together in the opposite direction.
- Repeat once. (The strands of your thread will now have been twisted separately three times in one direction and twisted together twice in the opposite direction.)
- Remove your newly twisted sewing thread from its anchor and set it aside.

You just twisted strength into thread by hand!

## *Drawing Transfer*

What lines will you follow in stitching your newly wrapped horsehair cords into place with your newly twisted fine thread? Along the lines of each segment of your drawing. To begin that process you will transfer the shape of each segment of the main drawing onto an appropriate piece of fabric.

First, you'll need to make a copy of your drawing on transparent tracing paper or vellum. This will allow you to control the placement of each drawing segment on the fabric.

Always align the drawing with the grain of your fabric. Aligning the vertical center-line of each segment of the drawing with the grain of the fabric will keep the direction of the fabric's weave consistent throughout your entire design. If you vary the angles of your drawing transfer, different pieces of the same fabric may appear to be different colors as light hits the grain.

Traditionally, drawing transfer was done with chalk powder and a perforated template. If you want to follow this method, use a

needle or pin to poke tiny holes along every line of your drawing. Then, place the perforated template on your fabric and dust the paper's surface with a small cloth bag filled with chalk powder, known as pounce. Remove the paper, and you'll see dotted lines on your fabric. Use a pen to draw over those chalk lines to mark them more durably.

Today, we are not limited to the traditional pounce-transfer method. Specially made transfer papers save time and increase accuracy in copying designs to fabric. A kind of carbon paper for fabric, this drawing-transfer aid is available in most fabric and quilt shops. There are waxed and wax-free varieties. I prefer to use the wax-free variety and to reinforce my transferred lines with ball-point pen. Choose paper and pen colors that will be visible on the particular fabric you're working with. The color choice may vary for different parts of your design. Whatever aids you employ, you'll want to make the finest and faintest indelible line you can see.

Frugal use of fabric was of utmost importance in traditional workshops. Brocade and other silk fabric were precious, had usually been gifted, and were not easily reordered. These days it may be a bit easier to acquire additional materials, but they remain costly, and frugality remains a cherished intention. Therefore, when transferring multiple segments of the drawing to a single piece of fabric, trace the segments close together in order to conserve fabric. In your effort to conserve, however, don't place the outlined segments so close together that you can't cut them apart after the cords have been stitched on. Leave half an inch (a centimeter or so) between shapes and remember to keep the grain of the fabric consistently aligned.

## Outlining Pieces

A couch stitch secures the silk-wrapped horsehair cords to the surface of the fabric along the transferred lines. Couching is a form of embroidery involving two threads—or, in our case, one horsehair cord and one matching thread. The heavier cord remains on the surface of the fabric, while the finer thread loops

through the fabric and over the cord to hold it in place along the lines of the design. Horsehair has just the right amount of flexibility to curve and bend as directed and just the right amount of rigidity to prevent it from flopping and wiggling. It's perfect for contours and outlines.

Because the loops of thread that will anchor the horsehair cord to the fabric are made from the same thread that wraps the cord, the loops will disappear into the cord, leaving only the cord-lines to stand out from the surface of the fabric. These strong outlines, together with a heavily layered effect, give Tibetan appliqué art its characteristic vibrancy.

### Thread your needles:

- Take a piece of fabric onto which you've transferred a portion of your drawing.
- Select a wrapped horsehair cord of an appropriate color and a fine, re-twisted thread of the same color.
- Thread a very fine needle with the re-twisted thread. This will be your sewing needle. Appliqué sharps work well.
- Thread one end of the horsehair cord through the eye of a thick needle with a large eye and a sharp point. Crewel, chenille, and darning needles will all work for this purpose.
- Knot the other end of the horsehair cord by stitching around and through it several times with the fine thread. This will prevent the wrapped covering on the horsehair from unwinding, and it will form a lump that will keep the end of the cord from coming through the fabric.
- Cut off the excess cord behind knot, leaving the fine thread attached to the end of the horsehair cord.

**Start your line:**

- Pull the horsehair cord through the fabric with the large needle, entering from the back (the "wrong side" in sewing lingo) of the fabric and pulling through to the right side of the fabric at the beginning of a line. The knot/lump that you made at the end of the cord will remain on the wrong side of the fabric. Let the cord dangle free with the large needle still in place.
- Pull the fine thread through the fabric from wrong side to right with the sewing needle. Bring it up at a point just in front of the cord along the same line.

Now you're ready to stitch.

**Stitch by stitch:**

- Hold the fabric so that the line you've drawn on it slopes downward toward your body. While Westerners tend to stitch in a horizontal orientation, from right to left or vice-versa, Tibetans stitch a line pointing downward and toward their body. In this method, the wrists remain neutral and relaxed. Gravity aids the stitcher as the horsehair cord dangles in the direction of the line it's following.
- Bring the sewing needle up through the line and pull the thread up on one side of the cord.
- Send the needle back down through the fabric on the other side of the cord—into the drawn line, just the tiniest fraction of an inch ahead of where it emerged. As you pull the thread tight, you will see that it forms a loop to hold the cord firmly along the drawn line.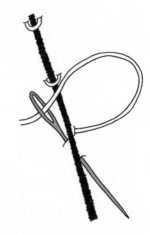
- Continue stitch by stitch, loop by loop, attaching the cord to the surface of the fabric along the

drawn line. Coax the cord to curve along your line. Leave the cord free to follow your nudges, then tighten your stitches to hold it securely in place.

- Push the needle with your index finger to take a stitch. A leather thimble on the index finger of your stitching hand will protect your fingertip while retaining its ability to grasp and pull the needle.
- Pull the needle through (still toward yourself) using the thumb and middle finger of your stitching hand.

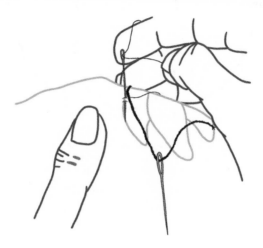

- Use shorter stitches in tighter curves, longer stitches along straighter lines.
- At points and corners, use your thumbnails to pinch the cord, bending it sharply to mimic the line. Use tiny tight stitches to hold those sharp angles in place.
- Enjoy the twang of the thread as you tighten it but be careful not to break it. Learn how much pull is just enough. Dance with your materials. Listen to them. Get to know them. Respect them.
- At the end of the drawn line, use the big needle to carry the remaining horsehair cord through to the wrong side of the fabric. Make another stitch-through knot to keep the cord from unraveling. Leave a short (1/4 inch) tail and cut away any excess cord.

*Couched and cut.*

*Couching stitch seen from the back of the fabric.*

# *Prepare for Assembly*

Now that you've outlined several pieces with horsehair cords, it's time to cut those pieces out and prepare them for assembly. This step is fairly simple but must be done with care. It's important not to cut any of your stitches while clipping, and to fold in such a way that the horsehair cord stands out as a clear, crisp outline around each piece.

### Cutting

- Cut out each cord-outlined piece, leaving a narrow margin of fabric outside the couched cord line (1/4 inch or less). The narrowness of the margin depends on the size and intricacy of the piece it surrounds. You'll need to cut more closely around sharp points and curves and at the edges of very narrow pieces.
- Leave a wider margin of fabric on the un-outlined edges. These unfinished edges will be covered by the cord-outlined edge of another piece. Leave sufficient fabric to give the adjacent piece something to overlap and attach to.

### Clipping

- Using sharp-pointed scissors, clip diagonally into the margins around the couched horsehair cord. Clipping will allow this fabric edge to be folded back smoothly. Clip more densely around curves and less densely on straight lines. With practice, you'll gain a sense of how closely you need to clip.
- Clip directly into corners and sharp angles, always being very careful not to snip your stitches. To do this effectively, it's important to use scissors that come to a sharp point from all sides.

### Folding

- Apply a light coat of fabric glue to the back of your clipped edges.

- Fold these edges to the wrong side of the piece. Press with your fingernail and a small screwdriver (or similar tool) to make your folds precise. Use an iron to fix the glue and crisp the fold.
- Work the line with your tools so that the horsehair cord lies cleanly along the outer edge of the piece, standing out in relief and clearly visible from both front and back.

## *Assembly*

Working section by section, you'll cluster the cut-out and trimmed pieces into place, using your drawing template as a guide. As you join clusters with other clusters, an entire thangka will be built on the interconnection.

- Arrange the cut-and-folded pieces face up on the drawing, overlapping them so that the couched-cord lines match the lines of the drawing as closely as possible. Every raw edge should be covered by a neighboring piece's cord-outlined edge.

- Lifting each outlined edge gently, apply fabric glue to its underside with a toothpick. Then, press that edge onto the neighboring "underlapping" piece.
- Keep checking the placement of your pieces against the drawing template. They will shift and shift again. Continual readjustment is required. When assembling complex designs with multiple layers of overlapping pieces, it's useful to work with two copies of your drawing: a copy on cloth provides a foundation for laying out your pieces; a copy on tracing paper can be laid on top for fine tuning, allowing you to nudge pieces into their proper position.
- Have a hot iron ready at hand. Cover your assembled pieces with a thin muslin cloth and press with the hot iron to fix the glue.
- One by one, continue to place and glue the remaining pieces in the cluster. The glue will hold the pieces together temporarily until you stitch them for a more enduring hold.
- Pick up the same fine sewing needle and re-twisted thread that you used to couch the horsehair cords. You'll repeat

the same looping couch stitch that attached cord to fabric to stitch the pieces of your assembly together. This time, the needle comes up from the wrong side of the "underlapping" piece, through the space between the cord and the folded edge of the overlapping piece. Then turn the needle to the other side of the horsehair cord and go back down through the underlapping piece. In this way, the same stitch that previously held the cord to one piece of fabric will now hold two pieces of fabric together while hugging that same cord. Your stitches, always of the same thread that wrapped the horsehair cord, will melt into invisibility.

Through experimentation and experience, you'll get a feel for the order in which pieces need to be assembled to achieve appropriate layering. All raw edges should be covered and all contour lines visible.

Remember, there is no singular, continuous base holding all the individual pieces. Instead, the pieces depend on each other for support. The cord-outlined pieces are assembled like a jigsaw puzzle to create a unified picture. Each piece's place in the whole is fixed through its interaction with neighboring pieces. Every phenomenon is a composite of parts, interdependent and empty of any separate self.

Continue connecting piece to piece, cluster to cluster, figure to seat, sky to ground until your thangka is complete. Then frame it in brocade and be inspired to awaken.

I hope this overview helped you to understand the unique Tibetan appliqué methods that construct pieced-silk thangkas. When you next get a chance to look at one, you'll have a much deeper appreciation for the craftsmanship that created it. And if you're one of the rare few who would like to learn to make your own, please consider joining the Stitching Buddhas® Virtual Apprentice Program. I would be honored to accompany you on your path.

# Glossary of Selected Terms

*(T, S, and H indicate words originating in Tibetan, Sanskrit, or Hindi)*

**appliqué**—a needlework technique in which small pieces of fabric are stitched onto a foundation fabric to make a pattern or design. From French *appliquer*, to apply. By contrast, Tibetan appliqué, the art form I describe in this book, is a needlework technique in which pieces are outlined, overlapped, and stitched to one another to form an image or design. There is no foundation fabric.

**appliqué thangka**—a wall hanging depicting sacred Buddhist figures made from pieces of fabric. Also known as pieced silk thangka, *göchen* thangka *(T)*, or *göku (T)*.

**Avalokiteshvara** *(S)* / **Chenrezig** *(T)*—embodiment of fully awakened compassion. A figure of white light with two, four, or a thousand arms, who appears in varying forms in different countries where Buddhism is practiced. Also, a bodhisattva disciple of the Buddha who appears in several Mahayana scriptures.

**awaken**—to rouse from sleep or to stop sleeping. In Buddhism, the term "awaken" refers to an emergence from ignorance into full

awareness. With awakening comes liberation from the suffering inherent in clinging to delusion.

**bazaar**—a market or marketplace.

**bodhicitta** *(S)*—the wish to attain enlightenment for the benefit of all sentient beings. "Awakening mind" or "enlightenment-mind."

**bodhisattva** *(S)*—a person motivated by bodhicitta. An individual on the path to becoming a buddha. An awake, spiritually realized person who could enter nirvana but chooses, out of compassion, to remain in the world in order to free all living beings from suffering.

**brocade**—heavy fabric woven with a richly decorative raised pattern, often with gold or silver threads.

**buddha** *(S)*—awakened being. One who is awake. One who is awake to the true nature of reality. A person who has attained enlightenment.

**buddha-nature**—the fundamental luminous nature of mind that, cleared of all defilements, becomes buddha. Every sentient being has buddha-nature. In other words, all beings have the potential to become a buddha.

**Buddha Shakyamuni** (aka Gautama Buddha, Siddhartha Gautama, the historical Buddha)—a man, an ordinary person, born as a prince in sixth-century BCE India, who renounced his worldly life and began a spiritual quest that led to enlightenment. Having awakened to the nature of reality, he spent the remaining forty years of his life teaching so that others could achieve the same realization he had. These teachings became the foundation for Buddhism.

**Buddhadharma** *(S)*—The Buddha's teachings (contained in discourses and commentaries) and the inner experiences or realizations of these teachings.

**buddhahood**—a state of perfect enlightenment sought in Buddhism, the state of a fully awakened being.

**Buddhist**—one who takes the teachings of Buddha as their spiritual path, a practitioner of Buddhadharma.

**chai**—Hindi word for tea. Typically refers to a sweet, milky, hot tea made by boiling tea leaves with milk and sugar and, sometimes, cardamom and ginger.

**chai wallah** *(H)*—tea seller.

**chang** *(T)*—Tibetan barley beer.

**chuba** *(T)*—Tibetan wraparound dress or coat.

**couching**—an embroidery technique in which a cord or heavy thread is laid on the surface of a fabric and fastened at regular intervals by stitches taken with another thread.

**Dalai Lama**—a title given to the foremost spiritual leader of the Gelugpa school of Tibetan Buddhism in a lineage passed down through reincarnation. The title was initially awarded to the third Dalai Lama in 1546, with the first and second being recognized only posthumously. The Dalai Lamas are considered to be embodiments of Chenrezig, the bodhisattva of compassion. From the seventeenth century through the 1950s, the Dalai Lamas or their regents headed the Tibetan government, which administered all or most of the Tibetan Plateau with varying degrees of autonomy. The fourteenth and current Dalai Lama, Tenzin Gyatso, was born in the eastern Tibetan region of Amdo in 1935. In 1959, as the People's Liberation Army of communist China overtook Lhasa and threatened his life, he escaped to exile in India, ultimately settling in Dharamsala. The Dalai Lama continued to hold political leadership as head of the Central Tibetan Administration, a government in exile, until May of 2011 when he signed

a document formally transferring his temporal authority to the democratically elected leader, thus ending the 368-year-old tradition of the Dalai Lamas serving as both spiritual and temporal heads of Tibet. Tenzin Gyatso was awarded the Nobel Peace Prize in 1989 for his nonviolent struggle for the liberation of Tibet. He has consistently advocated policies of nonviolence, even in the face of extreme aggression. His principal commitments are cultivating warm-heartedness and compassion, encouraging harmony among the world's religious traditions, and preserving Tibet's language, culture, and natural environment.

**dharamshala** *(H)*—a shelter or rest house for spiritual pilgrims and travelers.

**Dharamsala** (also spelled Dharamshala)—a mountain town in the state of Himachal Pradesh, India, that serves as district headquarters of the Kangra district, as the fourteenth Dalai Lama's residence in India, and as the seat of the Central Tibetan Administration in exile.

**dharma** *(S)*—a word of many meanings. Dharma in the broadest sense refers to any knowable thing, object, or phenomenon— that is, to each of the interrelated elements that make up the empirical world. More specifically, as used most frequently in non-philosophical conversation and in this book, dharma refers to the teachings of the Buddha. This dharma is also known as Buddhadharma.

**dupatta** *(H)*—a length of lightweight fabric worn as a scarf or head covering.

**embroidery**—a variety of needlework techniques by which a fabric surface is decorated with thread. Satin stitch and stem stitch are the embroidery stitches most commonly used to embellish Tibetan appliqué art.

**enlightened**—freed from ignorance. In Buddhism, the term *enlightened* may be used interchangeably with *awakened* (to reality) and *liberated* (from suffering).

**Gangchen Kyishong** (also shortened to Gangkyi) *(T)*—an area of Dharamsala between Kotwali Bazaar and McLeod Ganj where most offices and associated housing of the Central Tibetan Administration are located. The Library of Tibetan Works and Archives and Nechung Monastery are also situated in this neighborhood.

**Gelug** (or Gelugpa) *(T)*—the youngest of the four schools of Tibetan Buddhism, the other three being Nyingma, Kagyu, and Sakya. Founded in the early fifteenth century by Tibetan monk-philosopher, Je Tsongkhapa, the Gelugpa school emphasizes ethics and monastic discipline as a central plank of spiritual practice.

**Gen-la** *(T)*—respectful term of address for a teacher or elder.

**Geshe** *(T)*—literally, "one who knows virtue." Refers to the highest academic degree in Buddhist philosophy for Tibetan monks and nuns, primarily in the Gelugpa tradition. Used as a title for anyone who holds a geshe degree.

**goser** *(T)*—literally "yellow head." Refers to persons of European ethnicity. See also *inji.*

**guru** *(H, S)*—a spiritual teacher.

**horsehair**—long strands of hair from the tail or mane of a horse.

**inji** *(T)*—a derivative of "English" used by Tibetans to describe foreigners of European ancestry. See also *goser.*

**ja / söl-ja** *(T)*—ordinary and honorific Tibetan words for tea.

Tibetan tea is usually served salty, not sweet. Hot black tea, milk, butter, and salt are churned together in a tall, narrow vessel for a frothy broth.

**ji** *(H)*—sir or ma'am. Used alone or added as a respectful suffix to a name or title.

**karma** *(S)*—the law of cause and effect, action and reaction.

**kesi**—ancient Chinese tapestry technique used to create some of the earliest textile thangkas (also transliterated as *k'o-ssu*).

**khata** *(T)*—scarf presented at ceremonial occasions and upon the arrival or departure of guests. When given as a farewell gesture, it augurs a safe journey. When given to arriving guests, it symbolizes welcome. Tibetan khatas are usually white, symbolizing the pure heart of the giver, though yellow khatas are also quite common.

**kora** *(T)*—circumambulation, a type of pilgrimage or meditative practice that involves circling a sacred place or object. Can also refer to the path on which circumambulators walk.

**Kotwali Bazaar** *(H)*—a popular market area in lower Dharamsala.

**la** *(T)*—suffix appended to a name or title to indicate respect. Tibetan equivalent of the Hindi "ji."

**lama** *(T)*—a spiritual teacher or monk. Tibetan equivalent of the Hindi "guru."

**lha** *(T)*—deity. Depending on context, *lha* can refer to a sentient being born in the god realm of samsara or to an ethereal being embodying enlightened qualities.

**lhadripa** *(T)*—thangka painter.

**Madhyamaka** *(S)*—philosophical view underpinning the Mahayana Buddhist tradition of Tibet. According to the classical Madhyamaka thinkers, phenomena are neither inherently existent nor nonexistent but are dependently co-arisen and empty of substance or essence.

**Mahayana** *(S)*—one of the two major branches of Buddhism. Literally the "great vehicle," Mahayana Buddhism originated in India in the first century BCE and is now practiced in a variety of forms in Tibet, China, Japan, and Korea. It is typically concerned with altruistically oriented spiritual practice as embodied in the ideal of the bodhisattva.

**mala** *(S)*—a strand of beads (traditionally 108, or a fraction thereof) used for keeping count of mantra recitations.

**mantra** *(S)*—words or syllables, usually of Sanskrit origin, recited in meditation.

**McLeod Ganj**—a higher-altitude suburb of Dharamsala, at almost 7000 feet above sea level, which comprises the Dalai Lama's residence, the Namgyal Monastery and Tsuglagkhang Temple, a Tibetan market area, and numerous hotels, guesthouses, and restaurants where Indian and Western travelers gather. During the British colonial rule of India, McLeod Ganj was a hill station where the British could escape the summer heat.

**mudra** *(S)*—a symbolic hand gesture.

**Namsa Chenmo** *(T)*—great master of clothing. Title given to the personal tailor to the Dalai Lama.

**nangpa** *(T)*—insider. Someone who seeks truth, freedom, and happiness not outside, but within the nature of mind. Common Tibetan word for a follower of Buddhism.

**ngondro** *(T)*—preliminary practices of Tibetan Vajrayana Buddhism consisting of thousands of repetitions of prostrations, mandala offerings, mantra recitations, and visualizations.

**om** *(S)*—a sacred syllable in Hinduism and Buddhism. It appears at the beginning of most Sanskrit prayers and mantras.

**patchwork**—a form of needlework that involves sewing together pieces of fabric into a larger design. The larger design is often based on repeating patterns built up with different fabric shapes.

**pecha** *(T)*—traditional Tibetan loose-leaf scripture book with narrow rectangular shape. Pechas usually have rigid top and bottom cover plates made of wood and are often wrapped in cloth for protection.

**puja** (also pooja) *(S)*—ceremonial worship or offering ritual.

**quilting**—a stitched textile technique in which at least three layers of material are joined together by stitches. Usually, a relatively thick or fluffy material is sandwiched between two lighter cotton fabrics. The stitches pass through all the layers to hold them together and create a three-dimensional surface pattern.

**Rinpoche** *(T)*—precious one. An honorific title for an incarnate lama or highly respected Tibetan Buddhist teacher.

**sadhana** *(S)*—methodical practice for the attainment of spiritual realization and the text or script that guides such practices. Sadhana may involve meditation, visualization, chanting of mantras, or offerings to a deity.

**salwar kameez** *(H)*—traditional dress of women in northwestern India and eastern Pakistan. The outfit comprises a pair of billowing trousers (salwar) worn with a tunic (kameez) and usually completed with a long scarf (dupatta).

**samsara** *(S)*—the cycle of life, death, and rebirth to which sentient beings are bound by karma.

**sangha** *(S)*—the Buddhist monastic community of monks and nuns. Frequently used in the West to refer to any community of spiritual friends, particularly those who share a Buddhist practice or have received empowerments from the same teacher.

**sari** (also saree) *(H)*—women's garment from the Indian subcontinent that consists of an unstitched length of fabric from 5 to 9 meters (15 to 30 feet) in length and 600 to 1,200 millimeters (24 to 47 inches) in width. It is usually worn over a short form-fitting blouse and a long skirt. The fabric is typically wrapped around the waist with one end draped over the shoulder, partly baring the midriff. Wrapping patterns vary from region to region.

**satin**—a smooth, glossy fabric, usually of silk, produced by a weave in which the weft threads catch the warp threads only at certain intervals.

**sentient**—able to experience and respond to feelings or sensations.

**shalgab** *(T)*—face cover. The veil that is draped over a thangka to hide its image from view.

**silk**—a fine, strong, lustrous protein fiber produced by silkworms to make cocoons and used by humans to make thread and fabric. Other insect larvae and spiders also produce silk but only that of the mulberry-eating silkworm, *Bombyx mori*, is cultivated for textile manufacturing. The word "silk" also refers to fabric woven from the silk fiber.

**Silk Road**—a network of trade routes that connected East and West across Eurasia. The route was central to the economic, cultural, political, and religious interactions between these regions from the second century BCE to the eighteenth century CE.

**stupa** *(S)*—dome-shaped Buddhist reliquary or shrine.

**sutra** *(S)*—a sermon attributed to the Buddha or one of his disciples. Initially passed on orally by Buddhist monastics, the sutras were later written down and composed as scriptures.

**tantra** *(S)*—an ancient Indian religious movement that seeks to harness a wide variety of experiences and mental and physical energies for use on the path to enlightenment. Also, the texts that describe and support such practices.

**tashi delek** *(T)*—Tibetan greeting used on happy occasions.

**terma** *(T)*—"treasure teachings" believed to have been hidden by highly realized spiritual masters of the past to be discovered, practiced, and taught by later masters.

**textile**—any cloth produced by weaving, knitting, or felting.

**textile art** (also fiber art or fabric art)—art constructed from plant, animal, or synthetic fibers or fabrics using techniques such as weaving, stitching, quilting, knotting, and felting.

**thangka** *(T)*—a Tibetan Buddhist wall hanging that can be rolled up. Most thangkas feature figurative images of buddhas, protectors, or other divine figures. Thangkas are usually painted with mineral pigments on cotton canvas and framed in brocade. The thangkas highlighted in this book, however, are made by stitching together pieces of silk fabric.

**torma** *(T)*—cakes of barley flour and butter used in tantric rituals or as offerings in Tibetan Buddhism. They are usually conical in form but may be modeled into specific shapes based on their purpose and may also be dyed in different colors.

**tsemkhang** *(T)*—a workshop where sewing takes place.

**Vajrayana** *(S)*—esoteric or tantric form of Buddhism. It includes practices that make use of mantras, mudras, mandalas, and the visualization of deities and buddhas to harness mental and physical energies in the attainment of enlightenment.

**veg wallah** *(H)*—fruit and vegetable seller.

**wallah** *(H)*—Anglo-Indian word for a person who performs a specific duty or is concerned with a particular activity. Examples include kitchen wallah, book wallah, tea or chai wallah, rickshaw wallah. (One Tibetan friend in India playfully referred to me as a "thangka wallah.")

**wang** *(T)*—a ritual of initiation or empowerment for Vajrayana practices.

**warp**—the longitudinal set of yarns in a woven fabric. This set of yarns is stretched on a loom before weaving.

**weft**—the transverse set yarns in a woven fabric. Weft yarns are drawn through the warp on the loom, passing over and under specific warp yarns to create a weave pattern with distinct surface characteristics.

**yabyum** *(T)*—image of male and female deities in union representing the union of wisdom and compassion that leads to enlightenment.

**yidam** *(T)*—a chosen meditational deity. The divine form a Vajrayana practitioner works with as a means to recognizing their own buddha-nature and realizing their enlightened mind.

# About the Author

Leslie Rinchen-Wongmo is a textile artist, teacher, and author of *Threads of Awakening: An American Woman's Journey into Tibet's Sacred Textile Art*. Curiosity carried Leslie from California to India, where she became one of few non-Tibetans to master the Buddhist art of silk appliqué thangka. Her artwork has been exhibited internationally and featured in magazines such as *Spirituality & Health, FiberArts, and Fiber Art Now* and in the documentary *Creating Buddhas: The Making and Meaning of Fabric Thangkas*. To share the gift of Tibetan appliqué with stitchers around the globe, she created the Stitching Buddhas® virtual apprentice program, an online hands-on course that bridges East and West, traditional and contemporary. After two decades abroad, Leslie returned to Southern California where she now lives with three cats and enough fabric to last several lifetimes. Learn more at threadsofawakening.com.

*Author photo © Doug Ellis*

# SELECTED TITLES FROM SHE WRITES PRESS

She Writes Press is an independent publishing company founded to serve women writers everywhere. Visit us at www.shewritespress.com.

*The Buddha at My Table: How I Found Peace in Betrayal and Divorce* by Tammy Letherer. $16.95, 978-1-63152-425-7. On a Tuesday night, just before Christmas, after he had put their three children in bed, Tammy Letherer's husband shattered her world and destroyed every assumption she'd ever made about love, friendship, and faithfulness. In the aftermath of this betrayal, however, she finds unexpected blessings—and, ultimately, the path to freedom.

*The Buddha Sat Right Here: A Family Odyssey Through India and Nepal* by Dena Moes. 16.95, 978-1-63152-561-2. Stressed-out midwife Dena Moes longed to escape the hamster wheel of modern motherhood—so she tore off her Supermom cape, shuttered the house, and took her husband and preteen daughters on a yearlong odyssey through India and Nepal.

*Finding Venerable Mother: A Daughter's Spiritual Quest to Thailand* by Cindy Rasicot. $16.95, 978-1-63152-702-9. In midlife, Cindy travels halfway around the world to Thailand and unexpectedly discovers a Thai Buddhist nun who offers her the unconditional love and acceptance her own mother was never able to provide. This soulful and engaging memoir reminds readers that when we go forward with a truly open heart, faith, forgiveness, and love are all possible.

*Amazon Wisdom Keeper: A Psychologist's Memoir of Spiritual Awakening*, Loraine Y. Van Tuyl, PhD. $16.95, 978-1-63152-316-8. Van Tuyl, a graduate psychology student and budding shamanic healer, is blindsided when she begins to experience startling visions, hear elusive drumming, and become aware of her inseverable, mystical ties to the Amazon rainforest of her native Suriname. Is she in the wrong field, or did her childhood dreams, imaginary guides, and premonitions somehow prepare her for these challenges?